Drawing
the
Human Body

Giovanni Civardi

Drawing *the* Human Body

An Anatomical Guide

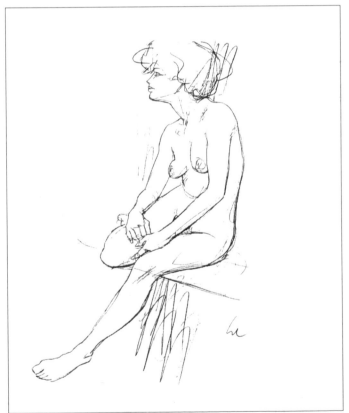

Sterling Publishing Co., Inc
New York

In dedicating this book, I wish
to express my gratitude to Professor Gottfried Bammes
(*Ordinarius em. Fur Kunstleranatomie,*
Hochschule fur Bildende Kunste, Dresden)
for honoring me with his friendship and for expressing freely
his honest and considered opinions on the significance of anatomy
in the art studio and in the formation of the artist

Translated by Rosa Iacono
Internal graphics by Grazia Cortese
All drawings by Giovanni Civardi
Photocompositions and lithographs
by Jo-Type-Pero (Milan)

Library of Congress Cataloging-in-Publication Data Available

10 9 8 7 6 5 4 3 2 1

Published by Sterling Publishing Company, Inc.
387 Park Avenue South, New York, N.Y. 10016
English translation © 2001 by Sterling Publishing Co., Inc.
Originally published as *Morfologia Esterna del Corpo Umano:*
Una Guida Anatomica per Disegnare Correttamente la Figura
© 1999 Il Castello srl, Milan.
Distributed in Canada by Sterling Publishing
%o Canadian Manda Group, One Atlantic Avenue, Suite 105
Toronto, Ontario, Canada M6K 3E7
Distributed in Great Britain and Europe by Cassell PLC
Wellington House, 125 Strand, London WC2R 0BB, England
Distributed in Australia by Capricorn Link (Australia) Pty Ltd.
P.O. Box 6651, Baulkham Hills, Business Centre, NSW 2153, Australia
Printed in Italy
All rights reserved

Sterling ISBN 0-8069-5891-X

Contents

Preface

The difficulty is not to make a work of art; but to enable oneself to do so.—Constantin Brancusi

The study of the human body, whether with the intent of rendering it for pictorial or sculptural recognition, can be approached through a variety of instructional methods. These tend, however, to follow two basic fundamental paths.

The first, definable as "perceptive" (gestalt), comes from comprehensive observation, attention, emotional impact, and a sharing of the subject as a whole, representing "what is seen." The other, definable as "constructive," places the major emphasis on the more rational aspect of perception to effectively represent "what is known" about the subject.

Defined in such brief summary, these two methods obviously appear confined to diametrically opposing paths. The lines of study are, however, sufficiently complex conceptually so that, if correctly intertwined, the two paths often integrate and strengthen themselves reciprocally. Mature and authentic artists tend to apply them in an appropriate manner with an almost sure instinct.

Modern schools of the art of drawing, with a distinct preference for the first process (which most certainly provides students with more immediate gratification), do not overlook incorporating the second, more traditional "academic" (in the best significance of the term) method, providing not only set rules or stereotypes but a foundation for the understanding of anatomy—an integral "lecture" on the human body. Didactic experience in this field, however, suggests to me a different combination of the two procedures. Remember, even if gained only from observation, precise anatomic information is indispensable for the solid preparation of an artist who is interested in the human body, strives for wider acceptance, and desires to comprehend fully and objectively what he or she wants to express, whether widely figurative or in the abstract.

Maybe, especially in these years of cultural and biological confusion, there comes a disorientation with regard to the human body (so-called "post-organic" interpretation, bone grafts, prosthesis, genetic manipulation, surgical alteration, anthropomorphized animals, computer construction of virtual reality, etc.). Yet, there is the desire "to know" and not remain in ignorance; the ability to choose–accept or refuse; and to alter based on knowledge, liberty, creativity, and autonomy.

Further, to complement more distinctly the parallel path in this way does not make it suffer; on the contrary, it becomes even stronger. This fact was affirmed to me recently with the happy announcement, "Everyone sees what they have learned to see."

This is the conviction that has guided my life's work and, in particular, this present book, in which I have tried to focus the artist's attention on the exterior form of the body and reveal, although synthetically, the underlying anatomic structure that determines the visible form.

This work is based on two preceding books published in Italian. To be completely honest, with regard to the iconography portion, the volume *Anatomia Artistica* is more scientifically based and closer to the traditional concept of anatomy. Full descriptions of the external aspects of the corporal regions and territories, however, are reproduced in this book. This book is further integrated and completed from *Schizzi di Anatomia Artistica*, a book of sketches published separately. *Schizzi* ("Sketches") contains more in-depth anatomic information (bone-joint myology) not included here in favor of much new information of more interest to the serious artist.

Here, the sketches are intertwined with anatomy notes as a guide for attentive observation by the artist, and by the merely curious, of the external morphology of the human body in its entirety, each of its regions one by one, and its variable individual aspects. Above all, this volume constitutes an invitation to observe and to research, through the close study of living models, the characteristics of bodily form and anatomy relative to design.

It can be useful to include certain technical notes leading to the realization of a book.

I requested a few years time in order to work diligently on it, since the drawings are almost all taken directly from actual models posing. The few exceptions that caused me to consult photographic documentation were due to such concerns as the uncertain position of a subject and the necessity to "fix" distinctly transitory muscular motions.

Instead of expressively interpreting the form, I preferred to document it using a rather neutral, almost linear art style. The method illuminates the model in a way that produces shade sufficient to delineate interesting detail and is in harmony with the intent to stimulate the studious to recreate "in life"—to exist with the model in the situation, instead of simply observing a design.

Each drawing was executed on small, smooth, 40-by-60 centimeter Bristol board, using pencils of various strengths.

Giovanni Civardi
Milan, September 1998

Structure of the Male and Female Body

(sketches 1–2)

For the study of structure and form (morphology) and for the purpose of anatomical description, the human body is observed in its most natural and characteristic, erect position with the upper joints hanging stretched alongside the torso, jaw up and forward, and lower joints extended and close together. This state is called the "anatomical position," to which references are made when describing the body's positioning and its spatial relationship and orientation to the corporal organs.

In this position, the body presents to the observer an anterior face (sketch 1a), a posterior face (1b) and a side view, or profile (1c). To study the human body in its entirety, it must be observed at sufficient distance (at least two yards) for a view comprehensive enough to gather together the general characteristics of the structure, for example: the relationship between body parts, sexual differences, muscular and skeletal formation, and the distribution of fatty membranes (panniculus). Observation of the frontal (or the back) view reveals the symmetry of the body in respect to the median sagittal plane and shows the transversal alignment of the shoulders to the pelvis, the relationship between chest and abdomen, and the axis of the lower joints. Lateral observation allows visualization of the corporal axis (which normally extends laterally from the outer ear to the anklebone). It also reveals the anterior profile of the torso, the curvature of the neck and back, as well as fatty and muscular consistencies of the abdomen, buttocks, and legs.

The muscles determine the comprehensive form of the human body, the skeleton (which constitutes the fundamental structure) on which they are massed, and of the fatty panniculus. The trunk (or axis), the principle part of the body, consists of an upper rounded portion (the head), a smaller, somewhat cylindrical middle portion (the neck), and an extensive lower portion in a flattened cylindrical form (the trunk or torso). Two appendages are connected to the upper part of the trunk, the upper limbs. Two appendages are also joined to the lower part of the trunk, the lower limbs, which extend from the bottom of the trunk to the floor.

A practical proportional assessment of the human body (see page 12) generally requires a comparison of width and length, choosing one unit of the body (for example, the head) as a unit of measure, which will also relate bone and muscular points of reference on the nude. The height of the head corresponds to the distance from the top of the cranium to the base of the chin.

The natural rule indicates that the total height of the body equals about seven and a half heads. The neck and the rest of the trunk measure in length about three heads, the maximum distance between the two protruding shoulder points is two heads, the maximum width of the buttocks is about one-and-a-half heads, the length of the upper limbs is equal to three heads, and the length of the lower limbs equals three and a half heads. Half of the body's height should be at the pubic level.

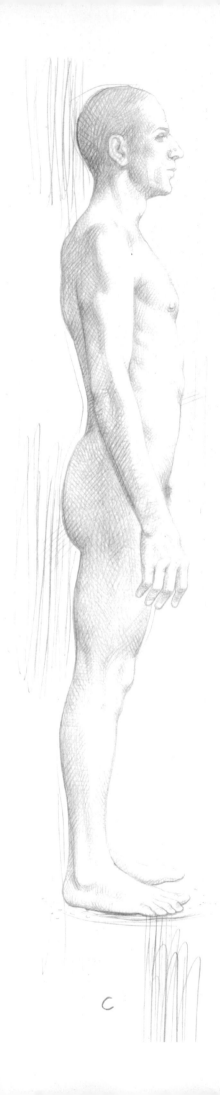

c

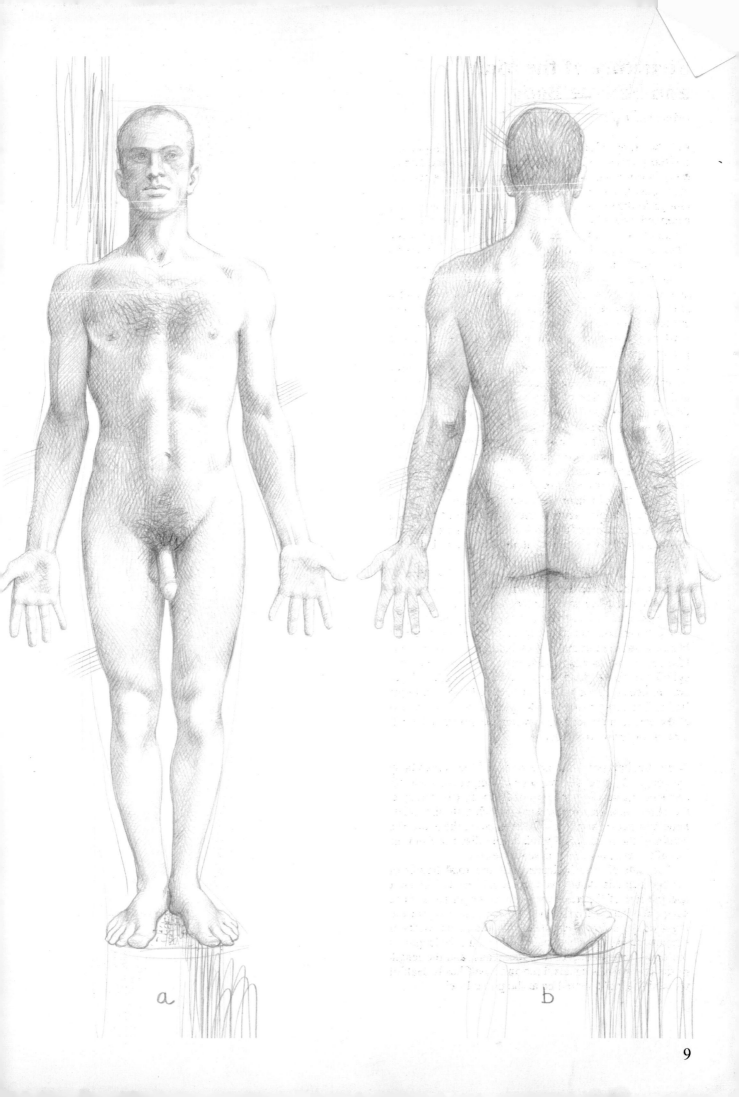

a b

The relative proportional relationship of the female body is somewhat different than that of the male with regard to the characteristics of the muscles and the bones, and the protruding fatty tissue in the two sexes.

The most relevant morphological differences between the male body (sketch 1: 26-year-old model, 69 inches tall) and the female body (sketch 2: 23-year-old model, 64 inches tall) that have interest for the artist are "secondary" divisions. These prevalently regard the locomotive apparatus (the skeleton in particular) and the integument apparatus. In fact, the major part of the corporal differences between man and woman can be brought back to two fundamental facts: 1) the different reproductive compositions (the woman's pelvis is larger and shorter and the mammary glands are very developed); and 2) the different times of sexual maturation (development is more rapid in the female and determines minor dimensions and strength in the locomotive apparatus).

In the first approximation, the most relevant corporal differences are as follows:

Man: Tends to have an elongated head, a longer face, a flatter torso; his trunk is shorter in respect to his stature; he has a longer humerus and femur in relation to total length of the limbs; and a straighter and longer pelvis. Hair is distributed on the face, torso, and forearms; pubic hair extends near the naval.

Woman: Tends to have a more rounded head, shorter face, more profound torso, relatively long trunk in relation to stature, relatively shorter humerus and femur, major development of subcutaneous fat (breasts, buttocks, and legs). Longer hair on head, but minor amounts on body; pubic hair delimited horizontally. The pelvis is short and wider than the shoulders. Inclination of the axis of the upper and lower limbs is more accentuated. The rib cage is more curved in the upper part of the torso.

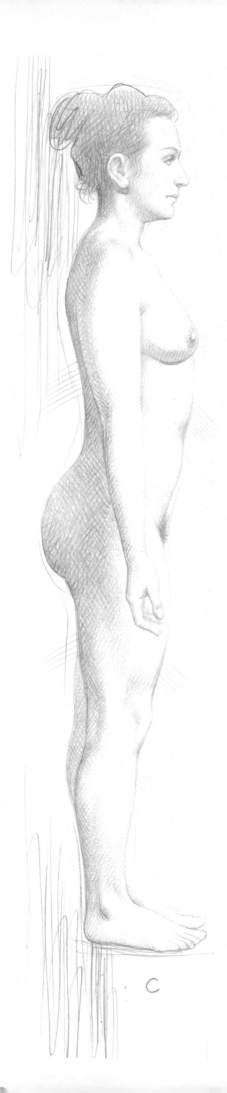

10

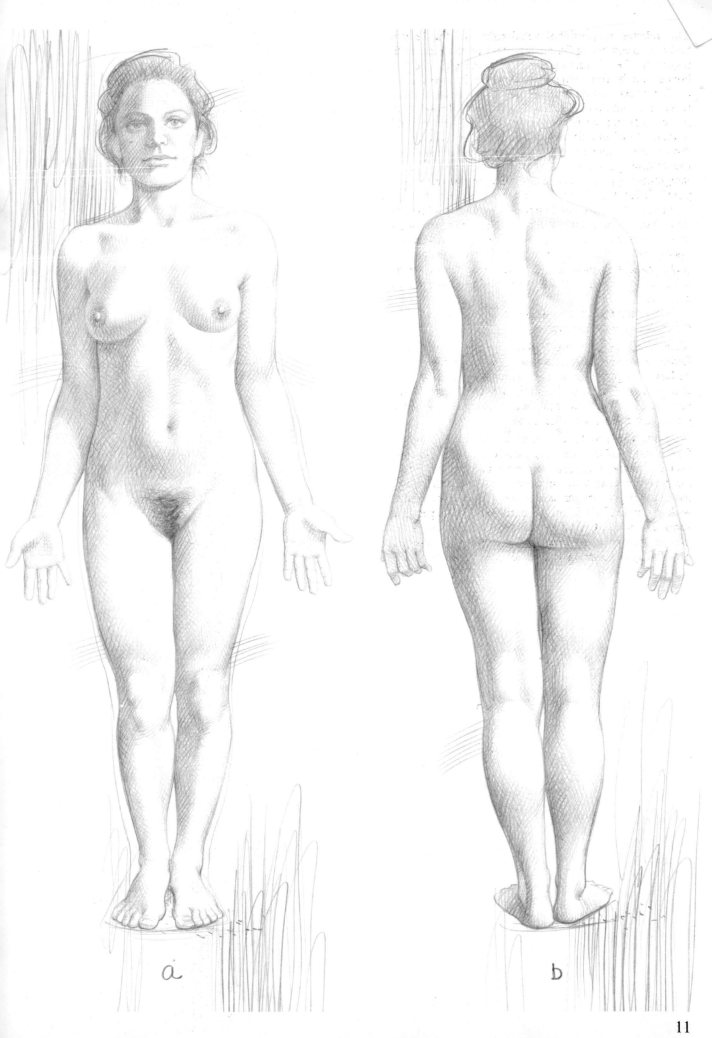

a

b

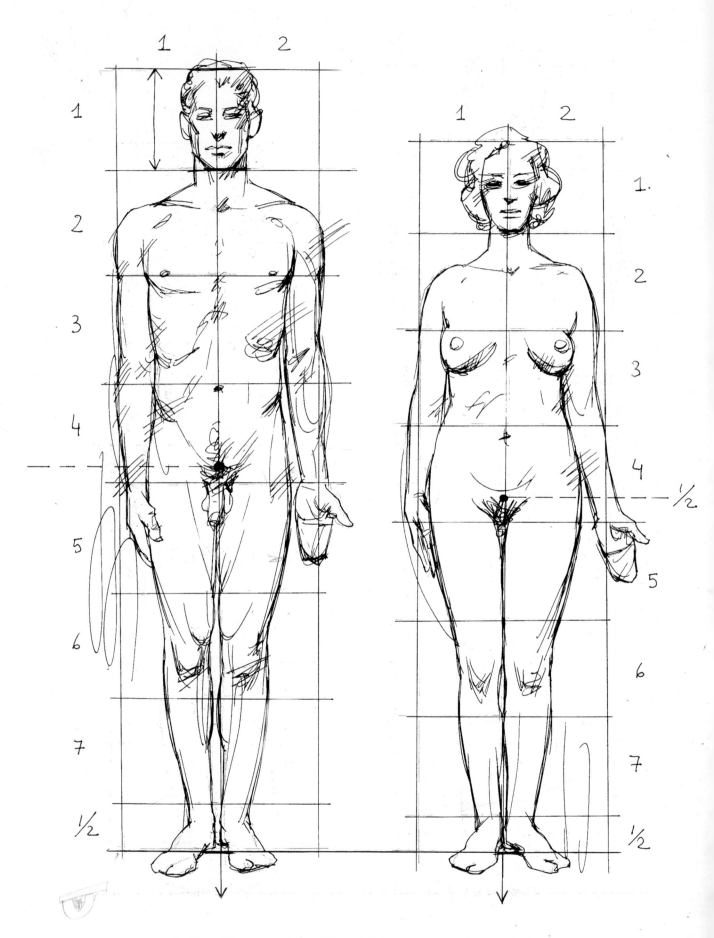

Outline of the proportions of the adult human male and female bodies,
according to a "scientific" scale

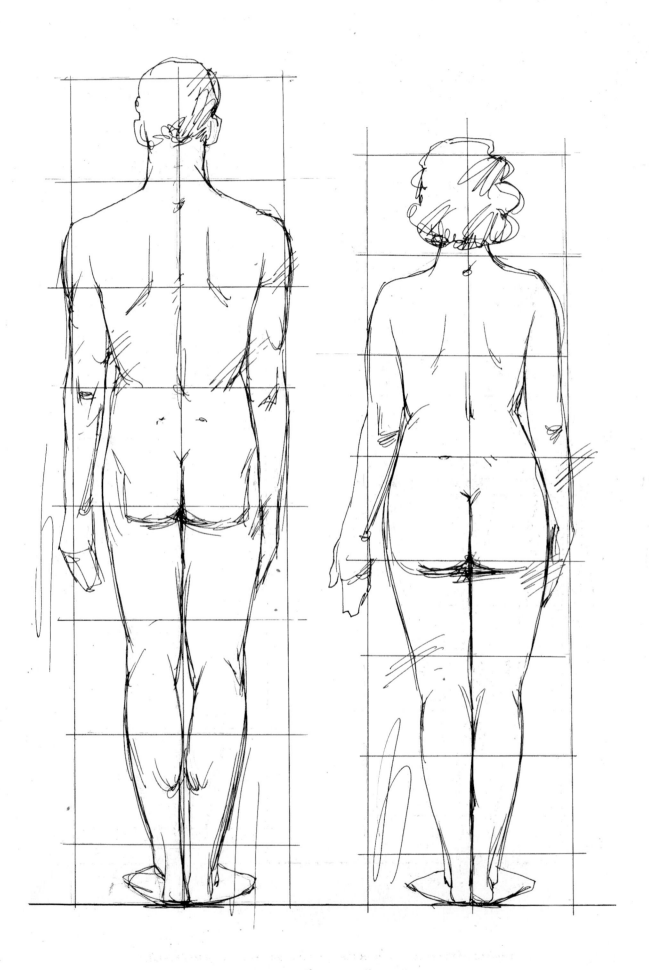

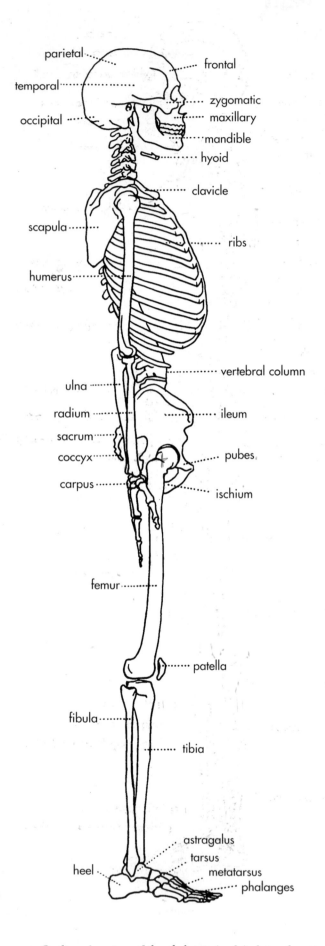

parietal ...
temporal ...
occipital ...
... frontal
... zygomatic
... maxillary
... mandible
... hyoid
... clavicle
scapula ...
... ribs
humerus ...
... vertebral column
ulna ...
radium ...
sacrum ...
coccyx ...
carpus ...
... ileum
... pubes
... ischium
femur ...
... patella
fibula ...
... tibia
astragalus
tarsus
heel ...
metatarsus
phalanges

Outline drawing of the skeleton (male): lateral projection

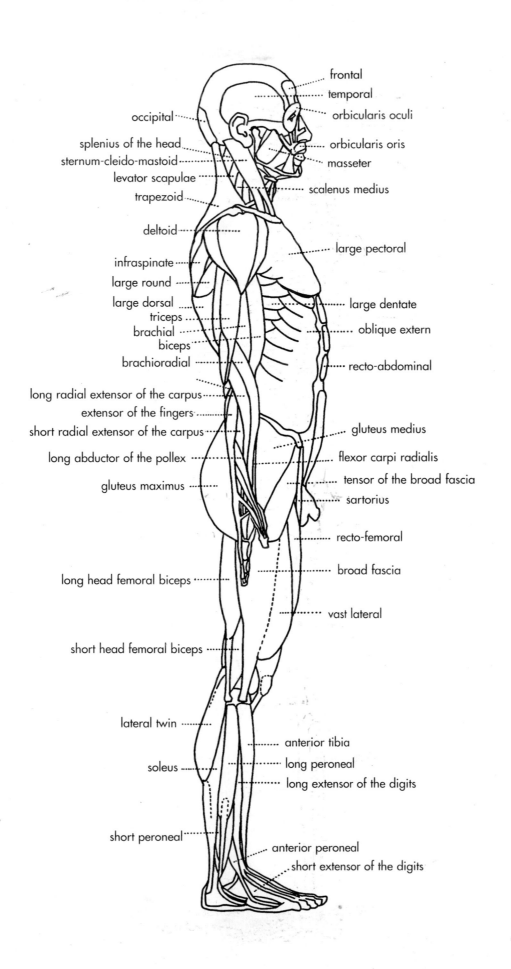

frontal

temporal

orbicularis oculi

occipital

splenius of the head

sternum-cleido-mastoid

levator scapulae

trapezoid

deltoid

orbicularis oris

masseter

scalenus medius

large pectoral

infraspinate

large round

large dorsal

triceps

brachial

biceps

brachioradial

large dentate

oblique extern

recto-abdominal

long radial extensor of the carpus

extensor of the fingers

short radial extensor of the carpus

long abductor of the pollex

gluteus maximus

gluteus medius

flexor carpi radialis

tensor of the broad fascia

sartorius

recto-femoral

broad fascia

long head femoral biceps

vast lateral

short head femoral biceps

lateral twin

soleus

anterior tibia

long peroneal

long extensor of the digits

short peroneal

anterior peroneal

short extensor of the digits

Outline drawing of the superficial muscles: lateral projection

15

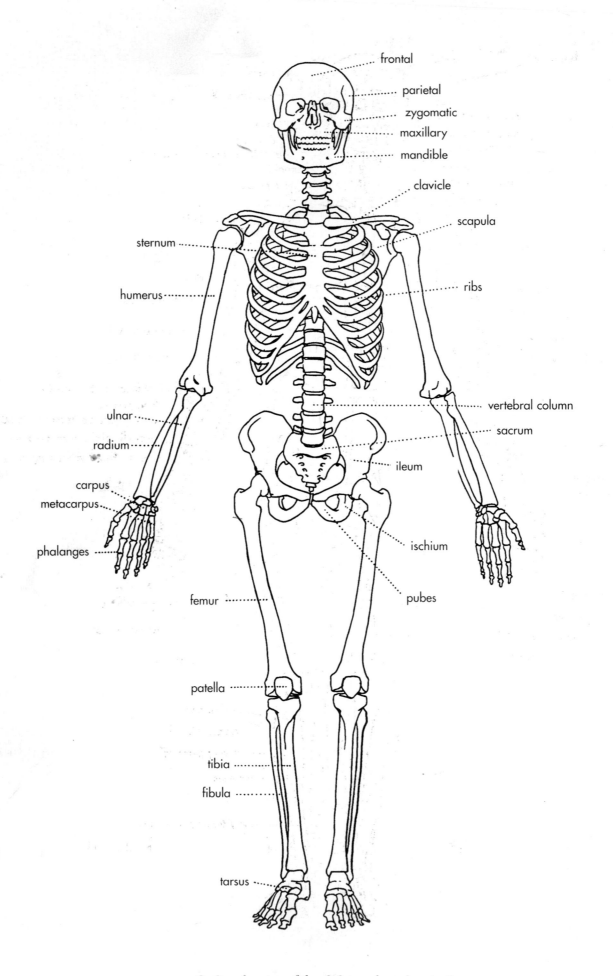

frontal
parietal
zygomatic
maxillary
mandible
clavicle
scapula
sternum
ribs
humerus
vertebral column
sacrum
ulnar
radium
ileum
carpus
metacarpus
ischium
phalanges
pubes
femur
patella
tibia
fibula
tarsus

Outline drawing of the skeleton: frontal projection

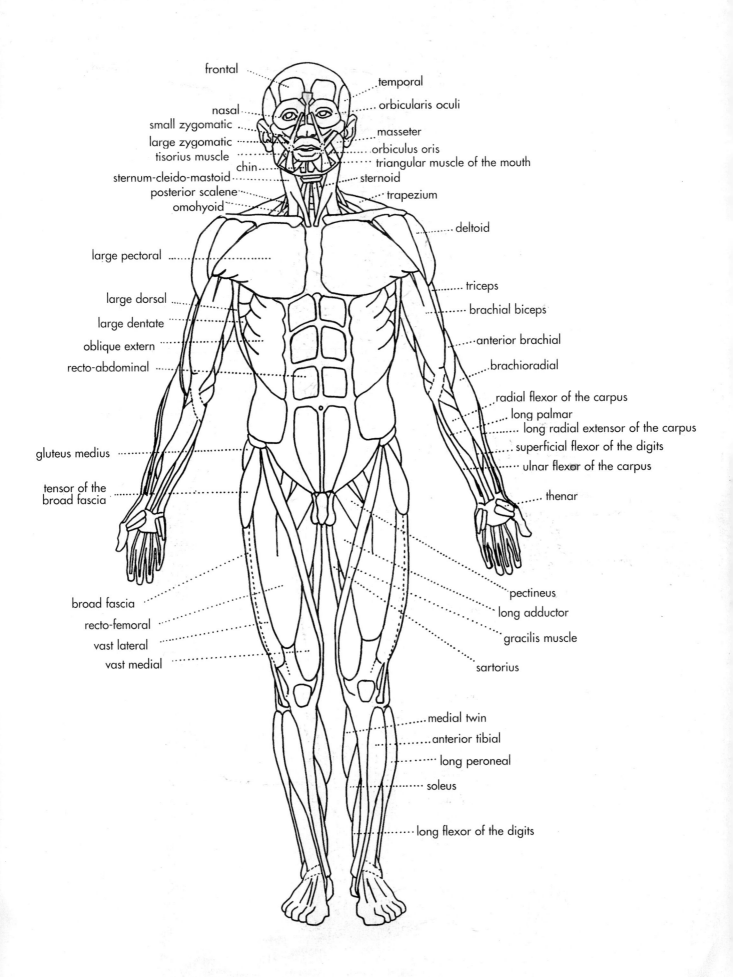

frontal

temporal

orbicularis oculi

nasal

small zygomatic

masseter

large zygomatic

orbiculus oris

tisorius muscle

triangular muscle of the mouth

chin

sternum-cleido-mastoid

sternoid

posterior scalene

trapezium

omohyoid

deltoid

large pectoral

triceps

large dorsal

brachial biceps

large dentate

anterior brachial

oblique extern

brachioradial

recto-abdominal

radial flexor of the carpus

long palmar

long radial extensor of the carpus

superficial flexor of the digits

gluteus medius

ulnar flexor of the carpus

tensor of the
broad fascia

thenar

broad fascia

pectineus

recto-femoral

long adductor

vast lateral

gracilis muscle

vast medial

sartorius

medial twin

anterior tibial

long peroneal

soleus

long flexor of the digits

Outline drawing of the superficial muscles: frontal projection

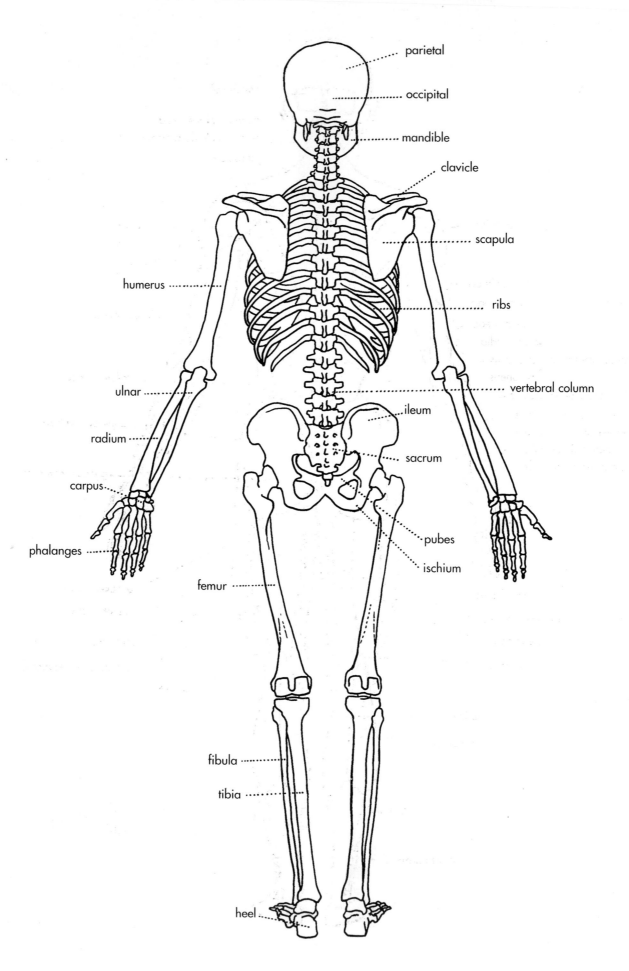

parietal

occipital

mandible

clavicle

scapula

humerus

ribs

ulnar

vertebral column

radium

ileum

sacrum

carpus

pubes

phalanges

ischium

femur

fibula

tibia

heel

Outline drawing of the skeleton (male): dorsal projection

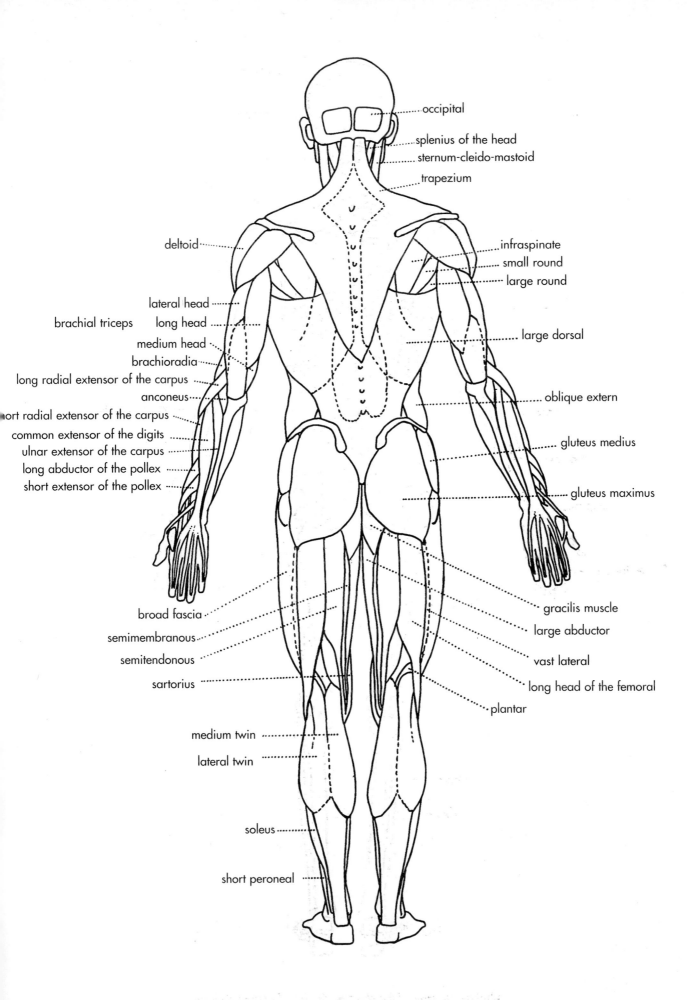

occipital

splenius of the head

sternum-cleido-mastoid

trapezium

deltoid

infraspinate

small round

large round

lateral head

brachial triceps long head

medium head

brachioradia

long radial extensor of the carpus

anconeus

short radial extensor of the carpus

common extensor of the digits

ulnar extensor of the carpus

long abductor of the pollex

short extensor of the pollex

large dorsal

oblique extern

gluteus medius

gluteus maximus

gracilis muscle

large abductor

vast lateral

long head of the femoral

plantar

broad fascia

semimembranous

semitendonous

sartorius

medium twin

lateral twin

soleus

short peroneal

Outline drawing of the superficial muscles: dorsal projection

19

The Head

(sketches 3–11)

External Morphology

The head is the uppermost part of the human body, situated above the vertebral column and joined to the body by the somewhat cylindrical, more restricted segment, the neck. The head has a complex rounded, ovoid form, and is distinguished into two portions: the cranium, which is the more elevated quasi-spherical or elongated ovoid part; and the face, or the part lying beneath the cranium. The face is also ovoid in shape, but more elongated vertically. The outer limits of the cranium and face are outlined by two lines beginning at the roots of the nose and following the arched orbitale, the posterior limit of the zygomatic bone, and the external acoustic opening and rejoining in the proximity of the apex of the mastoid, the line of division between the head and the neck (see sketch 3). Overall, the external morphological division differs from the osteological mainly because the forehead is also considered part of the face, defined by the line of attachment of the implanted hairs in the skin (scalp) that covers the cranium.

The bones of the face, particularly complex and covered by numerous subcutaneous muscles, contain cavities in which the principle sensory organs are lodged (beyond the first passages of the digestive and respiratory apparatus). On the external, numerous conformations of relevant interest are noted also for artistic representation; for example: the slightly arched forehead; the eyebrows, corresponding in part to the arched orbit; the eyes, contained in two orbit cavities; the nose, an elongated pyramidal protrusion on the middle axis of the face; the upper and lower lips, which outline the oral cavity and cover the teeth; the cheeks; and the concave cartilage of the outer ears, which are post-symmetrical to the sides of the head.

Sketch 3: *External morphology of the male head*

1 - Projection of the arch of the zygomatic, which runs under the skin.

2 - The action of the muscles that work under the upper lip, a slight fatty deposit, the diminishing elasticity of the skin and individual repeated movements cause a skin projection outlined below the nasal-labial crease.

3 - The base of the nose has a triangular form, and the nostril openings converge towards the lobes.

4 - At the front of the masseter, a fatty area shades the anterior borders of the muscle and smooths the passage of the outer skin towards the cheeks.

5 - Protuberance of the lower border of the mandible: a variably inclined plane which, according to the position the head assumes, joins the neck.

6 - Weak ovoid projections, determined by the overlapping of the orbicular muscles of the mouth, of some fascicles coming from muscles near the active angles of the mouth.

7 - The upper orbital border is more pronounced in respect to the ocular bulb.

Sketch 3: *Principal regions of the head and neck*

A - Parietal	O - Frontal
B - Temporal	P - Upper-orbital
C - Intra-temporal	Q - Orbital
D - Auricular	R - Nasal
E - Zygomatic	S - Lower-orbital
F - Maxillary	T - Labial
G - Mastoid	V - Genio
H - Nape	U - Mental
I - Sterno-cleido-mastoid	Z - Lower-mandibular
L - Carotid	W - Hyoid
M - Super-clavical	J - Suprahyoid
N - Lateral of the neck	Y - Upper-sternal
X - Limiting line of cranium and face	

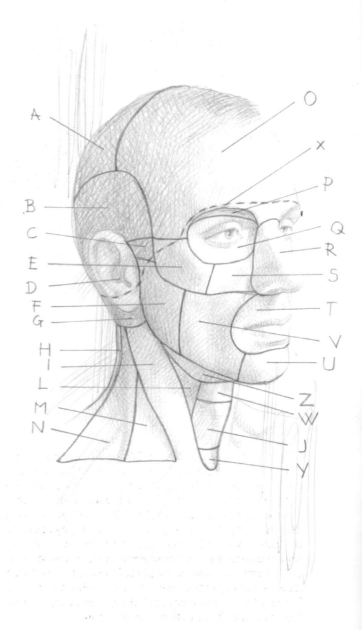

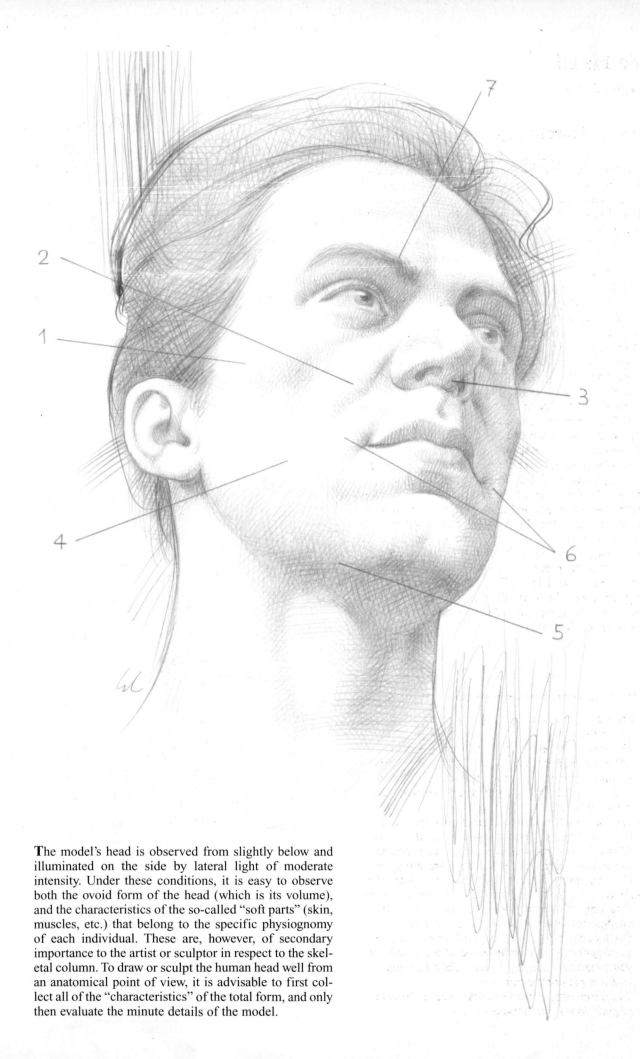

The model's head is observed from slightly below and illuminated on the side by lateral light of moderate intensity. Under these conditions, it is easy to observe both the ovoid form of the head (which is its volume), and the characteristics of the so-called "soft parts" (skin, muscles, etc.) that belong to the specific physiognomy of each individual. These are, however, of secondary importance to the artist or sculptor in respect to the skeletal column. To draw or sculpt the human head well from an anatomical point of view, it is advisable to first collect all of the "characteristics" of the total form, and only then evaluate the minute details of the model.

21

Notes on Osteology

The cranium is made up of many firmly united bones, which outline the two parts by which the skeleton of the head is distinguished: the cranial box (or cranium) and the facial block. The form and dimension of the cranial bones present differences in the two sexes, the diverse races, and various ages. They are, in large measure, under the skin in order to contribute to the determining external aspects of the head and the characterizing of the physiognomic features. The bone structure of the head is important and of much interest to the artist.

The union of seven bones constitutes the cranial box. Of the seven, three are unequal (occipital, sphenoid, and frontal) and two equal (temporal and parietal).

The occipital is in the form of a shell and is situated in the lower-posterior part of the cranial box. It connects with the first vertebra. The sphenoid is deeply seated in the middle part of the base of the cranium, but it is also visible on the outer portion of the cranium, coming to a sharp end. The frontal forms the anterior part of the cranial box: its most extensive portion, the squama, is externally curved with two slight symmetrical projections (the frontal sketches) while, below, two curvilinear projections form the upper ovoid borders. The temporal is situated in the lower, lateral part of the cranium and is made up of a smooth, semicircular plate (the squama) from which the jawbone's cuneiform and mastoid processes originate downward. The deepest part of the temporal contains the hearing organ, communicant with the external by way of the acoustic canal.

Sketch 4: Head of the male model from different viewpoints

1 - *Thyroidal cartilage (Adam's apple): an under-skin part of the larynx in the form of a triangular pyramid: almost constantly visible in the male, while a very minimal projection in the female.*
2 - *Glabella: a small, flattened, slightly inclined area, usually hairless, situated between the eyebrows and the root of the nose.*
3 - *The width of the mouth is usually less than the distance between the pupils; the width of the base of the nose is equal to the distance between the lachrymal caruncles. With good comprehensive approximation, the head of a human male adult, seen from the front, is able to be subdivided into three parts of equal measure: one from the roots of the hair to the eyebrows, another from the eyebrows to the base of the nose, and the third ending at the chin.*
4 - *The external acoustic canal is a fixed point of reference: if the head is observed from the side, it can be described as an equilateral triangle joining this point (sometimes a little more downward, towards the attachment of the earlobes) and other set points, one on the root of the nose and the other on the edge of the chin.*
5 - *The nasal sub-septum joins at the upper lip near the filter, but not at a right angle: almost always, with ample individual variation, the connection is recorded with a small inclined plane.*
6 - *In the back of the nose, the upper tract is bone, while the lower is cartilage. The corresponding planes meet, determining a slight angularity.*

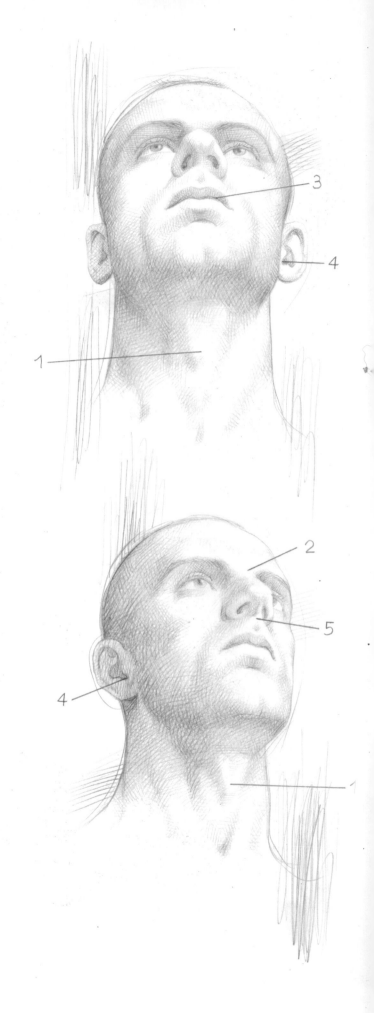

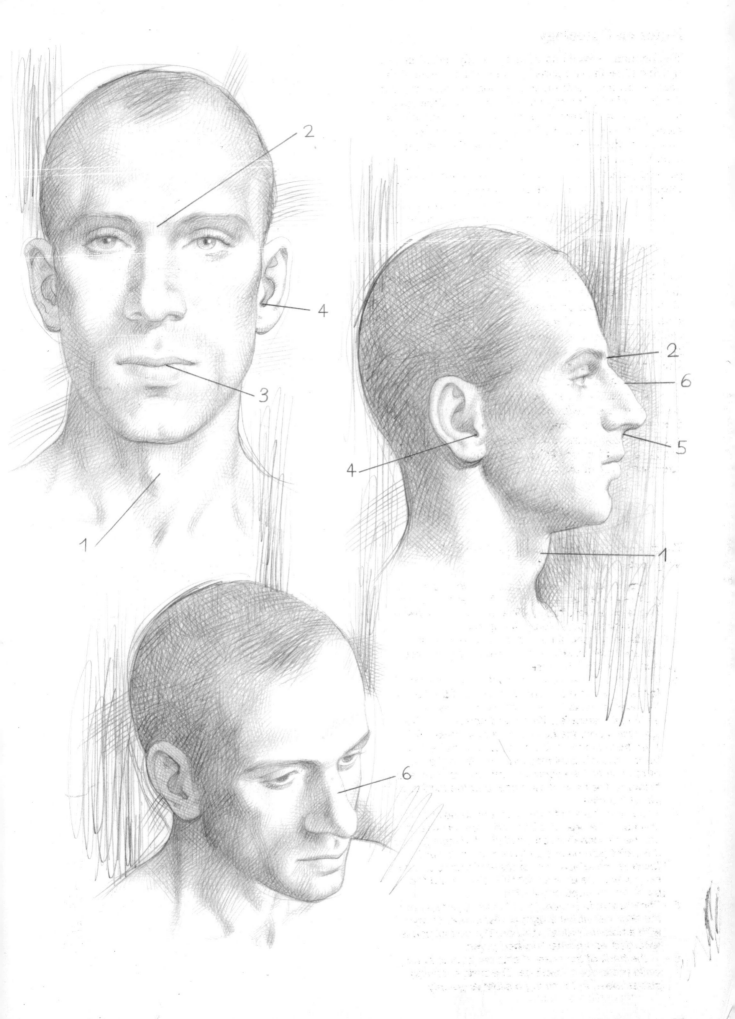

2

4

3

1

2

6

4

5

1

6

The parietal is an almost quadrangular bone at the external curved surface, firmly united at the frontal and at the occipitals through the highly indented borders. The two parietal bones, adjoined, constitute a large portion of the dome of the cranial box.

Equal and symmetrical bones, some unequal bones, and the mandible form the facial block. Muscles are inserted on top. Between the bones, which determine the form of the jaw for the subcutaneous parts, one can identify the maxilla, zygomatic, nasal, and mandible.

The maxilla is a bone made up of a sizeable volume from which comes many processes. United to a smaller companion bone, the two form the support for the upper dental arch.

The zygomatic constitutes the more lateral part of the facial skeleton. Determining the projection of the jaw is very important to the external morphology of the face. The temporal process diverges from the principal part, which contributes in forming the zygomatic arch and frontal process, which is direct in height and laterally outlines the orbital cavity. The nasal is in the form of quadrilateral bone plates compressed between the frontal and maxillary and constitutes the bone portion of the external skeleton of the nose.

The mandible is a voluminous, superficial, movable and curved, semicircular bone. It is made up of a principle part, the body on whose border the teeth of the lower arch are implanted, and two lateral parts, the ramifications that detach themselves from the posterior extremity of the body and articulate with the temporal.

Notes on Arthrology

The bones of the cranial box and facial block come together firmly with sutured joints; so their possibility of movement is practically nil. The only mobile joint is that of the mandible with the temporal bone. The articulate movements are ample and allow the opening of the mouth cavity by means of shortening of the mandible.

Sketch 5: Head of the male model from different viewpoints

1 - Sternum-cleido-mastoid
2 - Slight longitudinal depression between the trapezium muscles, in proximity to the insertion of the occipital. Corresponds to the nape ligament and attenuates until culminating before rejoining the seventh cervical vertebrae (prominence of the-vertebrae)
3 - Weak ovoid protrusion of the frontal "tumors"
4 - The temporal pit in the cranium is effectively a depression, but during life is occupied by the temporal muscle. In addition, a strong tendon covers its surface. That is what renders the superficial form of the region, which is somewhat hidden and at times slightly curved.
5 - The head seen from overhead (vertical norm) demonstrates the maximum width at the level of the parietal bone, while limiting the frontal.
6 - Still, looking upward at the head reveals the position and orientation of the outer ear that removes itself from the cranial inner wall. To have an exact vision of the coverings it is necessary that the head be divided into three quarters.
7 - Trapezium
8 - Angle of the mandible
9 - Nasal
10 - Seventh cervical vertebra

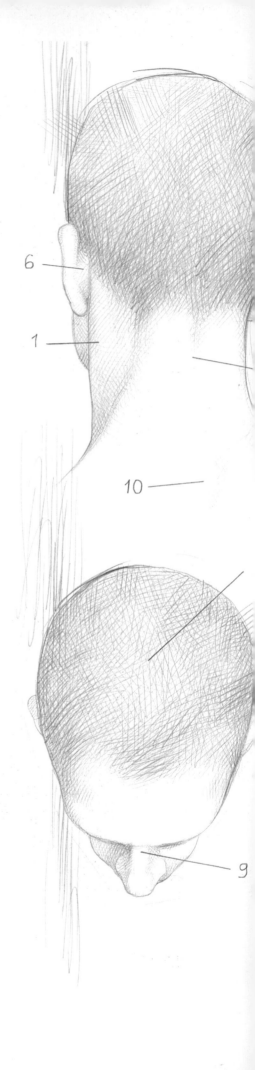

24

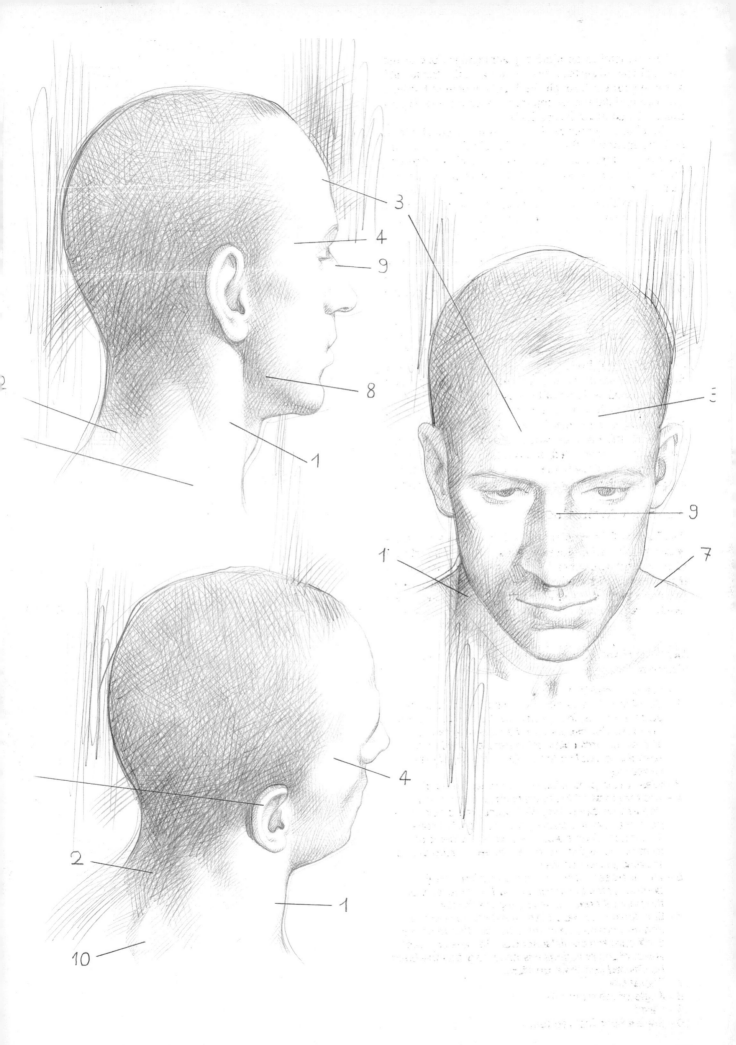

3

4

9

8

2

1

3

9

1

7

4

2

1

10

25

Notes on Myology

The pertinent applied locomotive apparatus on the cranium is divided into two groups: the masticatory muscles and the mimetic muscles.

The masticatory muscles determine the movement that raises the mandible, thus closing the mouth. They are the masseter, the temporal, and the internal and external pterygoids.

The mimetic muscles, inherent to facial expression, are primarily situated on the facial block, and only in part on the cranial box. Almost all intrude on the skin to work the skin of the eyelids (orbicular muscles of the eye), of the nose (nasal, dilation of the nostrils), of the lips (sphere of the mouth, zygomatics, canine, incisors, etc.), the dome of the cranium (frontal and occipital), or act on the coverings of the ear (auricular), or constitute the cheeks (divulgers). Some also connect to the skeleton, others to the platisma muscle, and others to the muscles of the neck and back: sternum-cleido-mastoid, trapezium, scalene, splenius, etc.

Morphological Differences by Gender

Comparing the form of the male head and that of the female reveals certain characteristics that are especially important to observe when designing a drawing.

In general, the man tends to have a more elongated face and a longer head, while the woman tends to have a more rounded head and a smaller and more pointed face. The masculine cranium is larger in dimension in relation to the feminine. In addition, it presents a major inclination of the forehead, more accented upper-bone projections of the orbit, and a sharper angle on the lower-jaw profile. One also quickly recognizes that, in the male, the projection of thyroidal cartilage (Adam's apple) is greater. In the woman, the lips are more voluminous, exposing more readily the natural pigment of the lips. The hair on the head is longer and thicker, while body hair is fine and largely absent from the face.

Sketch 6: Head of the male model from different viewpoints

1 - *The extension of the head on the neck rejoins the width at around 55 degrees based on the flexibility of the cervical tract of the vertebral column.*
2 - *The flexion is, instead, more limited—around 45 degrees.*
3 - *The lateral rotation, effected in major part by the sternum-cleido-mastoid muscles, reconnects normally at 70 degrees on either side.*
4 - *The lower borders and the angle of the mandible are subcutaneous and appear sharply outlined, especially during the extension and rotation of the head.*
5 - *Frontal bone and muscle*
6 - *Zygomatic bone*
7 - *Nasal bone*
8 - *Zygomatic arch*
9 - *Temporal mastoid process*
10 - *Hyoid bone*
11 - *Mandible*
12 - *Occipital*
13 - *Sphere of the lips*
14 - *Sternum-cleido-mastoid*
15 - *Thyroidal cartilage*
16 - *Upper orbital borders*
17 - *Group of suprahyoid muscles (digastric, stylohyoid, mylohyoid, geniohyoid)*

26

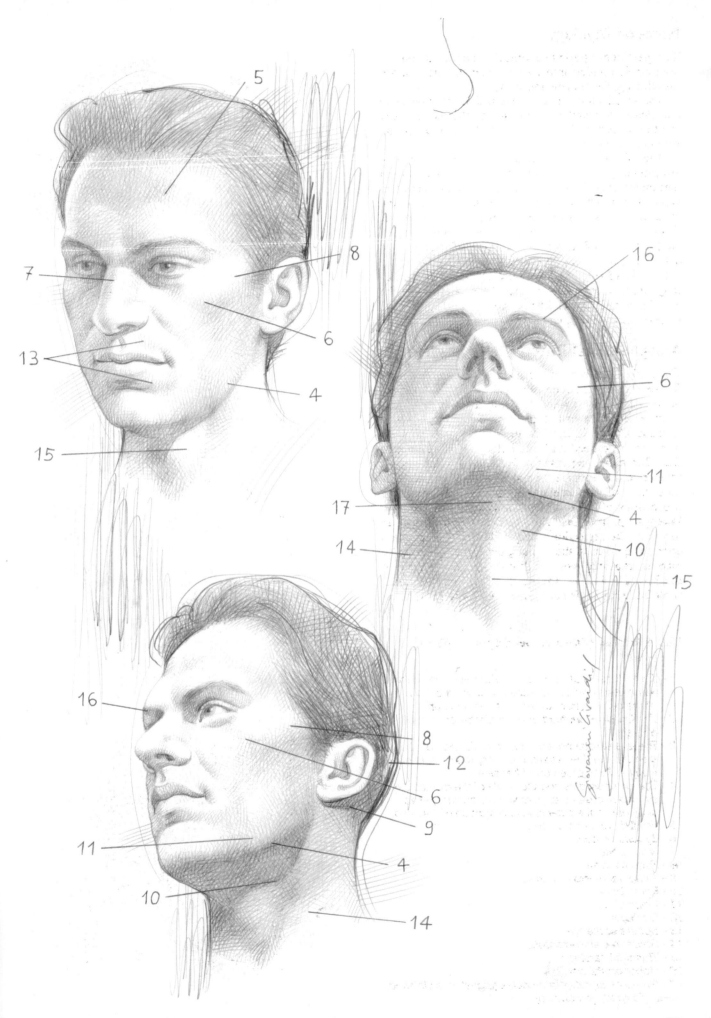

27

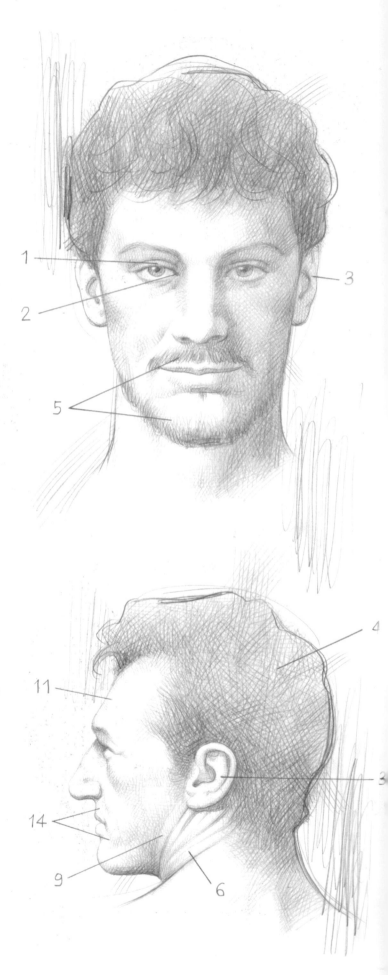

Sketch 7: Various male head types

1 - When the eye is in the normal, straight-ahead (staring) condition, the upper eyelid partially covers the disc of the iris, while the lower hardly grazes it. The situation obviously changes if the opening of the eye is greater, or if the eyelids are distended or drawn near—the effect of expressions of various states of mind or stimulated by certain conditions.

2 - The lachrymal caruncle, set at a medial angle to the eye, does not provide support, but instead displacement, and can be considered a point of secure reference. The distance between the two caruncles corresponds to the width of the eye, measured between the lateral and medial angles.

3 - The length of the outer ear corresponds, in individual adults, to the length of the nose.

4 - To correctly design the human head, it is necessary to perceive the formal and dimensional characteristics of the inner cranial box, with particular regard to the occipital area, although it is usually hidden by the head of hair.

5 - The facial hair of the adult male is usually more visible in individuals with white hair, rather than those with dark or blond hair. Facial hair is individually variable in density, color, and disposition. The beard usually covers part of the cheeks, the chin, and the sub-mandible region. Mustaches cover the upper lip.

6 - The rotation of the head provokes some transitory creases along the sternum-cleido-mastoid muscle.

7 - The facial block, observed downward or upward, reveals the ovoid or semicircular conformation: the positions of the eyes, nose, lips, and outer ears respond to the rule of perception and follow the "line" of construction available following the curvature of the surface.

8 - Temporal

9 - Masseter

10 - Group of superhyoid muscles (digastric, mylohyoid, geniohyoid, stylohyoid)

11 - Frontal

12 - Sphere of the eye

13 - Canine muscles, small and large zygomatic

14 - Sphere of the mouth

15 - Nasal muscles and raiser of the nose "wings"

16 - Triangle of the chin

17 - Sternum-cleido-mastoid

18 - Platysma

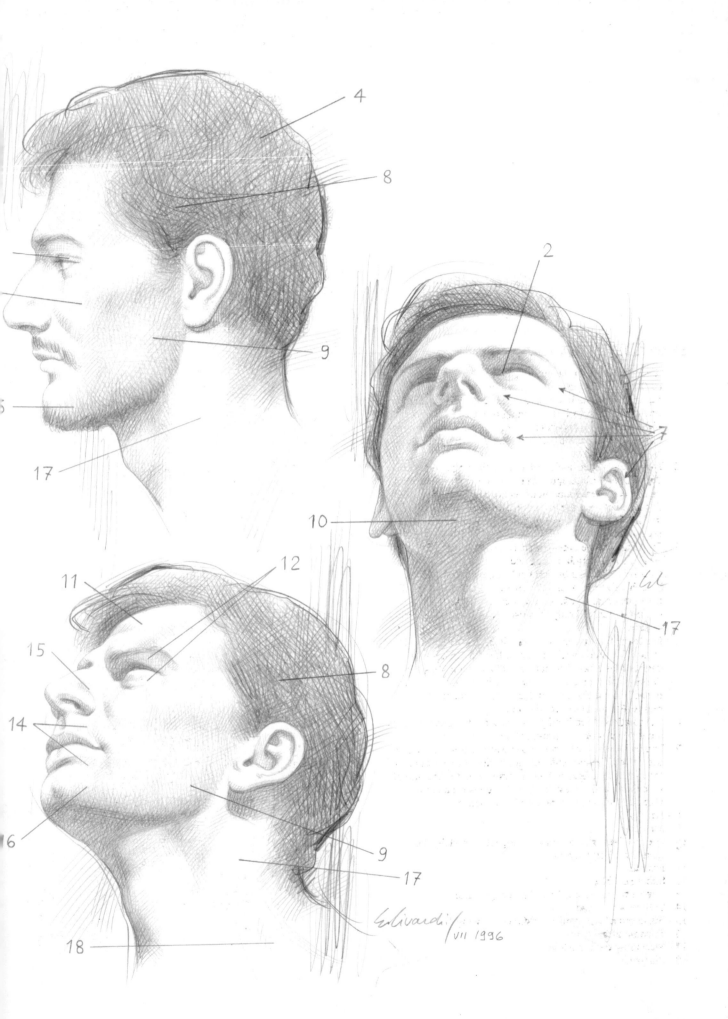

Facial Expression and Display of Emotion

The eyes and lips are the parts of the face richest with expressive possibility. These two areas are very important as they alone determine the complex gestures of the face. In nature, the mimicry mechanism is equal, whether male or female, although some individuals may express irony with scarce efficacy or perfectly manifest pain and desperation with the subtlest change of expression.

Now we are able to reveal some specific characteristics of the mouth and spherical region. The upper portion of the face is dominated by the eyebrows, eyes, and eyelids—very mobile and disposed elements, as is noted, in correspondence of the orbit. The very visible eyebrows closely follow the upper spherical arch: the head of the brow is the densest portion and closest to the nose, and the coda or lateral portion is pointed (see Morphology of the Eye, appendices page 154). The movements of whole or single portions of some brow muscles (frontal, pyramidal, middle, spherical, corrugate) contribute to numerous different expressions. Although the brows have the function of shielding the eye from falling sweat or rain streaming from the forehead, protecting from too much light or in dangerous situations, in reality it seems that their main significance, above all, is in manifesting state of mind. Consequently, the eyebrows are able to assume various positions in the surrounding areas (transversal or vertical wrinkles on the forehead, creases around the eyelids).

The shortened and drawn-near eyebrows produce some vertical wrinkles near the root of the nose (glabella), while razing horizontal ones. They present themselves in diverse situations: aggression against others or intense attention and protection of the eyes (in this case, causing also a heightening of the lower eyelids and contraction of the jaw muscles). The raised eyebrows wrinkle the forehead and disperse a bit along the external in a vast gamut of different expressions (surprise, stupor, expectation, anxiety, etc.), having a progressive significance of eyelid enlargement and amplification of the visual field.

Sketch 8: Head of the female model from different viewpoints

1 - The comprehensive form of the head is determined by the skeleton and presents some slight but characteristic differences between the two sexes, naturally with ample individual nuances. For example, in the woman, the forehead appears more vertical and continues on medially almost to the back of the nose since the area of the glabella is less inclined.

2 - The feminine mandible, like the rest of the bones, is smaller than the masculine. The angle of the mandible is more rounded; the branches more inclined, the whole conferring a decisive oval contour of the entire feminine face as seen from the front.

3 - The zygomatic arches are subtle, but at the level of the zygomo the face appears larger in proportion to the male.

4 - The upper margin of the sphere, constituted from the frontal bone, is less prominent and almost flattened in the woman.

5 - The outer ear has the conformation of the more delicate circumvolution and is of smaller dimensions than that of the male. The morphological differences are not very relevant.

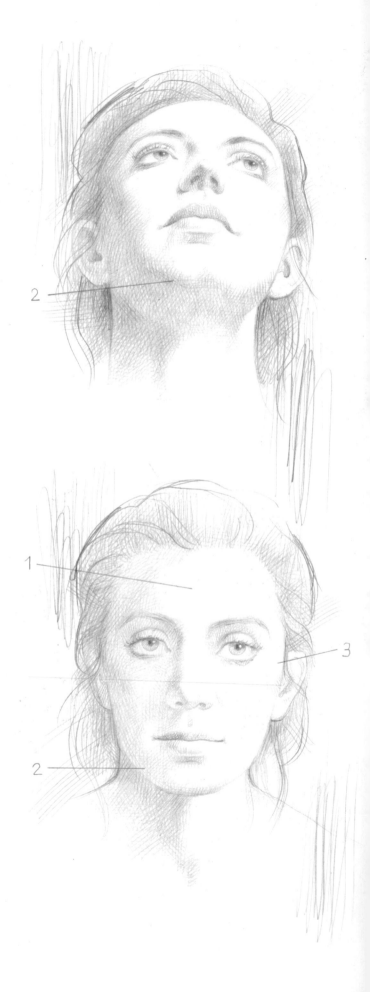

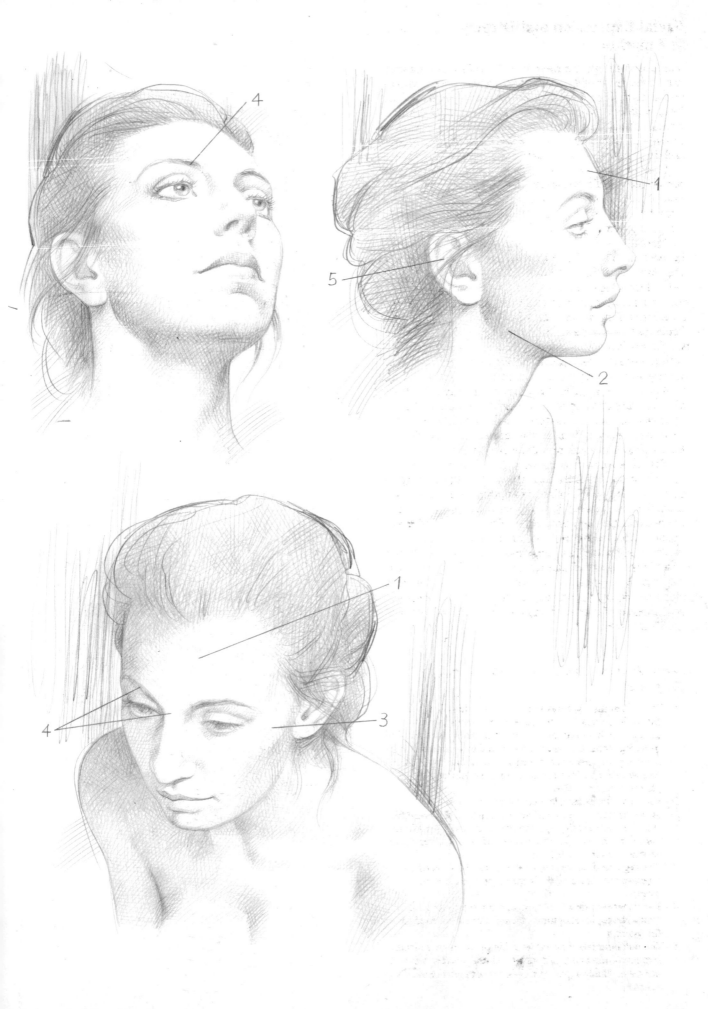

The drawn-near and raised eyebrows provoke, on the forehead or in-between the brows, some small wrinkles, or creases, and express complex emotions of anxiety and pain.

The raising of only one eyebrow, while the other becomes shortened, obviously determines diverse and contrasting skin effects in relation to each, and has significant contradictory significance: expressing an uncertain state of mind (perplexity, interrogation, etc.).

The visible part of the ocular bulb is surrounded by the eyelids, mobile plates whose contractions determine partial and total closing or dilation with accentuated cutis creasing, above all at the base of the eyelid and at the lateral angle near the temple.

The lower portion of the face is dominated by the lips, formed by complex spherical muscles and disposed to the closing of the mouth. The emotional states determine a variable and rich series of gestures of the lips based on the combination of movements they are able to accomplish: opening and closing, advancing and retracting, heightening and shortening, tensing and relaxing. The action of the spherical muscle of the mouth is more delicate since its deeper fibers compress the lips against the teeth, while the superficial fibers push them out. Together the muscles clench the lips firmly, or curl them. But the spherical muscle does not work alone. Other muscles of the region work in opposition (regarding the opening the mouth) to realize the more subtle expressive gradations. In a synthetic manner they can be subdivided into several groups: muscles which heighten the lips in expressions of anxiety, contempt, laughter, smiling, etc.; muscles which shorten the lips in expressions of irony, disgust, pain, unhappiness, etc.; muscles which project the mouth in expressions of distrust, perplexity, pain, etc.

The shortening of the mandible marks the opening, more or less ample, of the mouth. It therefore sets also the effect of the supra- and sub-hyoid muscles that work it, and also the subtle and large skin muscle, the platysma, which is situated on the sides of the neck. Its contracting also causes the raising of the skin in long parallel projections characterized in the expressing of anger, physical force, and fear.

Sketch 9: *Various female head types*

1 - The arch of the cranium is less curved in the woman than in the man.
2 - The feminine face is hairless, but the head of hair is more abundant than that of the male, and grows longer and thicker.
3 - The nose is rather subtle and smaller by reason of the minor development of the underlying bone and cartilage structures. Its back is usually regular and straight.
4 - The eye, in the minor dimensions of the sphere, appear slightly larger than that of the male.
5 - The lip coloring is usually more ample and exposed, in relation to that of the male.
6 - The eyebrows are subtler and usually arched.
7 - The sternum-cleido-mastoid muscle normally appears less raised and somewhat subtle, especially in the tract in which the tendons insert themselves on the sternum.
8 - The prominence of the chin is slight and rounded. Rarely is a median depression seen; it is, instead, typical in a man.

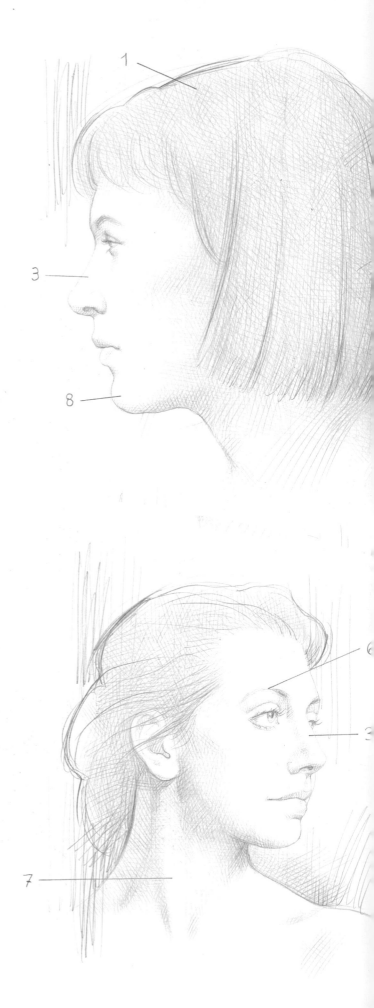

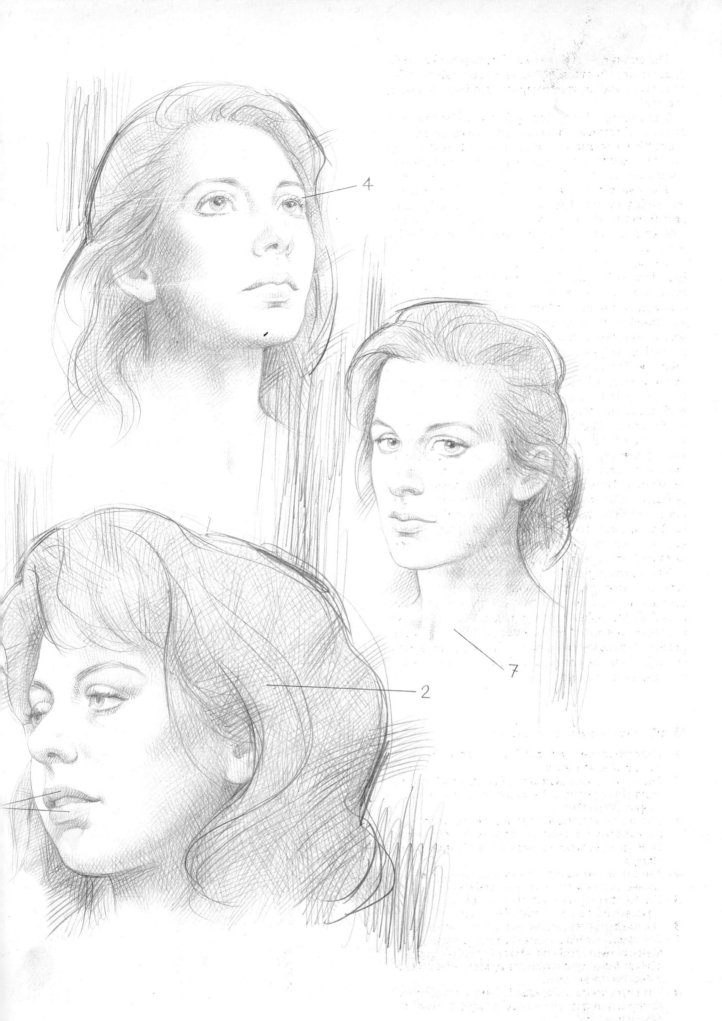

4

7

2

Artists of the past took attentive and profound care in their study of human expressions and in reproducing them exactly. Think of the paintings and sculptures of historical or celebrated figures or the religious icons that dominated until almost the twentieth century. In the decades since, and into contemporary times, interest in realistic representation of the art figure has progressively weakened, remaining alive primarily in portraiture and illustration. In any case, to design facial expressions well, these basic considerations should prove valuable.

Designing a truly expressive gesture becomes easier if the characteristics are developed and refined as a whole (else they become caricatures), omitting such minute and marginal details as, for example, an excessive analysis of small wrinkles.

The expression of the face alone is very significant, but one should not overlook that the gestures of the entire body collaborate in manifesting state of mind. The effect of a particular study could be countermanded by the thoughtless angle of the hands or an improper relationship between the head and shoulders.

A single mimicry muscle seldom works individually but in synergy—at times in opposition—to determine the complex and delicate changes of the skin. Since the expression appearing on the face is transient and fleeting (although habitual repetition of some gestures writes "character lines" on the individual's face), the knowledge of anatomy must be integrated with attentive observation and, if possible, the study of sequential photographs, movies, or videos. Illustrators often study their own faces, mimicking in a mirror, and sometimes arranging for points of view other than frontal.

Facial expression is best studied by looking at three groups, each characterized by a dominant tendency:

Neutral: The face does not show muscular contractions or skin alterations; the components are found only in normal anatomical relationships with slight nuances that consent to be recognized as the expressions of serenity, decision, or moderate attention.

Positive: The face seems to dilate, as if subjected to the thrust of centrifugal tension. The enlargement of the mouth, the dilation of the eyelids, and the elongation of the eyebrows denote, in general, "optimistic" expressions: laughter, smiling, surprise, and happiness. This individual has nothing to fear in the external world, so opens him- or herself up with pleasure.

Negative: The face seems to contract under pull of centripetal pressure. The shortening eyebrows, closing eyes, curling nose, and downward curving lips denotes "pessimistic" expressions: crying, pain, disgust, sadness, skepticism, and anger. An individual fearing aggression or threatening hostility "closes up," to protect and defend. Intense aggressiveness (anger, suffering, terror) causes the dilation of the nostrils and opening of the mouth which presents a more threatening and visually protective mask: the changes also augment the taking in of air, in line with the physiological situation of fight or flight.

Sketch 10: Basic expressions

1 - Sarcastic
2 - Joyful/laughing
3 - Surprised/astonished
4 - Scornful
5 - Angry
6 - Contemptuous/disgusted

34

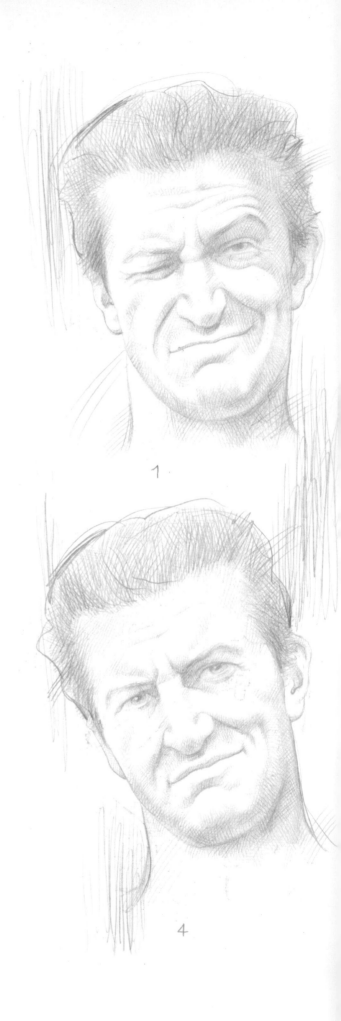

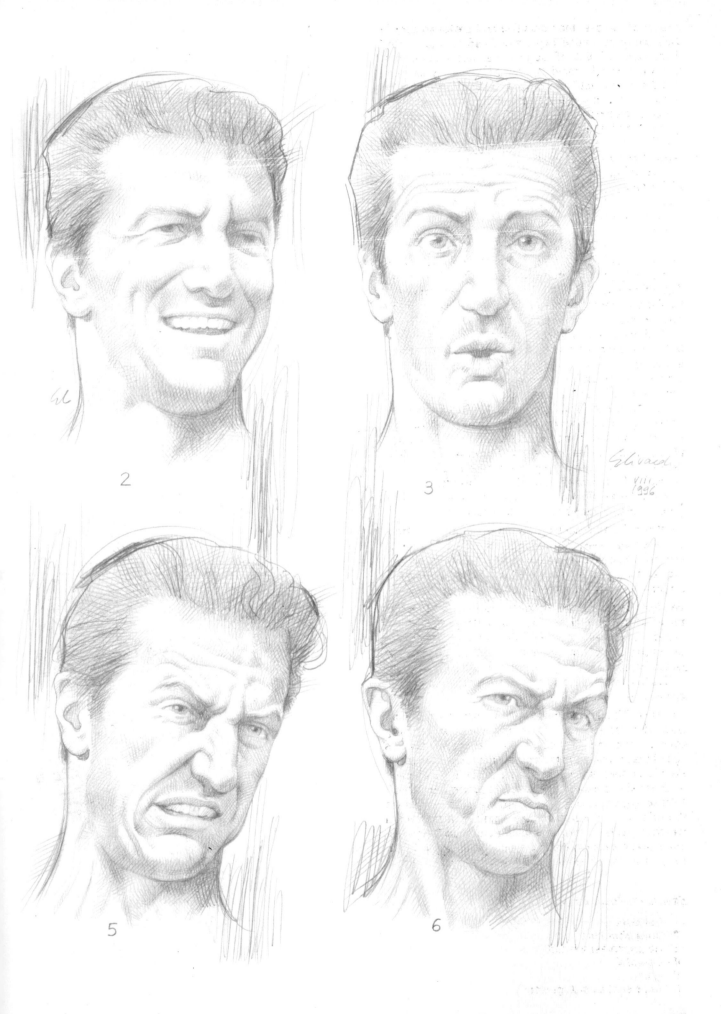

2

3

Elivard
VIII
1996

5

6

Muscular Mechanism and Expression

Serenity, Meditation, Reflection

Eyebrows are drawn near and shortened, forming two or three vertical wrinkles in the middle of the forehead. Eyelids are half or fully closed, but are not contracted. Muscles used: corrugate of eyebrows, spherical mouth.

Attention, Awe

Eyebrows are raised at the arch, causing some wrinkling of the forehead. Eyelids are enlarged, and mouth slightly open. Muscles used: frontal and occipital, elevator of the upper eyelid, shorteners of the mandible.

Pain, Agony

Eyebrows are raised and drawn near, with head tilted slightly upward; they form transversal and vertical wrinkles only mid-forehead. The gaze is directed upward. The lips are contracted. Muscles used: corrugate of the eyebrows, frontal (median portion), elevator of the upper eyelid, quadratic of the upper lip, triangular of the mouth. At times: temporal, masseter, platysma.

Prayer, Invocation, Ecstasy

Eyebrows are completely raised, the gaze direct and upward, and the mouth half closed; this forms transversal wrinkles on the forehead. Muscles used: frontal, elevator of the upper eyelid, small zygomatic.

Smile

Mouth is partially or totally closed, lips pulled slightly curve upward. The nasal-labial crease is accentuated, with slight dimples formed on cheeks. Lower eyelids are slightly raised and form small creases at the base and across the temple. Muscles used: spherical of the eye (lower portion, eyelid), small zygomatic, and nasal.

Laughter

Eyes are half closed and mouth is partially open, with a concave arch across the upper lip. Eyebrows are raised slightly. The nasal-labial crease is marked, the nostrils dilated. Long creases are formed under the eyelids and at the temples. Muscles used: spherical of the eye, nasal, and quadratic of the upper lip and large zygomatic.

Crying

Eyes are partially closed, eyelids contracted, and forehead corrugated. Dilated nostrils form small wrinkles on the sides and back of the nose. Mouth is slightly open and assumes a quasi-quadrilateral form, with the lower lip curved downward and the formation of oblique creases on the seam of the chin. The chin becomes corrugated, and long creases are formed on the neck (platysma). Muscles used: corrugate of the eyebrows, spherical of the eye, quadratic of the upper lip, triangular of the lips, mental.

Disgust, Contempt

Eyebrows are drawn together and slightly raised, forming vertical wrinkles on forehead; lower part pushes slightly upward and outward. The labial junction is shortened, the chin corrugated, the nasal-labial path is pulled upward at the upper extreme and downward in the lower. Muscles used: spherical of the eye and of the mouth, quadratic of the upper lip, triangular of the lips, corrugate of the eyebrow, mental.

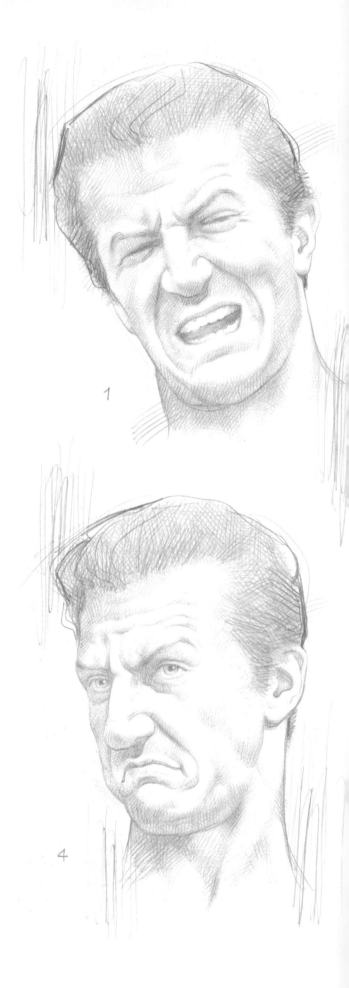

1

4

36

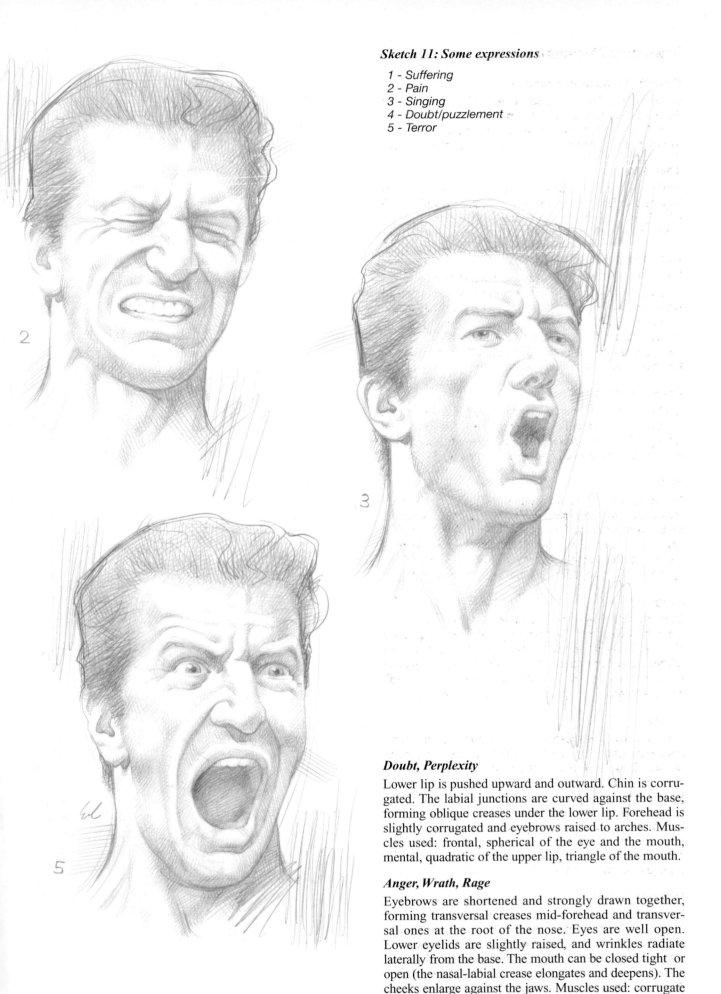

Sketch 11: Some expressions

 1 - *Suffering*
 2 - *Pain*
 3 - *Singing*
 4 - *Doubt/puzzlement*
 5 - *Terror*

Doubt, Perplexity

Lower lip is pushed upward and outward. Chin is corrugated. The labial junctions are curved against the base, forming oblique creases under the lower lip. Forehead is slightly corrugated and eyebrows raised to arches. Muscles used: frontal, spherical of the eye and the mouth, mental, quadratic of the upper lip, triangle of the mouth.

Anger, Wrath, Rage

Eyebrows are shortened and strongly drawn together, forming transversal creases mid-forehead and transversal ones at the root of the nose. Eyes are well open. Lower eyelids are slightly raised, and wrinkles radiate laterally from the base. The mouth can be closed tight or open (the nasal-labial crease elongates and deepens). The cheeks enlarge against the jaws. Muscles used: corrugate of the eyebrow, spherical of the eye, nasal, canine, quadratic of the upper lip, masseter, and platysma.

37

The Trunk

(sketches 12–39)

External Morphology

(sketches 12–17)

The trunk, or torso, is the axis part of the human body, excluding the head. It is separate from the upper and lower limbs, which constitute the appendages of the body. The trunk, taken as a whole, has a cylindrical yet slightly flattened shape. It can be subdivided into an upper tract, or thorax, and a lower tract, or abdomen.

On the abdomen, the major axes are slightly inclined on the arched plane, following the curvature of the vertebral column. They come together on sectors of the neck (a cylindrical segment in conjunction with the head), the shoulders, and the buttocks for a more organic description of the form. The thorax section, corresponding to the breastplate, has a trunk form, more flattened in an anterior-posterior sense, with the base stretching over the abdomen. On its anterior face, the pectoral projections can be recognized. They are separate from the slight sternum depressions, and the upper part is outlined by the projection of the clavicle. On the posterior face, the dorsal region corresponds to the vertebral column and is outlined by the sides of the shoulder and rib regions. The presence of the shoulders augments the extent of the upper thorax tract.

The abdominal sector has an ovoid form. It is held up only by the lumbar of the vertebral column and enclosed below by the pelvic bones, while large muscles form the other inner portions. On its anterior face, the umbilical cicatrix is found in the slight depression of the median line, or face; the external genital organs are situated at the lower extremity.

The posterior and lateral surfaces continue in the regions of the sacrum, the hip, and the gluteus. They also continue onto the surface of the legs, except for the median posterior tract where the lower buttocks are outlined by a clear skin crease.

Morphological Differences by Gender

(sketches 12–19)

Comparing the trunks, or torsos, of the adult male and female reveals obvious differences (breasts, external genital organs, etc.). The artist must attentively consider these. For example, in the masculine body, the overall volume of the trunk progressively reduces from the shoulders to the hips, while the opposite happens in the feminine body, depending on the overall skeletal structure. In the male, development of the shoulders is predominant in respect to that of the pelvis. In the female, the reverse tendency is encountered, where the width of the pelvis is greater to that of the shoulders. The measurements are joined by the anterior and superior iliac spines and between the acromion processes.

In pelvic formation, the male/female difference is quickly revealed. The differing dimensions are easily observed (wider width, larger inclination, and shorter length in the female pelvis). The slight characteristic indentations in the sacral region correspond to the upper posterior iliac spines.

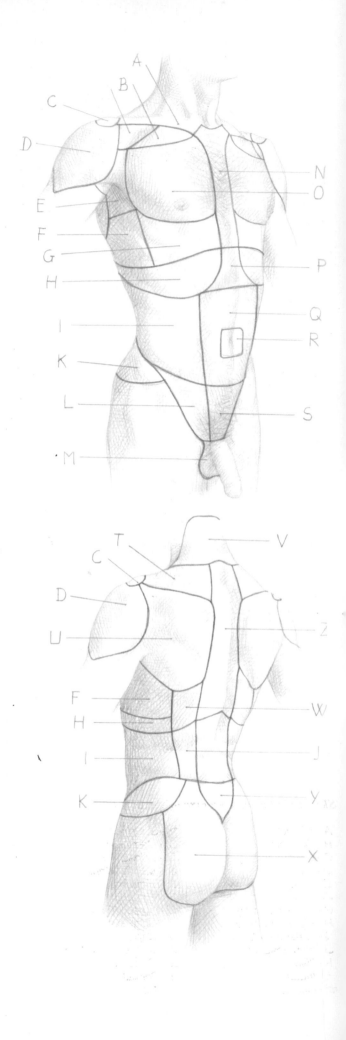

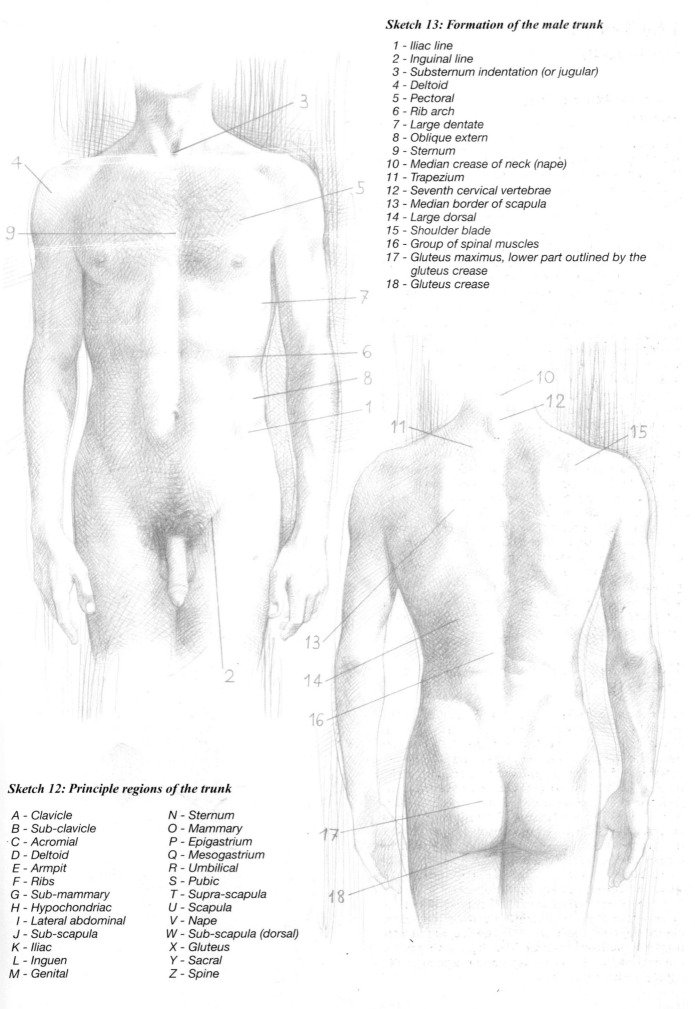

1 - Iliac line
2 - Inguinal line
3 - Substernum indentation (or jugular)
4 - Deltoid
5 - Pectoral
6 - Rib arch
7 - Large dentate
8 - Oblique extern
9 - Sternum
10 - Median crease of neck (nape)
11 - Trapezium
12 - Seventh cervical vertebrae
13 - Median border of scapula
14 - Large dorsal
15 - Shoulder blade
16 - Group of spinal muscles
17 - Gluteus maximus, lower part outlined by the gluteus crease
18 - Gluteus crease

Sketch 12: Principle regions of the trunk

A - Clavicle	N - Sternum
B - Sub-clavicle	O - Mammary
C - Acromial	P - Epigastrium
D - Deltoid	Q - Mesogastrium
E - Armpit	R - Umbilical
F - Ribs	S - Pubic
G - Sub-mammary	T - Supra-scapula
H - Hypochondriac	U - Scapula
I - Lateral abdominal	V - Nape
J - Sub-scapula	W - Sub-scapula (dorsal)
K - Iliac	X - Gluteus
L - Inguen	Y - Sacral
M - Genital	Z - Spine

The pelvic border, or iliac crest, is very important from an art designer's point of view because it is visible, sub-skin, for a major part of its stretch, particularly anteriorly (iliac blades). These reference points are indispensable to the artist in deducing the correct positioning of the pelvis in the various body positions.

In the male, the fatty tissue is usually moderate and concentrated in certain areas (sub-mammary, above the iliac, gluteus, and above the pubic area). In the woman, fatty tissue is more abundant in the same areas (mainly the breasts), but also around the navel, in correspondence to the seventh cervical vertebrae. The distribution of hair is also different. In the male, the hair is diffused on the upper part of the thorax and, at times, on the back. The pubic hairs extend from the external genital organs across the navel, while the woman's are distributed horizontally. In the man, the arch of the ribs, which indicates a useful line of separation between the thorax and the abdomen, is sufficiently restricted, while rather ample in the woman. The masculine abdomen is creased vertically, from the central depression (dawn line) of the direct muscles. This region in the female has more delicate gradations caused by fatty tissue. The feminine thorax cage is shorter and more curved. The abdominal region appears more elongated proportionally than in the male. The navel is situated on the dawn line: in the man it is almost equidistant between the pubic area and the lower point of the sternum, whereas, in the woman, it is situated slightly higher and has a more vertical aspect.

In drawing the trunk, it is necessary to pay attention to the correct positioning of the skeletal structure (the vertebral column, pelvis, scapula bond). The characteristic differential forms between the sexes depend on this, and other muscular and skin elements alone are too variable to be considered as a secure proportional reference.

Notes on Osteology

At the top of the trunk, segments of the appendages, or upper limbs, form a channel for the bones of the scapular belt. Likewise, those of the lower limbs form a path for the pelvic belt. For better morphological comprehension as to function, the skeleton of the trunk, relative articulations, and annexed muscles are subdivided into several sectors. The vertebral column, which is certainly the principle structure of the entire skeleton, runs through and sustains the entire trunk, uniting the articulator and muscular devices that surround it. The first of the sectors, pertaining to the cervical tract, is the neck. The second, pertaining to the thorax tract and cage, is the thorax. The third, pertaining to the lumbar tract, is the abdomen. The pelvis is included in the last sector because it is the means of bone attachment for the lower limbs (pelvic belt). It is considered pertinent to the trunk because it defines the lower part and represents the point of insertion for numerous muscles and ventral bands of the abdomen. An analogous consideration may be applied to the scapular bands (clavicle and scapula) from the functional point of view pertinent to the upper limb, but morphologically it is attributed to the trunk.

The vertebral column (see Functional Characters and Movements of the Vertebral Column, Appendices page 157) is an apparatus made up of short bones formed into columns on the median plane and united by joints and ligaments. The vertebral column is divided into sectors according to the morphological characters of the vertebrae: cervical vertebra (7), thorax (12), lumbar (5),

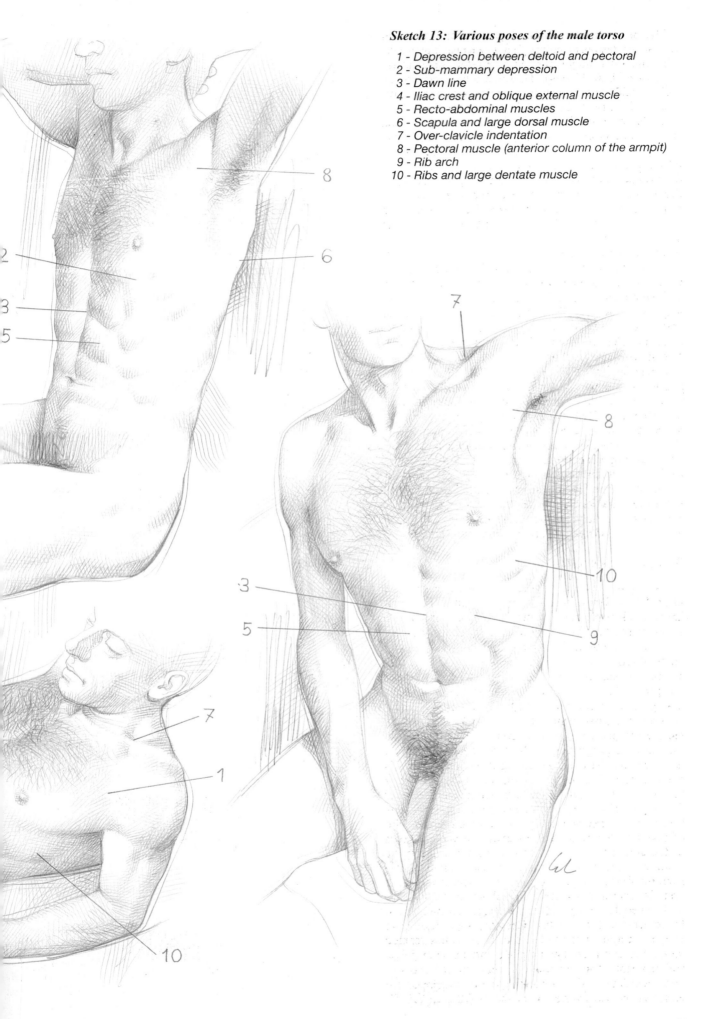

Sketch 13: Various poses of the male torso

1 - Depression between deltoid and pectoral
2 - Sub-mammary depression
3 - Dawn line
4 - Iliac crest and oblique external muscle
5 - Recto-abdominal muscles
6 - Scapula and large dorsal muscle
7 - Over-clavicle indentation
8 - Pectoral muscle (anterior column of the armpit)
9 - Rib arch
10 - Ribs and large dentate muscle

sacrum (5), and coccyx (3/4). The "free" vertebrae are the first 24, while the vertebral sacrum-coccyx elements are fused between them and practically immobile. The vertebral column in its entirety presents an almost cylindrical aspect, but when observed, the comprehensive volume of the vertebrae increases progressively from the cervical to the last lumbar, and then decreases.

The skeleton of the thorax is made up of twelve vertebrae of the thorax tract and twelve pairs of bones. The ribs articulate dorsally with the vertebrae and ventrally (except for the last two pairs) with an unequal median bone, the sternum, through cartilage. The comprehensive bone formed in this way is the thorax cage, also serving as the scapular band of the clavicle and of the scapula.

There are twelve pairs of ribs, curved bone plates, of which the first ten articulate (through cartilage and in different ways) with the sternum, while the last two flexible pairs are shorter and do not reconnect. Their positions are almost parallel at the connecting points. As a whole, they confer a cone-shaped or flattened-ovoid form at the thorax cage. The form is largely open at the upper and lower extremities. In the lower, the axis (in an individual in the erect position) is obliquely direct downward and forward.

The anterior face of the thorax cage shows the sternum, rib cartilage, and ribs that run across the sides.

The side faces reveal the maximum height of the cage and the typical ovoid aspect. They also show the ribs, in an oblique direction across the lower part, regularly parallel and with spaced interval between them. The posterior face presents the thorax tract of the vertebral column. The ribs depart from the oblique direction across the lower part.

The general form of the thorax cage is variable in relation to respiratory movements and an individual's constitution. The aspects are readily seen in normal life and, because the bone structure is in large measure just under the skin, easily palpable. However, the bones of the thorax cage distinguish themselves in a downward direction by their diameter relationships and the form of the lower opening. Stretched and elongated thorax cages are of the long linear type; short and wide cages the short linear type. Cages of intermediate forms also depend on induced individual character, and develop from the muscular masses or pathological alterations.

The sternum is a median flattened bone, positioned anterior to the thorax cage, onto which the ribs connect. It is made up of three segments: the handle, or upper portion; the body, flattened and elongated; and the xiphoid process, a somewhat pointed lower segment. Whether the handle forms an angle with the body, the complex inclination of the sternum depends on individual characteristics; above all, on sexual dimorphism—a female's sternum inclination is minor compared to that of a male.

The clavicle is an elongated, flattened bone, slightly undulated in the shape of an S. Its major axis is quasi-horizontal. It articulates itself with the sternum and with the acromion of the scapula and is positioned on the an-terior face of the thorax cage.

The scapula is a bone plate with three recognizable forms that are morphologically interesting to the artist. The triangular blade has two faces, one pressing against the ribs and the other, dorsal, having at least the medial margins and the lower point perceivable on the surface. The spine, a large boney structure, is transversally projected on the dorsal face and is articulated at its termi-

nal part (acromion) with the clavicle. The coracoid process is another prominent bone that projects directly forward from the upper margin and marks the origin of the brachial biceps muscle. The glenoid cavity is situated laterally on the border of the scapula and articulates with the head of the humerus. The scapula bone is situated on the inner posterior portion of the thorax cage with the vertebral margin parallel to the vertebral column (in the anatomic position) and the median height extending from the third to the seventh rib. The scapula and the clavicle undergo relevant displacement in relation to the movement of the upper limb.

The pelvis is a strong, basin-shaped bone formed by the conjunction of two complex bones. The hipbone articulates forwards in a direct mode and backwards through the interposition of the sacrum bone. The resulting structure has remarkable stability, permitting the most delicate of joint movement in the presence of numerous robust ligaments.

The hipbone is a large flattened bone of varying degrees of depth, but on average rather subtle. It is made up of the union of three sections: the ileum, the hip joint, and the pubes.

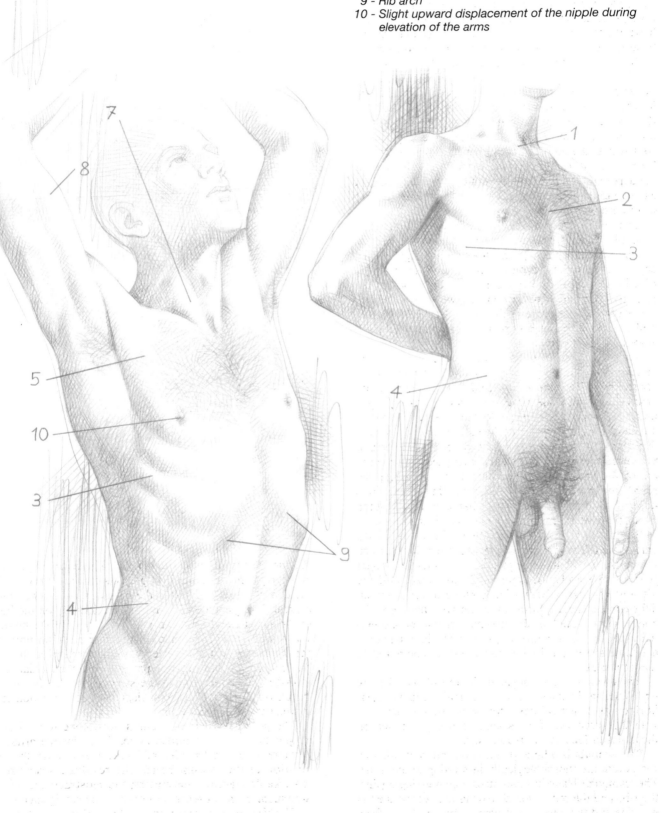

Sketch 14: Various poses of the male trunk

1 - Clavicle (and sternum-cleido-mastoid muscle)
2 - Sternum
3 - Ribs and large dentate muscle
4 - Oblique external muscle
5 - Large pectoral muscle
6 - Biceps, coracobrachial, large dorsal
7 - Sternum-cleido-mastoid
8 - Biceps
9 - Rib arch
10 - Slight upward displacement of the nipple during
 elevation of the arms

The ileum is the largest section and it is made up, in part, of layers. The blade, the most restricted part, is the body that contributes to the formation of the acetabolum (the seat of the articulation with the femur). The iliac crest is the upper border of the blade. It starts initially with the anterior iliac blade and ends with the upper posterior iliac blade.

The hip joint, the post-inferior part of the hip bone, consists of a section that confines the ileum in the acetabolum and a branch that unites with the lower section of the pubes, outlining a quasi-round obstructed opening.

The pubes is made up of bone that, when fused with the hip joint and ileum, forms the acetabolum cavity, one of the strengthened descending branches that descend from the hip joint. The two pubic branches meet on a median plane and form an articulation, the pubic symphysis.

The pelvis is a bone structure very characteristic to medical practice, and to anthropological or racial research. It is the part of the skeleton presenting the most relevant sexual differences. Compared to the male, in the female the iliac ditches are larger and more outwardly inclined. The obstructed openings are triangular (or oval), and theinclination of the complex is greater; it is, on the whole, shorter and wider in size.

Notes on Arthrology

The articulations between the elements that constitute the bone structure of the trunk allow, in general, little possibility of movement. The mechanics of a joint is largely realized in allowing for small, partial movements.

The vertebrae (as you will see more clearly later) are united for half the joint and reinforced by numerous strong ligaments. The ligaments come together at the mass of the column in a remarkably robust joint with mobility and elasticity.

The joints can be divided into two functional groups: synarthrosis, the joints between the vertebral bodies; and diarthrosis, the joints between the joint processes. At this point, the joints that have certain characteristics become joined with the cranium (upper occipital, upper-ondontoid, vertebral-cranium, etc.). The skeletal

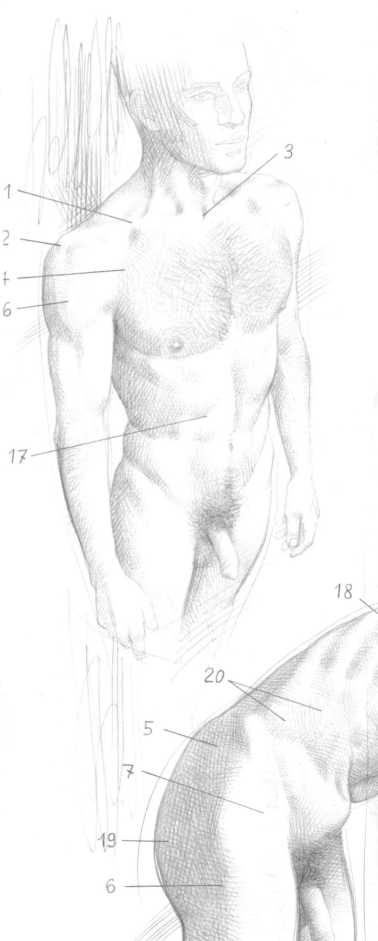

Sketch 15: Flexion, extension, and rotation in the male trunk

1 - Clavicle and scapular belt
2 - Acromion
3 - Jugular indentation
4 - Deltoid-pectoral track
5 - Gluteus medius and iliac crest
6 - Large trochanter
7 - Tensor of the wide fascia
8 - Large pectoral
9 - Large round
10 - Large dentate
11 - Brachial biceps
12 - Coraco-bracchiale
13 - Large dorsal
14 - Crease of external oblique muscle
15 - Triceps
16 - Deltoid
17 - Rib arch
18 - Large dentate
19 - Gluteus maximus
20 - Oblique extern

8

10

13

20

14

5

19

9

9

16

8

11

15

11

16

8

9

10

13

1

1

19

6

15

45

elements of the thorax cage, the ribs, and the sternum are articulated between them and with the vertebral column by means of the rib-vertebral joints and the rib-sternum. The joints of the scapular belt (the acromio-clavicle, sternum-clavicle, and above all the scapula-humerus that will be retained in relation to the limb) provide movements to the upper limb in respect to the skeletal axis.

The fundamental joint of the pelvis is the hip, which interacts with the femur. It is this articulation of the hip that, for functional reasons, indicates dealings with the lower limb.

The joints of the pelvis are, instead, almost immobile, or have only very reduced movements. There are two: the sacrum-iliac and the pubic symphysis.

Notes on Myology

For a more useful description of the form of the external trunk (often defined as "torso"), it is convenient to include also the axo-appendicular muscles, which form connections between the axis and the appendix muscle sections, corresponding to the scapular belt (for the upper limbs) and the pelvic girdle (for the lower limbs). The rachis musculature is formed by the equal and symmetrically aligned muscular systems along the vertebral column, from the cranium to the coccyx. They are divided into two groups: the spinal muscles (or the vertebral tubes) and the ventral musculature of the rachis. All of these muscles are positioned around the vertebral column.

The musculature of the neck is complex and divided into several groups: the lateral musculature (or paravertebral) made up of scalene muscles and covered by platysma; the sternum-cleido-mastoid muscle; the muscles of the hyoid-bone region (suprahyoid and sub-hyoid). Some muscles (sub-occipitals, splenius, recto) are considered in the musculature of the rachis, while the trapezium muscle determines the external morphology of the nape of the neck.

The musculature of the thorax consists mainly of intrinsic muscles, or organic muscles that intrude on the bone elements of the thorax cage and of the vertebral column. They also exercise their prevalent action on the respiratory mechanism. Such muscles are further grouped in two systems: the muscles of the inter-rib spaces (inter-rib, rib elevators, transversals of the thorax) and the spinal-rib muscles (posterior, lower and upper dentate). The diaphragm muscles join at these muscles as well.

Still, the gross axo-appendicular muscles divided in two groups determine the external morphology of the thorax and the back: thorax-appendicular (large and small pectoral, sub-clavian, anterior dentate) and spinal-appendicular (trapezium, large dorsal, rhomboid, elevator of the scapula). Together with these, the deltoids, over- and sub-spinal, sub-scapular, and large and small rounds are considered the shoulder muscles.

The musculature of the abdomen is made up of large muscles: quadrates of the loins, recto-abdominal, internal and external oblique, and transversal (to which the muscles of the perineum join themselves).

The musculature of the pelvis and of the hip is made up of the group of spinal-appendicular muscles (minor psoas, ileo-psoas) and of muscles of the buttocks (gluteus maximus and medius, internal obturator, twins, quadrates of the femur, and tensor of the broad fascia)

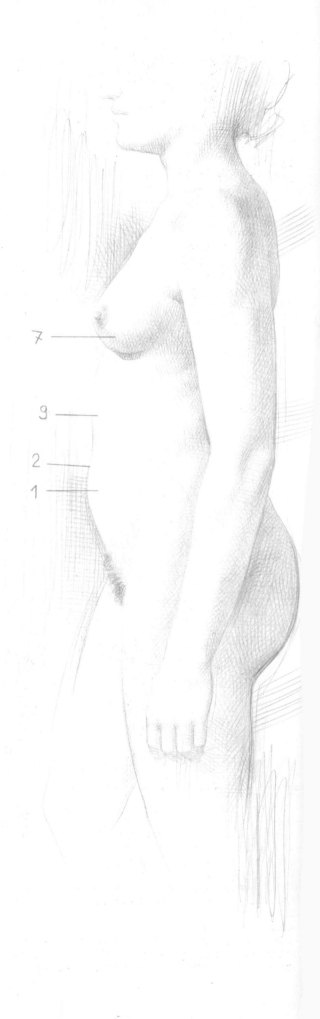

46

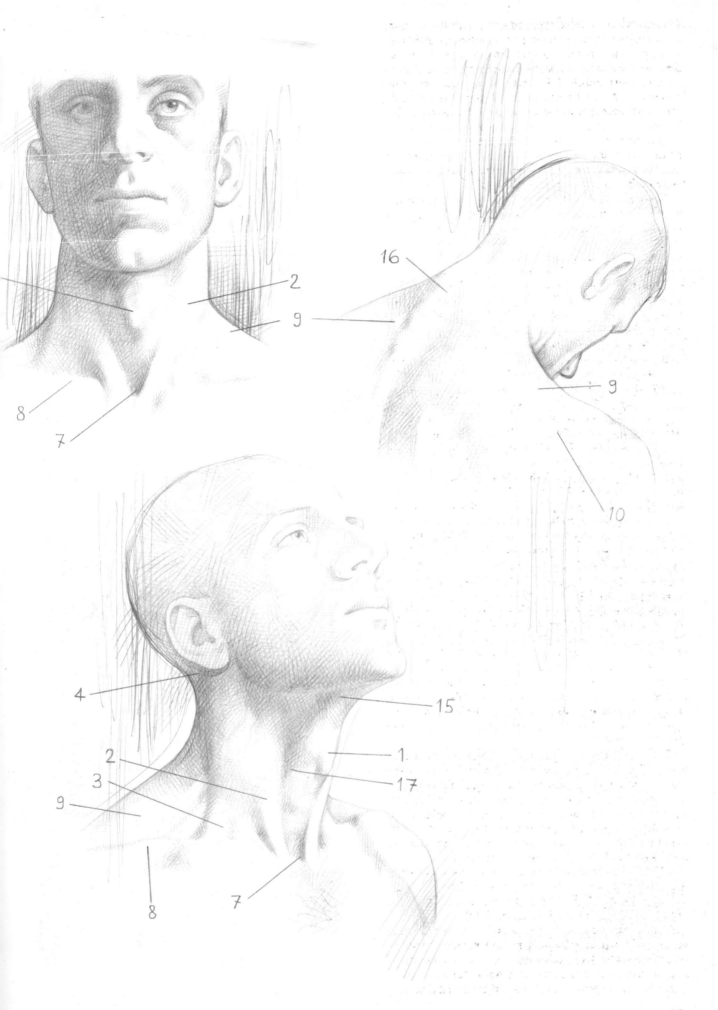

2

9

16

9

8

7

10

4

15

2

1

3

17

9

7

8

The anterior region of the neck (the throat) is delimited laterally on the anterior margins of the sternum-cleido-mastoid muscles and in height by a rather inclined sub-mandible plane. The hyoid bone is hardly visible on the surface, except for the strong extension of the head. The median area is ulteriorly subdivided in a supra-hyoid portion and a sub-hyoid portion, corresponding in depth to the homonymous muscle.

The external morphology of the throat is heavily influenced by the presence of thyroidal cartilage (Adam's apple), a projection of the larynx that is vertically mobile during deglutition and phonation. It is formed by the anterior conjunction of two quadrangular plates in which the complete upper margin is curvilinear and slightly notched in the median edge.

The Adam's apple is more pronounced in the man, and less visible in the woman. Below the cartilage, the surface of the neck shows, at times, a modest swelling from the presence of the thyroid. The thyroid is a gland that can endure individual variations of volume. It is normally more accentuated in the feminine sex, which determines a rounding at the base of the neck.

The equal and symmetrical projections of the two sternum-cleido-mastoid muscles form the lateral pillars of the neck. Each one of these, from the mastoid process, medially converges against the upper border of the handle of the mandible. Here, the two sternum ends concur to outline the jugular dimple.

Below the skin of the area compressed between the dimple and the thyroidal cartilage are the transversal projections of some of the cartilage rings of the trachea, which are visible only in certain conditions.

The lateral surface of the neck is in large measure occupied by the sternum-cleido-mastoid muscle, which diagonally crosses it, binding the mastoid process at the sternum. Since there are two heads of origin, sternum and clavicle, a small depressed skin area (triangular dimple, easily visible during the rotation of the head) is determined between them. The posterior border of the muscle concurs to limit, instead, at the clavicle and at

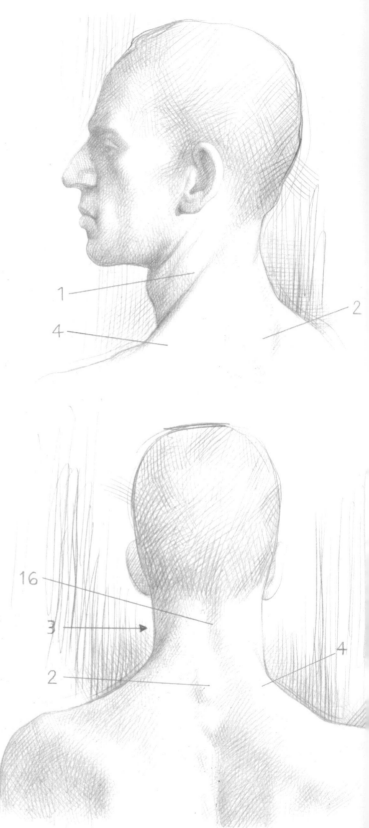

Sketch 19: Aspects of the male neck

1 - Overlapping of the sternum-cleido-mastoid at the trapezium and relative creases (see sketch 6)
2 - Seventh cervical vertebra
3 - The posterior face of the neck appears more flattened and enlarged, also shorter than the anterior, and in relation to the diverse levels at which the mandible and occipitals are found
4 - The base of the neck appears transversally enlarged for the presence of the trapezium muscles
5 - Digastric
6 - Hyoid bone
7 - Hypoglossal
8 - Mylohyoid
9 - Tracheal rings, thyroidal cartilage, thyroid gland
10 - Sternohyoid
11 - Homohyoid
12 - Clavicle end of the sternum-cleido-mastoid
13 - Platysma
14 - Splenius
15 - External jugular vein
16 - Nape ligament

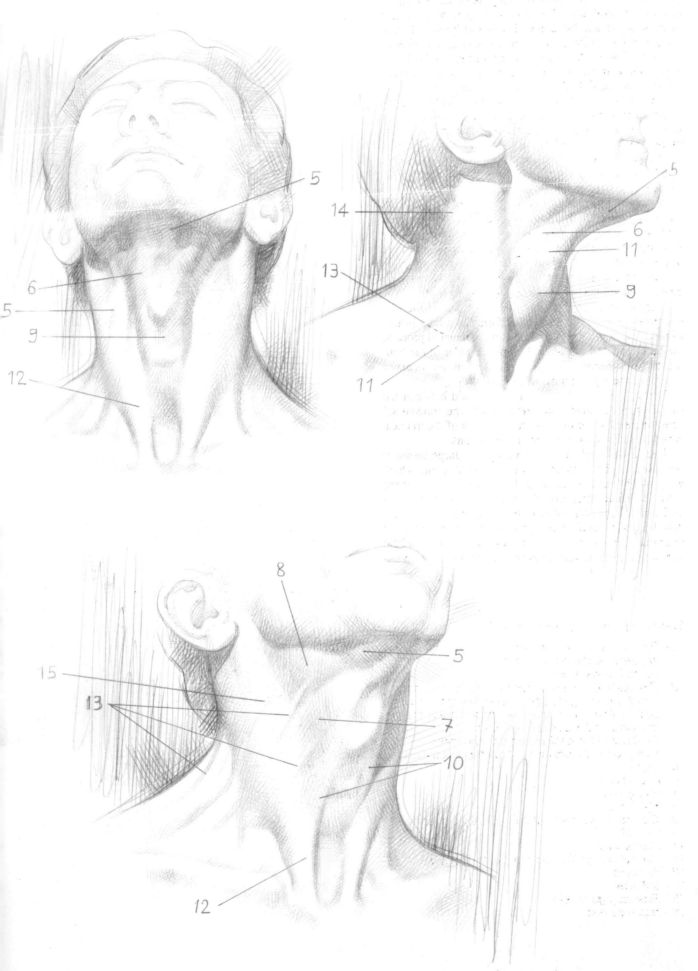

5

14

13

11

6

5

9

12

5

6

11

9

8

5

15

13

7

10

12

53

the margin of the trapezium. The trapezium is a vast triangular area (supra-clavicle pit) in which the scalene muscle, splenius, and elevator of the scapula are situated. The sternum-cleido-mastoid separately assumes different projections in relation to the movements that impress on the head. They are vertically crossed from the external jugular vein and covered by the platysma. The skin muscle covers an extensive area of either side of the neck.

The skin on the neck is supple, but a little more so in the posterior region. The throat is creased transversally by a pair of slight semicircular wrinkles at the upper concavity, more visible and characteristic in the female.

At times, the presence of fatty deposits in the sub-mandible region or at the base of the neck is visible. Advanced age, associated with state of health, promotes the formation of surrounding wrinkles. Wrinkles that pair in the median zone of the base of the mandible and are directly vertical across the hyoid bone, while provoking the projection of the digastric muscles, are typical.

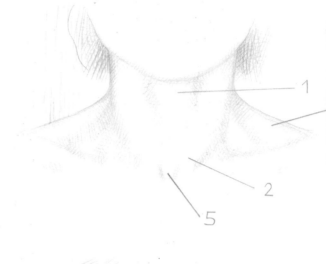

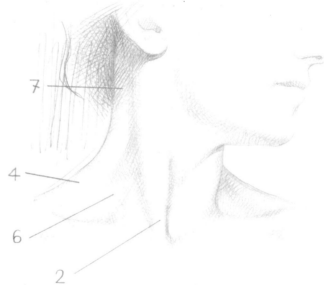

Sketch 20: *Aspects of the female neck*

1 - *In the woman, the thyroidal cartilage is less prominent. Its lower border is shaded from the presence of the thyroid gland.*
2 - *The clavicle head of the sternum-cleido-mastoid muscle is usually less apparent, except during the strong rotation of the head or in particularly forceful conditions.*
3 - *A small but regularly localized fatty deposit (more abundant in older women) attenuates the projection of the spinous process of the seventh cervical vertebra and of the thorax, and confers a slight convexity at the corresponding surface.*
4 - *Trapezium*
5 - *Supra-sternal (jugular) dimple*
6 - *Scalene muscle*
7 - *Splenius*

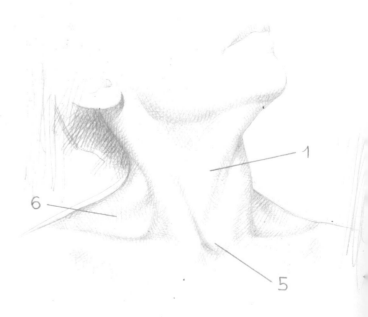

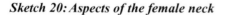

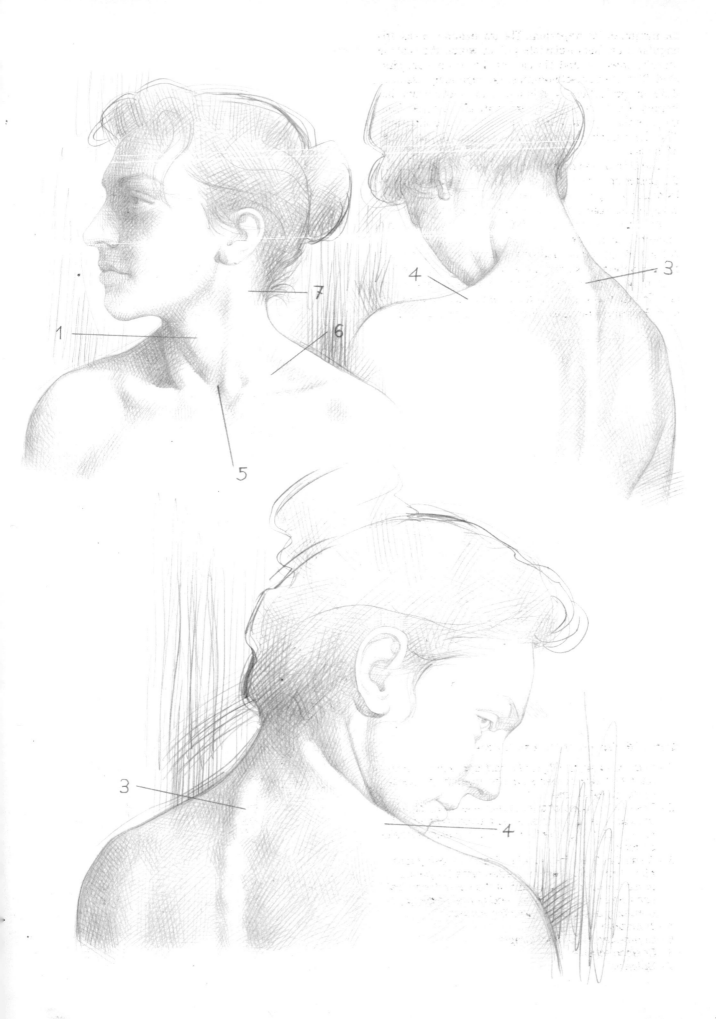

Morphology of the Shoulder
(sketches: 21–25)

The shoulder is the portion of the body that conjoins the trunk at the upper limb, which represents the robust but mobile attachment corresponding to the scapula-humerus joint. Morphologically, it accepts the deltoid region, the underarm region, and the scapular region, although from a strictly anatomic point of view the limits are more restricted.

The relative muscles are attached at the skeleton of the arm (upper portion of the humerus), the scapular belt (clavicle and scapula), and in part the thorax cage. Joints of different grades of mobility conjoin these bones: the sternum-clavicle joint; the acromio-clavicle joint, less mobile and bound by robust ligaments; and the scapular-humerus joint. These last joints, which have ample possibility of arm movement, consist of the head, the humerus (quasi-spherical form), and of the glenoid cavity of the scapula (less deep and enlarged). The two head joints, however, are contiguous of a robust joint capsule that completely surrounds them, reinforced by fibrous ligaments and the expansive tendons of some muscles at the insertion of the humerus.

The muscles that act, in various measure, on these joints are many. It seems useful here to list the principals. In the anterior region: the large pectoral, the coraco-brachial, the anterior portion of the deltoid, the large dorsal, the large round, and the long head of the triceps. Some of these muscles are superficial, well visible under the skin; but the majority are situated more deeply, influencing in various measures the complex external form of the shoulder.

The exterior aspect of the shoulder is rounded because it dominates the projection of the deltoid. This triangular muscle originates from the shoulder blade and the lateral tract of the clavicle. It inserts itself on the lateral face of the humerus, in proximity to the humerus head. It is situated, therefore, almost entirely on the anterior-lateral contour and posterior of the

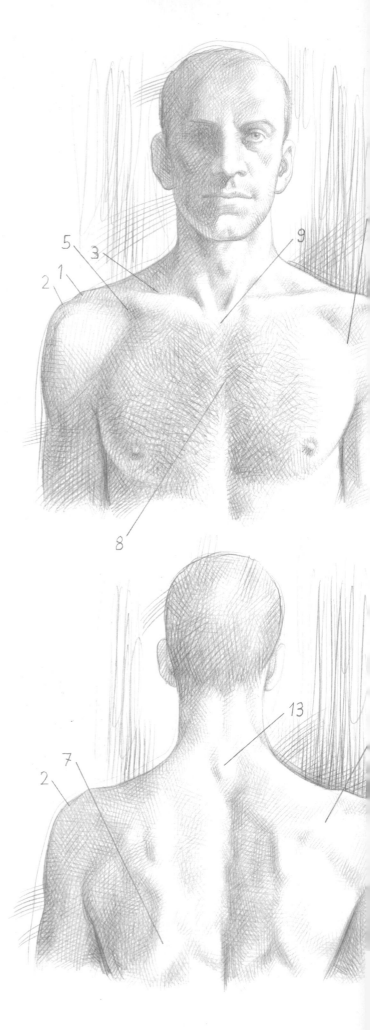

Sketch 21: Formation of the male shoulder

1 - Acromion-clavicle joint
2 - Acromion
3 - Supra-clavicular crease
4 - Large dorsal
5 - Sub-clavicular crease (its depth accentuates or attenuates in relation to the movement of the shoulder)
6 - Shoulder blade
7 - Median margin of the scapula
8 - Sternum
9 - Handle of the sternum
10 - Sulcus between the deltoid and the pectoral
11 - Super-spinate muscle
12 - Large round
13 - Seventh cervical vertebra
14 - Large pectoral (anterior pillar of the armpit)
15 - Deltoid
16 - Brachial biceps

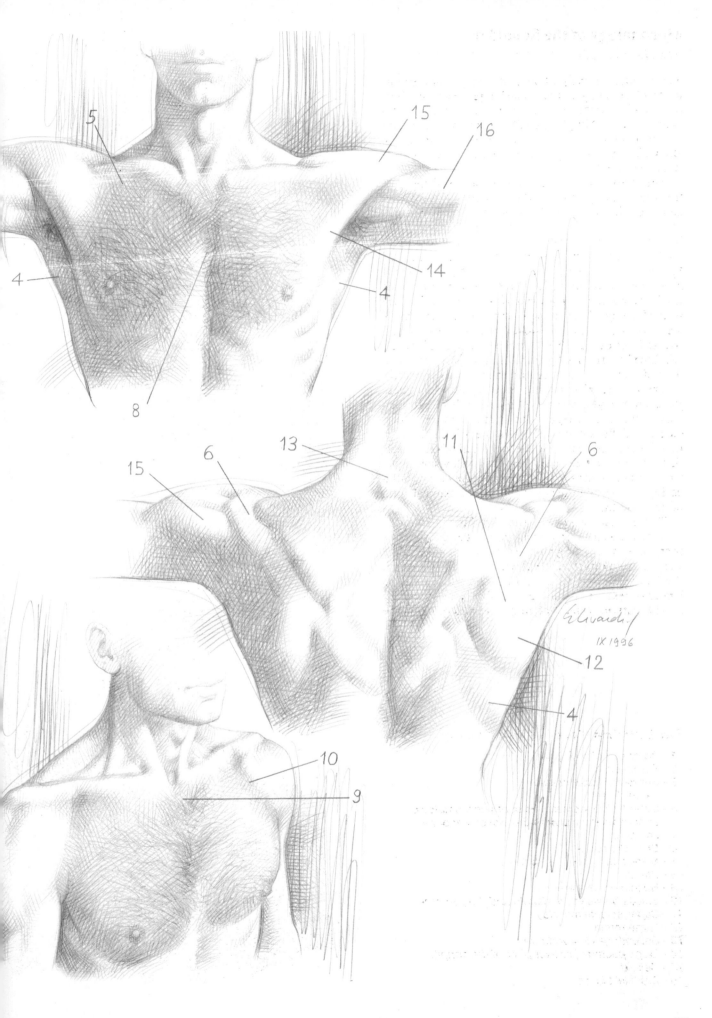

57

scapular belt and extends to cover the proximal tract of the humerus, occupying the internal deltoid region. The deltoid-pectoral crease of separation of the two related muscles initially delimits this and, in the posterior shadows without distinct limits, in the scapular region. The complex form of the shoulder is revealed and rounded on the upper anterior-lateral margin. Yet it is flattened on the posterior margin and in the inferior tract with the insertion of the humerus.

The dimensions and depth of the deltoid depend, in part, on the individual condition of physical exercise. Frequently, in athletic individuals, it is distinguishable under the skin, when normally a subtle layer of fatty tissue attenuates the projections and softens the modeled external. This is representative in individuals of the female sex because the fatty deposit is typically localized on the posterior face of the shoulder and extends on the upper portion of the arm, covering part of the triceps and determining the characteristic rounded projection of the feminine arm.

The protrusion of the lower margin of the pectorals (which form a point of passage across the underarm) and the projection of the lateral tract of the clavicle pair on the anterior plane of the shoulder. Underneath the projection of the lateral tract, a more or less accentuated dimple (sub-clavicle pit) incises at the position of the limb and of the characteristic individual bones. These almost disappear, for example, when the shoulders are strongly pulled back.

The projection of the acromion, the scapular tract that conjoins with the lateral extremity of the clavicle (always perceivable and considered an important point of reference) is revealed on the upper face of the shoulder. But the acromion is circled by the deltoid, that contracts in the abduction of the arm, augmenting the volume and therefore the thickness in depth of the bone protrusion. This, then, appears as indented in a more or less marked depression.

The posterior surface of the shoulder passes the scapular region without distinct confines. The scapular region is characterized by the protrusion of the shoulder blade, transversally positioned with a slight inclination across the lower part of the median plane. Its presence subdivides the region in an upper portion covered by the trapezium, in which the super-spinate muscles are lodged, and in a lower portion, which is more vast and occupied by the sub-spinate muscles partially covered by the large dorsal.

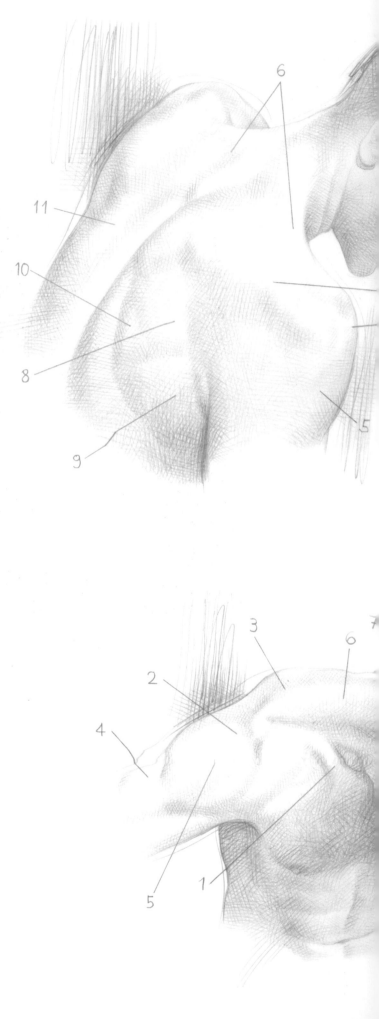

Sketch 22: Aspects of the male shoulder

1 - Clavicle
2 - Acromion
3 - Shoulder blade
4 - Triceps
5 - Deltoid
6 - Trapezium
7 - Seventh cervical vertebra
8 - Infraspinate
9 - Large round
10 - Rhomboid
11 - Median margin of the scapula
12 - Large dorsal

58

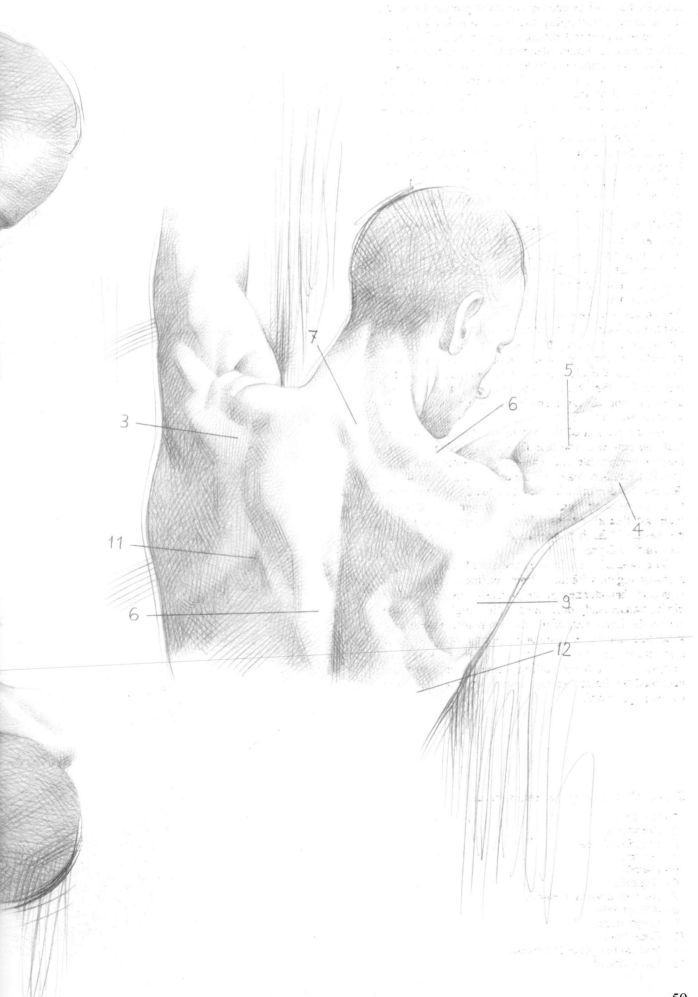

3

7

5

6

11

4

6

9

12

The external morphology of the scapular region is variable in relation to certain muscles, which determine the movements of the arm and of the shoulder. It is important to reveal the placement of the clavicle and of the scapula during the bilateral or unilateral movements of the shoulder and arm. The vertebral margins and lower angle of the scapula come near each other across the median plane (which is across the vertebral column). They can also separate and rotate to various degrees, running through the curvilinear part of the thorax cage, on which the rib face of the scapula almost rests.

The ample and complex movements of the shoulder are mostly the result of the scapula-humerus joint. They are, however, slightly augmented by the other involved joints (acromion-clavicle, sternum-clavicle) that allow the positioning of the scapula and, in minor measure, the clavicle. About two-thirds of the movements are due to the scapula-humerus joint, and one-third to other joints.

Dynamic possibilities are found in the mechanical limits of the muscles, tendons, and ligaments, and in the bone projection (small and large tuberosity of the humerus and acromial process of the scapula).

The movements secured by the shoulder joints at the upper limb break down into three spatial planes:

a) the long transversal axis realizes: 1) flexion in which the synergy action intertwines the biceps, deltoid (anterior part), and large pectoral (clavicle band); 2) extension (placed behind) that involves the large round muscles, large dorsal, sub-scapular, and deltoid (posterior part).

b) anterior-posterior long axis: 1) abduction (separation of the trunk) that involves the deltoid muscles (mostly the intermediate part), sub- and supra-spinate, and biceps (long head); 2) abduction (nearing and at the trunk) realized by the large pectoral muscles, large dorsal, sub-spinate, and sub-scapular.

c) There are limited possibilies for rotational movement across the longitudinal axis of the humerus. The association of singular movement, or the succession of flexion, abduction, extension, and abduction involves, in various measure, all of the shoulder joints and permits the circumduction of the arm in a way that is able to describe a cone in space and the points of the fingers to form a circle.

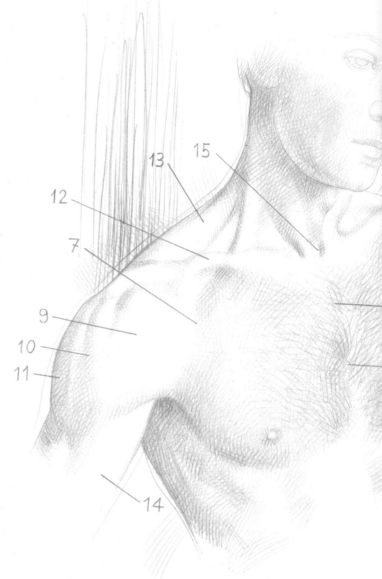

Sketch 23: Aspects of the male shoulder

 1 - Clavicle portion of the large dorsal
 2 - Large pectoral
 3 - Deltoid
 4 - Supra-clavicle crease
 5 - Sub-clavicle crease
 6 - Sternum-cleido-mastoid
 7 - Deltoid-pectoral crease
 8 - Acromion
 9 - Anterior portion of the deltoid
10 - Lateral portion of the deltoid
11 - Posterior portion of the deltoid
12 - Clavicle
13 - Trapezium
14 - Biceps
15 - Jugular dimple
16 - Body of the sternum
17 - Sternum angle
18 - Epigastrium depression
19 - Homohyoid
20 - Head clavicle of the sternum-cleido-mastoid
21 - Tucipite

60

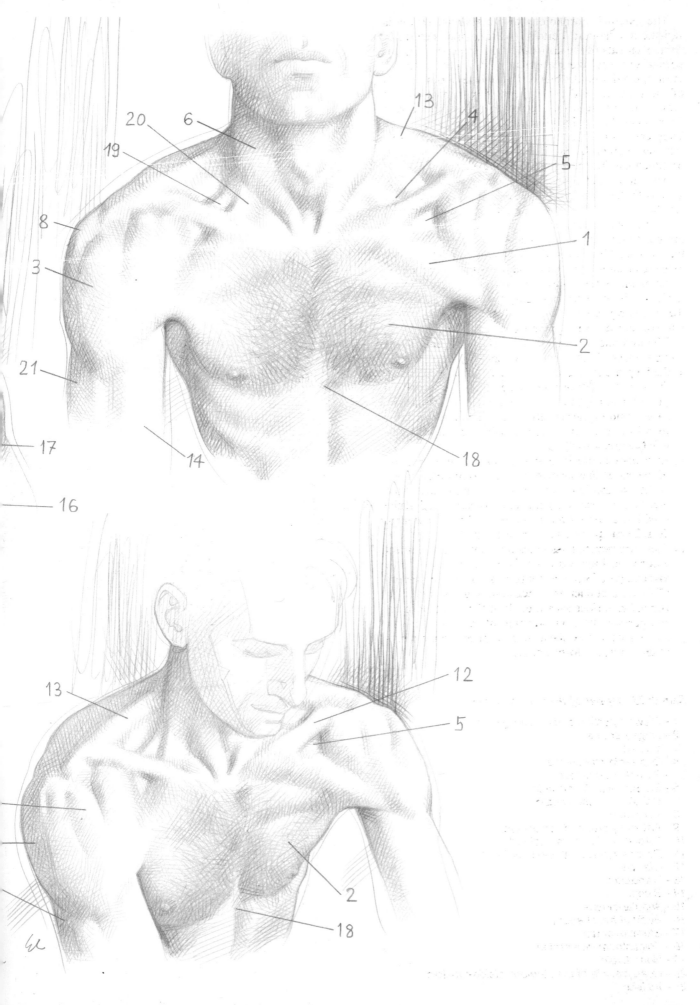

61

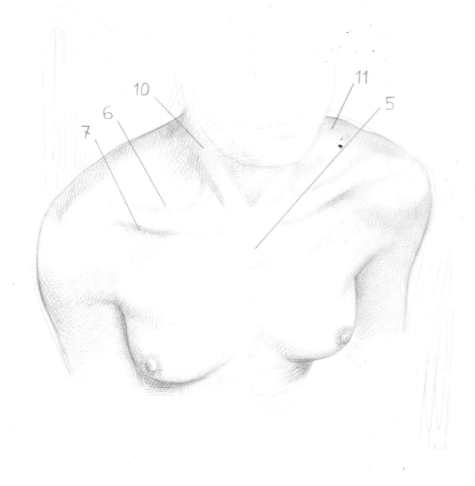

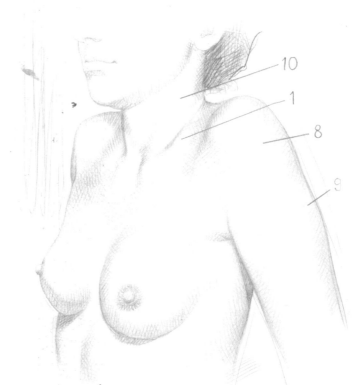

Sketch 24: Aspects of the female shoulder

1 - Clavicle
2 - Large pectoral
3 - Clavicle portion of the large pectoral
4 - Acromion
5 - Sternum
6 - Over-clavicle dimple
7 - Sub-clavicle dimple
8 - Deltoid
9 - Localization of the fatty rear-deltoid
10 - Sternum-cleido-mastoid
11 - Trapezius
12 - Grand dorsal

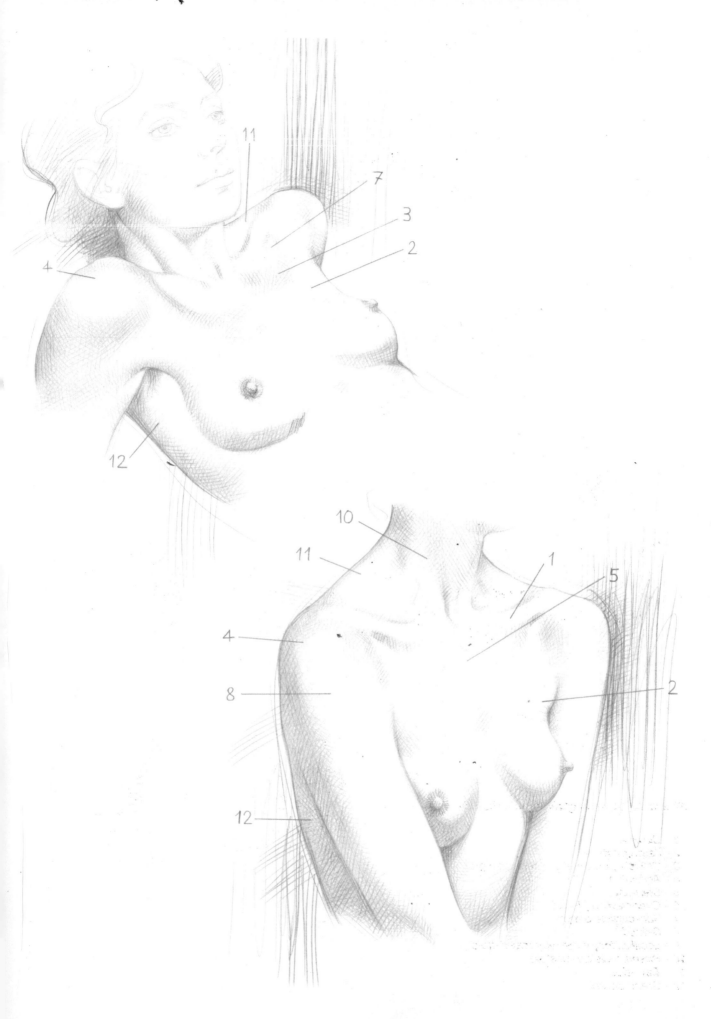

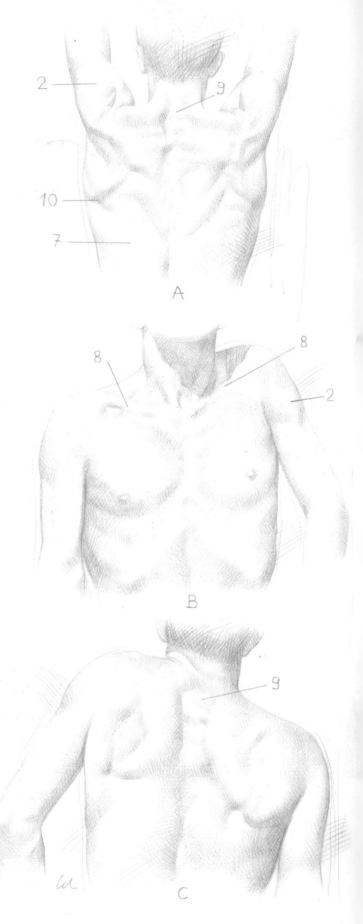

Sketch 25: Aspects of the mobility of the scapular belt and of the consequent morphological variations in men and women

A - Elevation of the arm: note the position of the scapula and the action of the trapezium and deltoid

B- C0 - Elevation of the left shoulder, using the trapezium (upper portion fiber), the rhomboid, and the elevator of the scapula. To confront the position and aspect of any antimere of the body

D - Abduction of the arms, crossing in the front, using the anterior portion of the deltoid. Compare with A and D the position of the scapula

F-G-H - Elevation of both shoulders

I-L-M - Morphology of the female shoulder during the elevation and anteropulsion of the left arm

1 - *Trapezium*
2 - *Deltoid*
3 - *Vertebral column*
4 - *Shoulder blade*
5 - *Median margin of the scapula*
6 - *Acromion*
7 - *Large dorsal*
8 - *Clavicle*
9 - *Seventh cervical vertebrae*
10 - *Lower angle of the scapula*

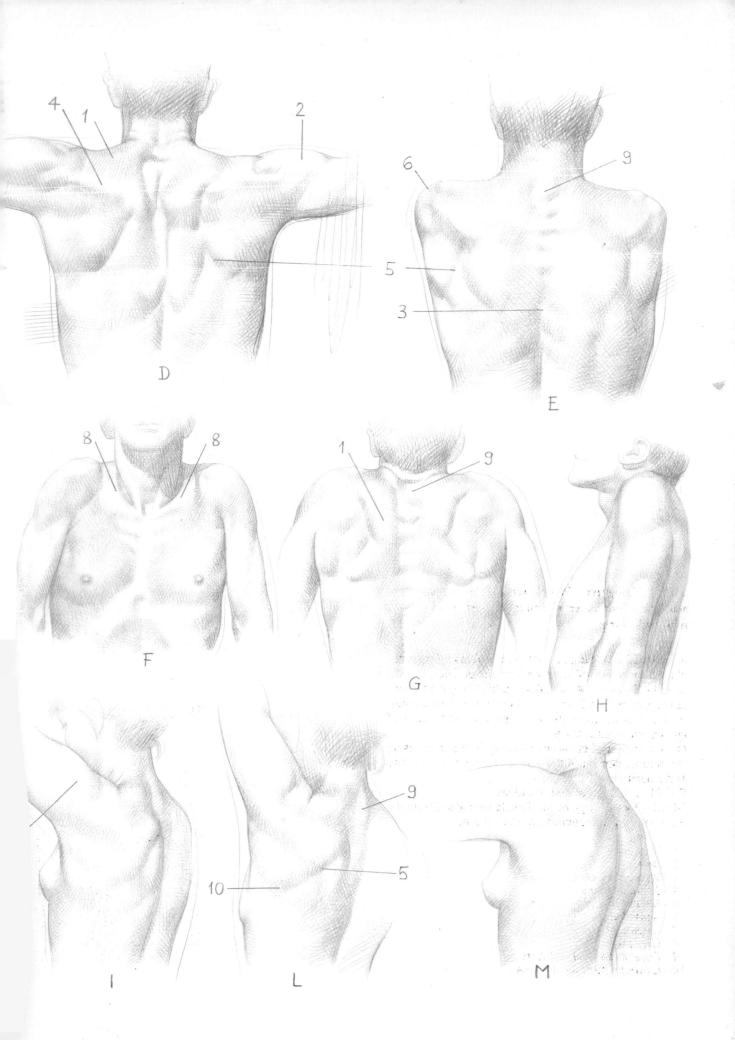

D

E

F

G

H

I

L

M

Morphology of the Armpit

(sketches 26–27)

The armpit region appears as a depression situated between the upper part of the thorax lateral inner portion and the upper median part of the brachial. If the limb is adherent to the trunk, the armpit cavity is reduced in an anterior-posterior sense, at a deep direct crevice. If the arm is in abduction, or separate from the trunk until rejoining the horizontal position, the armpit appears in its maximum depth. It results in a dome form or trunk pyramid, in which the apex (bottom of the armpit) corresponds to the median covering of the coracoid process and leads across the base of the neck.

The armpit hollow opens forward and laterally, defined by two muscular points, sheltered by the armpit portion of the superficial covering. The almost laminate anterior covering constitutes the anterior inner portion (or anterior pillar). It is formed by the large and small pectorals. The posterior covering, deeper and more ample in extension, constitutes the inner portion. It is formed by the large dorsal and the large round. It is useful to remember that, when designing or modeling a nude, when horizontally extended, the arm's anterior inner portion is brief, protruding, and oblique. As one looks forward, the entire armpit cavity is visible, while it is impossible to observe it dorsally.

The median inner portion of the armpit cavity is represented by the upper inner portion of the lateral thorax, or from the first four or five ribs covered by the anterior dentate. The lateral inner portion is reduced at a margin defined by the humerus and proximal tracts of the coraco-brachial and the edge of the biceps.

The armpit skin, particularly that of the bottom of the cavity, is rich in sweat glands, lymph nodes, and fatty tissue. The morphology of the armpit changes radically if the arm, because of abduction or rotation, is brought up vertically. In this position, the cavity flattens and reveals at times the projection of the humerus head.

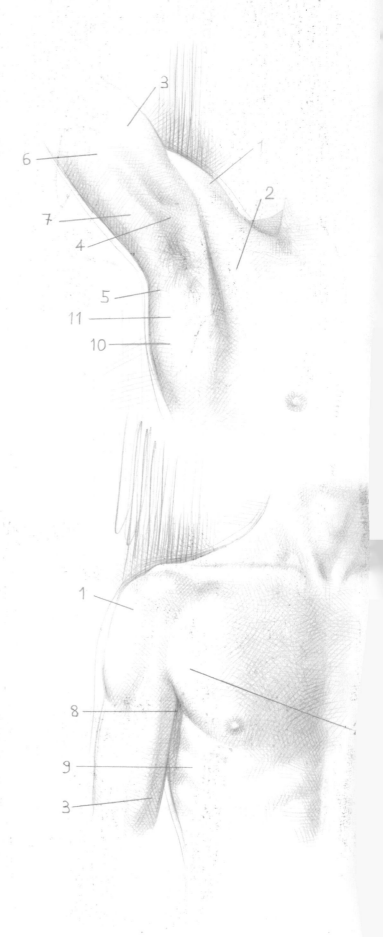

Sketch 26: *Some morphological aspects of the armpit in the male*

1 - *Deltoid*
2 - *Large pectoral (forms the pillar and anterior inner portion of the armpit)*
3 - *Biceps*
4 - *Coraco-brachial*
5 - *Large round*
6 - *Triceps: medium head*
7 - *Triceps: long head*
8 - *Virtual cavity of the armpit*
9 - *Large dentate*
10 - *Large dorsal*
11 - *Inner portion and posterior pillar of armpit (formed by large round and large dorsal)*
12 - *Armpit cavity*

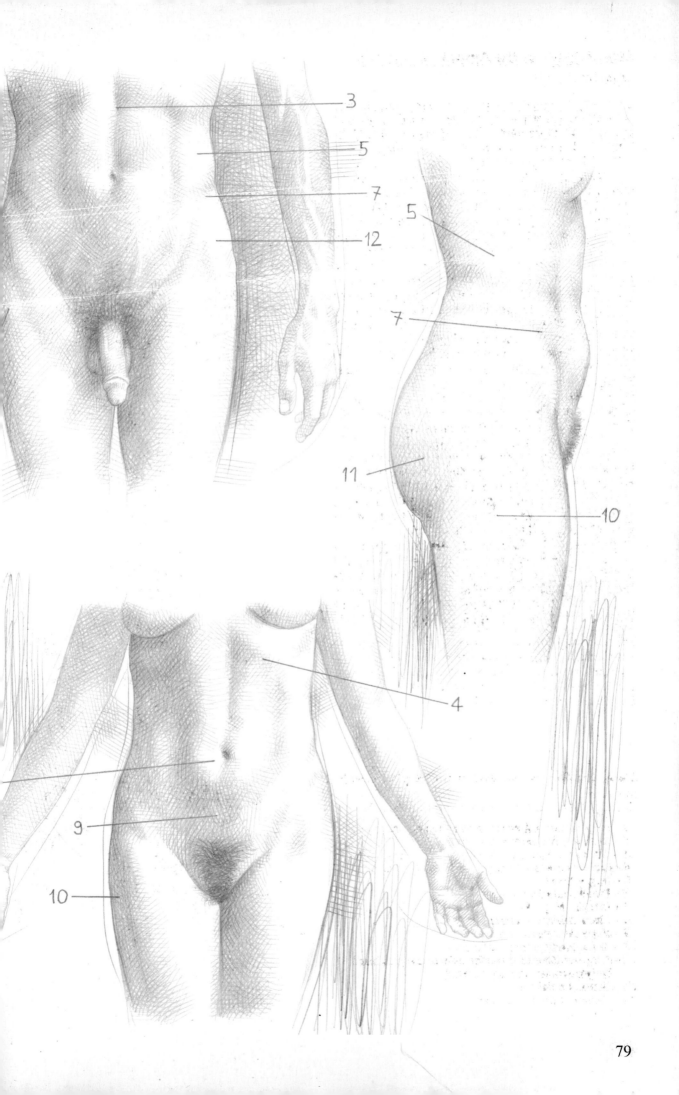

3

5

7

12

5

7

11

10

4

9

10

The dimensions of the abdomen, above all the transversal and anterior-posterior, are individually varied in relation to the bio-typological, physiological, and pathological characteristics. They also vary according to sex and age.

The height is more stable, however. Normally, in an adult, the abdomen is equivalent to about a quarter of total body height, or two times the length of the head. From birth to its first year, however, an infant's abdomen represents nearly a third of the total body height. It is voluminous in relation to that of an adult, but gradually, after the growth of the various other body parts, it conforms to typical adult proportions.

The form of the abdomen has a strict relationship to the morphological constitution of the subject. All the possibilities are noted, from the flattened abdomen of a long-lined individual to the globular more projected abdomen of a short-lined subject.

The sub-umbilical portion of the abdomen may be crossed, especially in women, by a weak semicircular crease that conjoins the anterior margins of the iliac bone. It is considered an accessory of the crease of principal flexion placed transversally at the abdomen above the navel.

The supra-pubic crease is shorter, but more marked. It is concave, and shaded across the inguinal crease that defines the upper confines of the pubic region.

This area is rich in body hair deposits in both sexes (see page 40). Corresponding to the pubic symphysis, it is prominent because it is seated on a well-localized deposit of fatty tissue (mound of Venus, in women, and penile in men).

The lateral limits of the abdomen shade in the sides, while the posterior limits confine the sacrum and lumbar regions). The side extends from the lateral inner portion of the trunk to the lower border of the thorax cage at the pelvis, where it rejoins the hip region.

Remember that, given the different dimensions of the thorax cage in the two sexes, the distance between the lower margin of the thorax cage and the iliac crest is larger in the woman than in the man.

The upper limit of the side is indicated by the crossing of the large dentate and oblique external muscles.

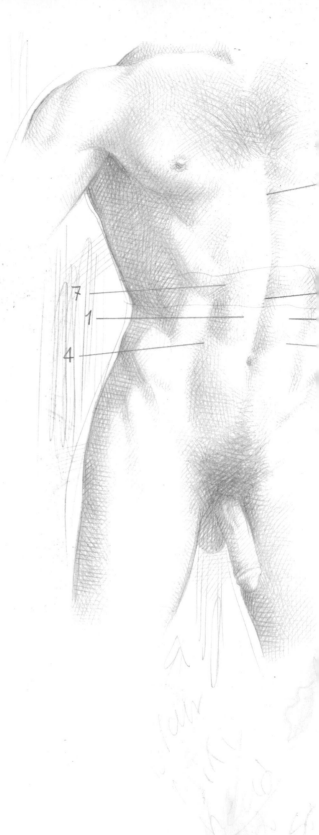

Sketch 33: Aspects of the straight muscles of the abdomen in the male and female

 1 - Rect-abdominal muscles
 2 - Inscriprion tendon of the straight abdomen muscle
 3 - Longitudinal median depression corresponding to the "dawn line"
 4 - Lateral limit of the recto-abdomen muscle
 5 - Upper anterior iliac spine
 6 - Oblique external muscle
 7 - Rib margin (arch)
 8 - Sixth rib
 9 - Iliac crest

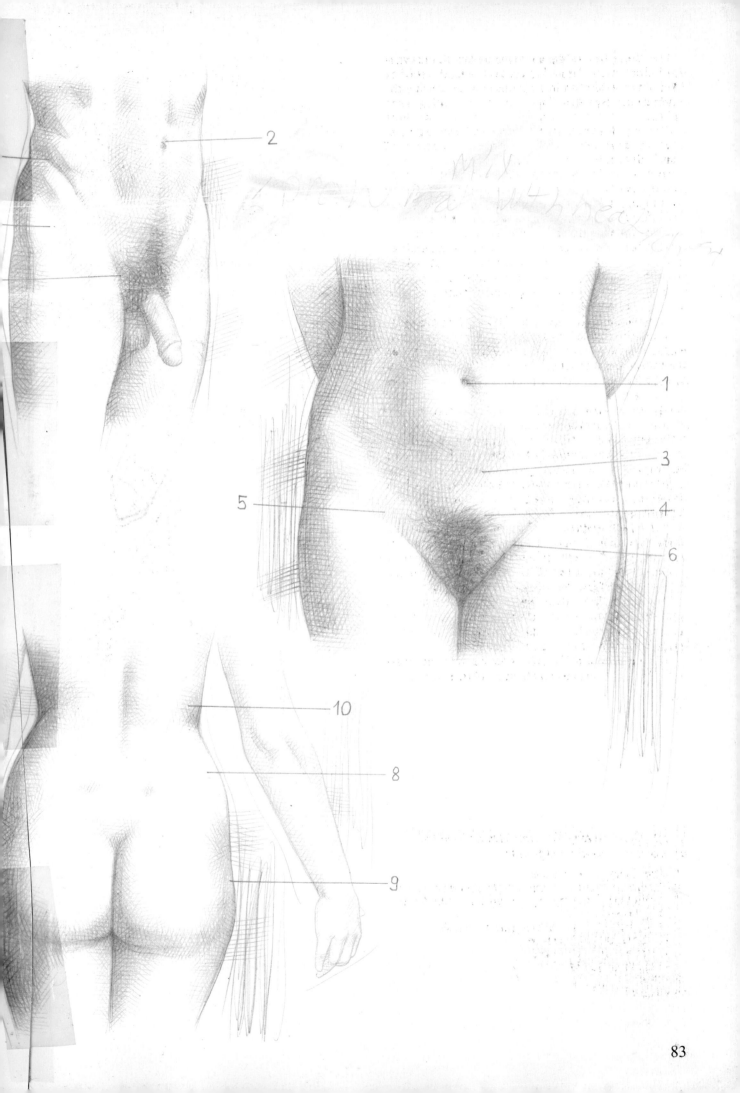

2

1

3

5

4

6

10

8

9

83

Morphology of the External Genitals

(sketches 34-35)

In both sexes, some parts of the genital apparatus are situated on the superficial portion of the anterior perineum. They are located at the lower extremity of the abdomen and are in certain measure externally visible; therefore, they have much interest for artists' purposes.

Man - The external masculine genital organs are the testicles and the penis. The testicles, two sexual glands that produce sperm, are paired in a quasisymmetrical position near the median plane. They have a slightly flattened transversally ovoid form and are contained in the scrotum, a skin sac where the left testicle is generally situated slightly lower than the right. The scrotum is covered in strongly pigmented skin and presents individual diversity in size and form in relationship to age and physiological situation. Its dimensions can contract (through muscular components contained in the inner portion) under emotional or temperature influences. The skin of the scrotum is creased with transversal wrinkles originating from a vertical cordon projection. It proceeds across the root of the sac and is strewn with random hairs that thicken across the pubic area.

The penis is the erectile masculine organ. It serves as the junction and path of the urethra, which conducts urine to the external. In a state of repose, it is situated on the anterior face of the scrotum. In this state, the median length of the penis is around ten centimeters.

The form, consistency, direction, volume, and dimension of the penis vary considerably according to whether it is in a flaccid or erect state. The erect state depends on the filling and stagnation of blood in the internal organs of the penis. The cavernous body, accompanied by a rich vascular deposit, augments the dimension of the penis to about a third larger and wider.

The penis, covered with hairless and pigmented skin, has a quasicylindrical form, except for the terminal portion. The terminal portion is enlarged, conical, and covers almost the entire prepuce. Part of the gland is uncovered, leaving visible the somewhat decentralized opening of the urinary canal. While the skin of the gland has a rosy color, the color of the prepuce is more pigmented. It is also very elastic and able to glide along the gland, permitting the uncovering of the terminus only partially at times. Certain populations, for religious or hygienic reasons, practice circumcision. This consists of surgically removing the entire prepuce, which leaves the gland permanently exposed.

Woman - The feminine genital organs are situated near the anterior area of the perineum and are made up the vulva, an unequal median projection of ovoid form, in which the canals of the uterus and the vagina are opened. The vulva starts initially with a rounded projection, the mound of Venus. It is formed (as seen) by an often-fatty layer situated at the level of the upper border of the pubic symphysis. It continues with two large skin folds, the outer lips, which are normally near the median plane. Descending, they converge to the seam at the center of the perineum, about one centimeter from the anal opening, laterally defined by a distinct crease of separation on the internal face of either leg.

The skin area of the mound of Venus and the lateral skin of the outer lips are generally densely covered with dark, undulating hair. Remember the diverse positions

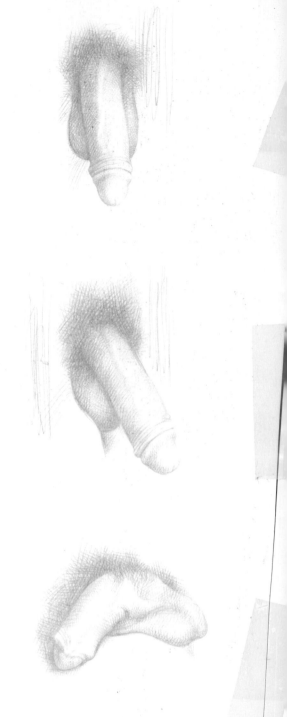

of the hair in the two sexes. In the woman, the hair terminates almost distinctly, with a transversal line posted slightly above the pubic symphysis. It extends to the median face of the leg. In the man, the hair continues, even if more randomly, along the median line almost to the navel and onto the root of the leg.

Below the outer lips of the female genitals, two other folds of various dimensions are found (the inner lips). The inner lips are fine, hairless, and rose colored, intensely at times. The inner lips protect the vestibule of the vagina and the urinary canal. Their margins are free and irregular, at times projecting past the outer lips.

Anteriorly, the inner lips conjoin in a complex way at a small erectile organ (the clitoris), homologous to the male penis yet very reduced in size. The median face of the inner lip gradually runs through the vestibule of the vagina, restricting the presence of the hymen, a fine partially incomplete membrane of variable form.

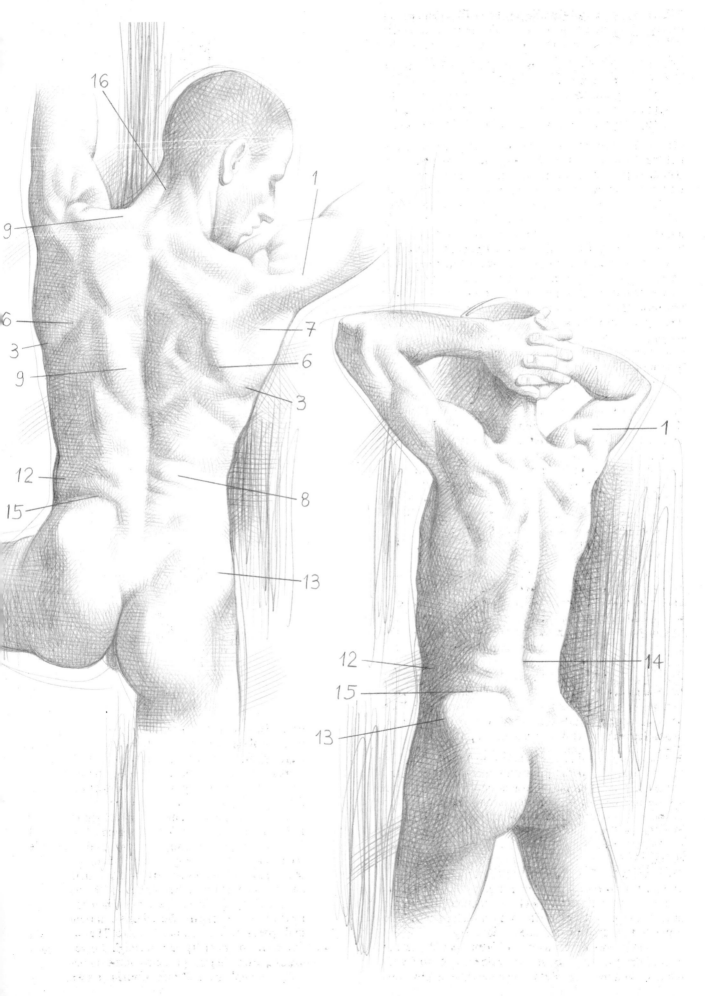

16

9

6

3

9

12

15

1

7

6

3

8

13

12

15

13

1

14

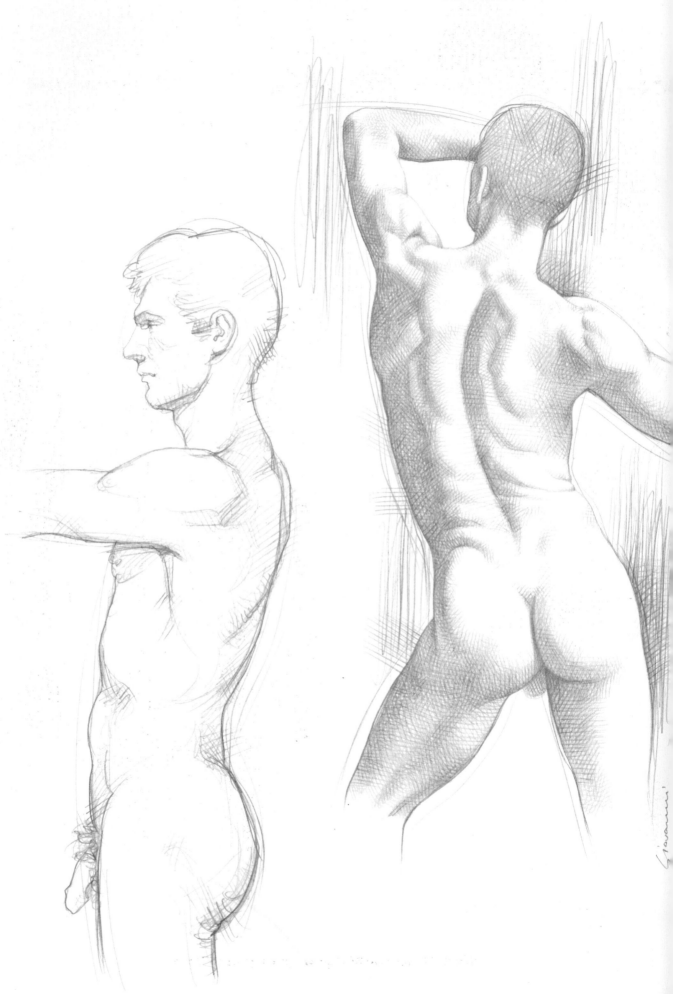

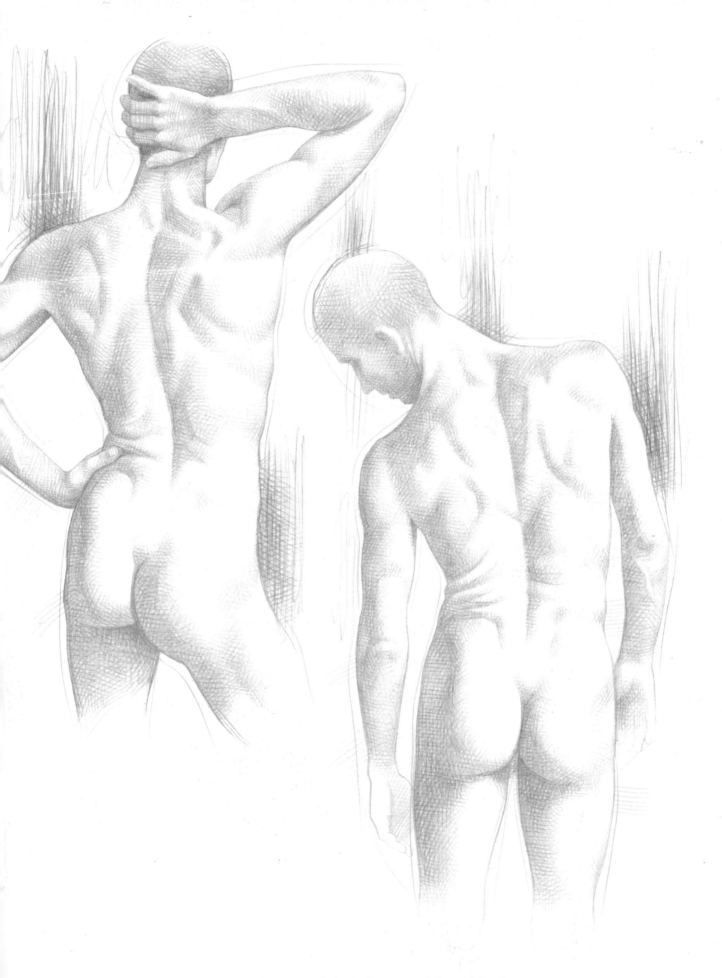

Sketch 39: Some morphological aspects of the male back

The Upper Limbs

(sketches 40–57)

Sketch 40: Principal regions of the upper limbs

A - Acromial
B - Deltoid
C - Lateral brachial
D - Anterior brachial
E - Median brachial
F - Lateral cubital
G - Anterior cubital
H - Median cubital
I - Cubital pit
K - Radial antebrachial
L - Radial antebrachial

M - Anterior antebrachial
N - Anterior of the wrist
O - Palm of the hand
P - Digital
Q - Posterior brachial
R - Posterior cubital
S - Olecranal
T - Posterior antebrachial
U - Posterior of the wrist
V - Back of the hand

External Morphology

(sketches 40–45)

The upper limbs are equal, symmetrical and placed on the sides of the trunk. Each is made up of a three parts (arm, forearm and hand) jointed with the scapular belt and conjoined at the thorax at shoulder level.

The gross muscles, anterior pectoral, posterior scapula, and upper deltoid, lead to the first segment of the limb, the arm. They determine the shoulder projection, which is rounded overall on the lateral and anterior planes while somewhat flattened posteriorly.

The arm has a cylindrical form that is slightly transversally compressed. It is attached to the trunk by way of the shoulder. With the lateral inner portion of the thorax, it defines the crevice of the armpit. Its muscles are situated around the only bone, the humerus. The humerus is divided into anterior and posterior tuberosities.

The forearm conjoins in the middle of the arm at the elbow joint. It has a flattened trunk-conic form with an enlarged proximal section. Its muscles are positioned around two bones, the ulna and the radium.

The hand is flattened and slightly concave on the palm surface. It has a complex form due to the presence of numerous bones. The carpus and metacarpus correspond to the wrist; the philanges correspond to the finger. The hand is attached to the forearm by way of the wrist joint and continues the limb's longitudinal axis.

Sketch 40: Formation of the male upper limb

1 - Deltoid
2 - Brachial biceps
3 - Tricep (long head)
4 - Humerus: median epicondyle
5 - Brachioradia
6 - Group of flexor muscles
7 - Radium
8 - Tendons of the flexor muscles
9 - Long radial extensor of the carpus
10 - Ulna: olecranon
11 - Ulna
12 - Group of extensor muscles
13 - Tricep (lateral head)
14 - Brachial
15 - Tendons of the extensor muscles
16 - Large pectoral

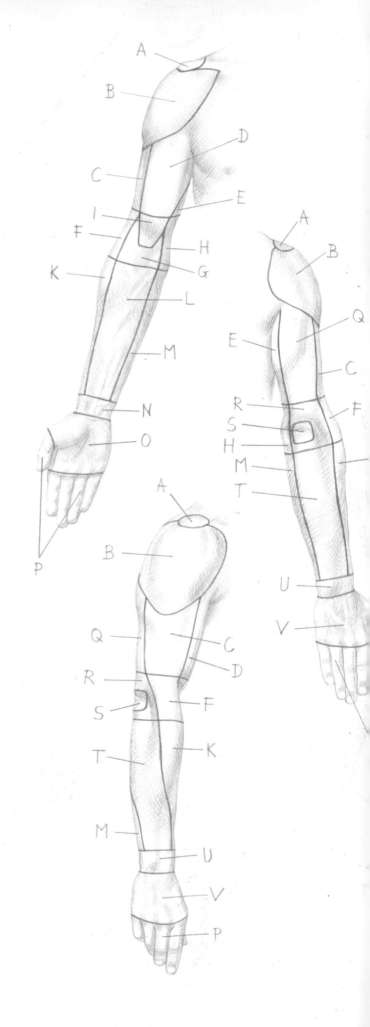

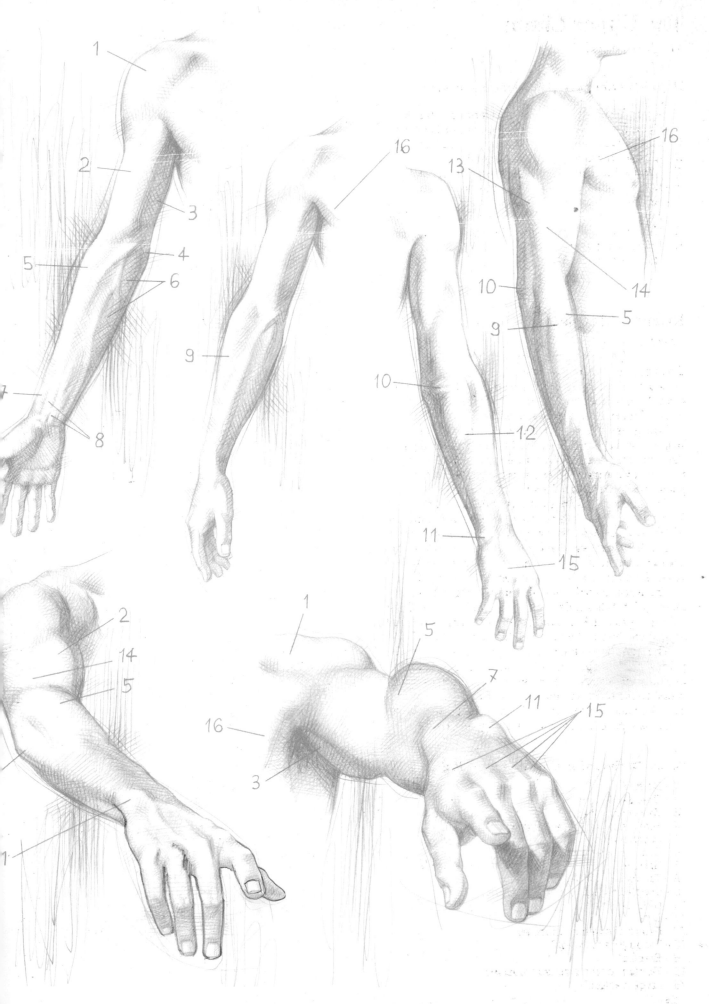

Notes on Osteology

The bone apparatus of the upper limb is made up of two elements, the clavicle and the scapula (see page 42), which are organized in the scapular belt. They operate as joint attachments at the level of the free part of the shoulder on the skeletal axis.

The skeleton of the upper limb contains the humerus or bone, corresponding to the arm,; the ulna and radium, corresponding to the forearm; and the carpus, metacarpus, and phalanges, corresponding to the wrist and the hand.

In the anatomic position, the bones are in a supine position as well. The bone segments are consecutively posted in a cranium-caudal sense and slightly angled. The two bones of the forearm are positioned parallel and therefore can be described as analogous to the lower limbs.

The bone structure of the upper limb is at least partially sub-skin (for example, at the elbow, the wrist, the back of the hand, and the fingers) and should be considered attentively on the part of the artist.

The humerus is a long bone where three sectors can be recognized. The cylindrical body (or diaphysis) runs from the slight sulci and the tendon attachments of the muscles. The somewhat enlarged and quasihemispheric upper extremity (or head) joins with the scapula in the glenoid cavity. The transversally enlarged and flattened lower body articulates with the ulna and the radium.

The radium is a long bone. In the anatomic position it is posted laterally in the forearm, where at leveled surfaces and triangular sections, the radium contrasts two extremities with different characteristics. The upper, proximally in articulation with the humerus, is subtle and cylindrical (head of the radium). The lower, in articulation with the bones of the hand (carpus), is more elongated and flattened.

Sketch 41: Aspects of the male upper limb

1 - Ulna
2 - Ulna: olecranon
3 - Humerus: median condyle
4 - Humerus: lateral condyle
5 - Biceps
6 - Deltoid
7 - Coraco-brachial
8 - Round pronator
9 - Ulnar flexor tendon of the carpus
10 - Radial flexor tendon of the carpus
11 - Triceps: lateral head
12 - Triceps: long head
13 - Triceps: median head
14 - Brachial
15 - Brachioradial
16 - Ulnar extensor of the carpus
17 - Posterior margin of the ulna and ulnar sulcus
18 - Radium
19 - Radial flexor tendon of the carpus
20 - Long palmar tendon
21 - Common flexor tendon of the finger
22 - Ulnar flexor tendon of the carpus
23 - Superficial extensor of the finger
24 - Large round
25 - Deltoid
26 - Tendon of the triceps

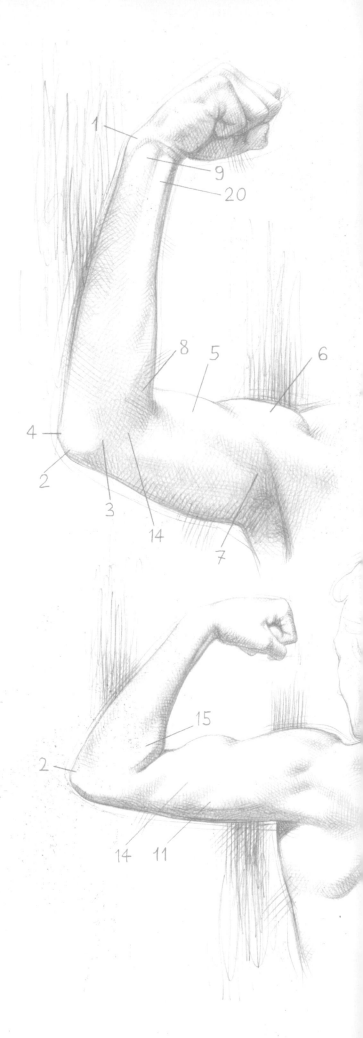

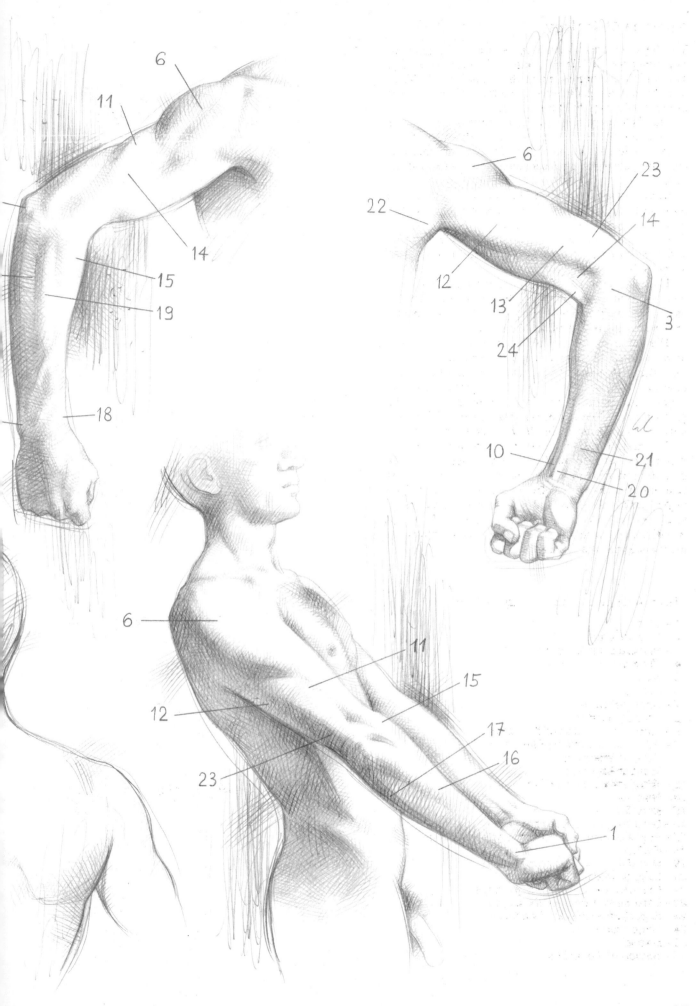

6

11

14

15

19

18

6

22

12

13

24

23

14

3

10

21

20

6

12

23

11

15

17

16

1

The ulna is a long bone with a complex form, contrary to that of the radium. It is posted medially in the forearm. The radium has triangular sections. In the upper tract it is large and robust, while it becomes more refined and rounded in the lower tract. The upper extremity is very voluminous and constitutes the principle part of articulation with the humerus. The lower extremity is very subtle and cylindrical with a brief but evident process situated posterior-medially.

Eight short bones, each with morphological characteristics, form the carpus. In their entirety they constitute a flattened half- moon formation, which is slightly concave in the anterior. The bones arrange in two flanked lines, each composed of four elements, but aligned in an irregular and complex manner.

The metacarpus is made up of five bones of diverse length and peculiar characteristics, which are, however, conducive to a common structure. They are a cylindrical body that is curved at the anterior concavity, a well-developed and hemispheric head in articulation with the phalanges, and an irregularly cubical narrow base in articulation with the bones of the carpus.

The phalanges are the small bones of the fingers that are positioned in a string, three for each finger; excepting the pollex (thumb), which is made up of only two (missing the intermediate). The proximal phalanges are the largest. The base joins with the metacarpi and the head with the succesive phalanges. The middle phalanges have similar characteristics to the first, but are smaller in dimension. The distal phalanges are very short and terminate with the enlargement of the spatula, which serves as a support for the nail.

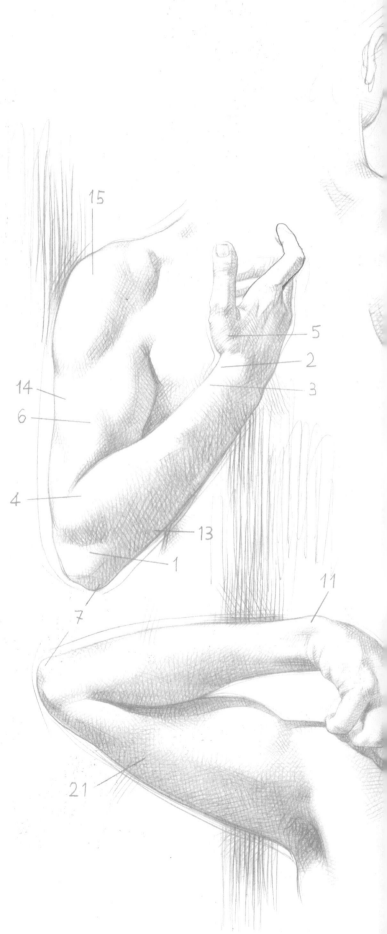

Sketch 42: Aspects of the male upper limb

1 - Long extensor of the pollex
2 - Short extensor of the pollex
3 - Long abductor of the pollex
4 - Brachioradial
5 - Long extensor tendon of the pollex
6 - Brachial
7 - Ulna (olecranon)
8 - Radial flexor of the carpus
9 - Long palmar
10 - Coraco-brachial
11 - Ulna
12 - Abductor of the fifth finger
13 - Ulnar extensor of the carpus
14 - Triceps: lateral head
15 - Deltoid
16 - Brachial biceps
17 - Superficial flexor of the finger
18 - Round pronator
19 - Ulnar flexor of the carpus
20 - Radium
21 - Triceps (median head)
22 - Median condyle of the humerus
23 - Large round
24 - Large dorsal

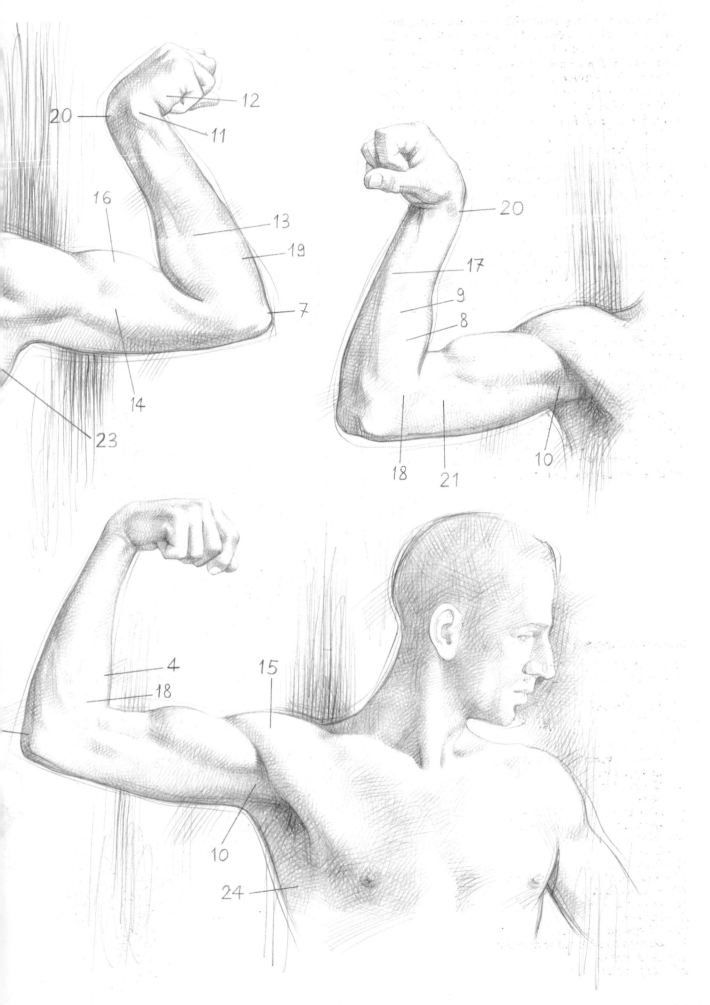

20

12

11

16

13

19

7

14

23

20

17

9

8

18 21 10

4

18

15

10

24

Notes on Arthrology

There are many free joints in the upper limb, in ratio to the quantity of humerus bone segments at the hand.

In functional and morphological consideration, the joints are divided into three groups: the joints of the scapular belt (see page 40), the joints of the free part (scapula-humerus joint, elbow joint, distal and proximal radium-ulna joint and radium-carpus joint), and the joints of the hand.

The scapula-humerus joint, or shoulder joint, effects the union between the head of the humerus and the glenoid cavity of the scapula. The two joint heads have no differences in extension and of surfaces at contact. The head of the humerus is quasihemispherical, while the glenoid cavity is enlarged and concave. Notwithstanding the presence of a robust joint capsule, reinforced by ligaments and expansion tendons of adjoining muscles, it allows ample possibility of movement, including abduction, flexion, extension, and circumduction.

The elbow joint effects between the humerus arm bone and the two bones of the forearm, the ulna and the radium. The joint is an articulation composed of three head joints contained in a single capsule. The specific characteristics of each head joint in relation to the others allow the angular displacement on a plane of only flexion and extension.

The joints between the ulna and the radium are structured to allow the characteristic pronation movement of the forearm. In the supine position the two bones are parallel. The pronation movement makes the radium rotate onto the ulna, turning over the palm of the hand.

The radium-carpus joint conjoins the forearm at the hand and effects between the lower joint surface of the radium and the bone of the proximal line of the carpus. Flexion and extension are the more ample movements; abduction, adduction, and circumduction are present in more limited measure.

The joints of the hand are particularly complex. The single bone segments have numerous surfaces of contact. A network of ligaments, which stabilize or render support in the movements, conjoins them. They can be divided into groups: carpus joints, carpus-metacarpus joints (relevant to the joint which corresponds to the pollex), intermetacarpal joint, metacarpus-phalange

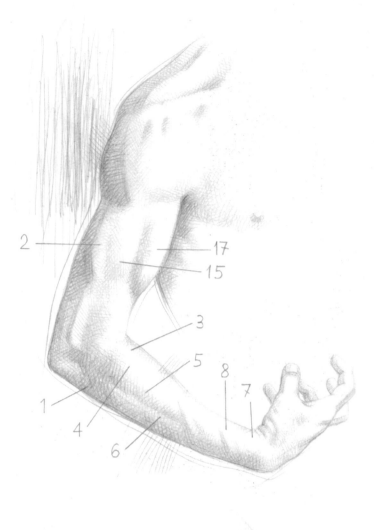

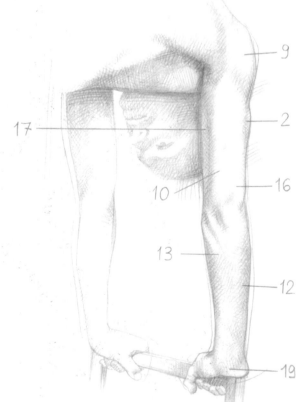

Sketch 43: Aspects of the male upper limb

 1 - Anconeus
 2 - Triceps: lateral head
 3 - Brachioradial
 4 - Long radial extensor of the carpus
 5 - Short radial extensor of the carpus
 6 - Common extensor of the finger
 7 - Short extensor of the pollex
 8 - Long abductor of the pollex
 9 - Deltoid
10 - Triceps: median head
11 - Ulna: olecranon
12 - Ulnar flexor of the carpus
13 - Radial flexor of the carpus
14 - Ulna
15 - Brachial
16 - Tendon of the triceps
17 - Brachial biceps
18 - Radium
19 - Bone of the carpus

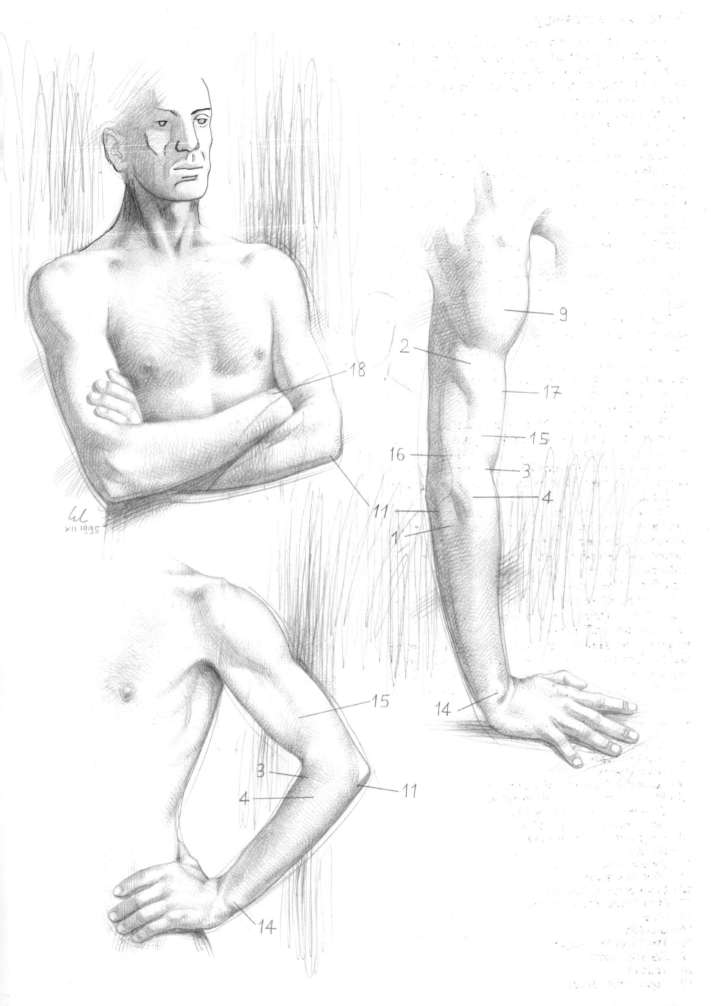

18

2

9

17

16

15

3

4

11

1

15

3

4

11

14

14

joints (which conjoin the head of the metacarpus to the base of the first phalange of the five fingers), and inter-phalange joints (which conjoin the phalanges of each finger). In the last two groups of joints, the articulation surfaces are bound at contact by the capsule and the collateral ligaments. The only consenting movements are of flexion, accentuated enough to almost rejoin at a right angle, and of slight extension.

Notes on Myology

There are many muscles of the upper limb. The number of muscles in a proximal-distal direction increases considering the augmented bone angle and the specific function of the hand.

The muscles in relation to the corporal axis sector and the upper appendicular sector function on the scapular belt and the proximal tract of the humerus. They are the axo-appendicular muscles (including the spinal-appendicular and the thorax-appendicular muscles) and shoulder muscles. This has been noted when dealing with the trunk (see page 56). The muscles of the arm are long and parallel at the humerus, which they cover almost completely. The flexor muscles of the forearm are posted in the anterior loggia (biceps, coracobrachial, brachial, and anconeus). Only one extensor muscle, the triceps, is posted in the posterior loggia. The muscles of the forearm are even more numerous and include a paunch, which prolongs in subtle tendons. Therefore, the forearm tract has a larger diameter at the elbow in respect to that of the wrist. They are divided into two groups, which prevalently work on the hand. They are the flexor muscles posted in the anterior loggia (round pronator, radial flexor of the carpus, superficial flexor of the finger, etc.) and the extensor muscle posted in the posterior loggia (common extensor of the finger, ulnar extensor of the carpus, long extensor of the pollex, etc.).

The hand muscles are located on the surface of the palm. On the dorsal surface, only the forearm extensor muscles are found. The muscles are short, flattened, and divided into three groups. The muscles of the thenar eminence are laterally situated in correspondence to the pollex (short abductor, short flexor, opponent and abductor of the pollex). The muscles of the hypothenar eminence are situated medially (adductor, short flexor, opponent of the little finger). The groups of inter-bone and lumbar muscles are situated between the metacarpi.

Sketch 44: Aspects of the female upper limb

1 - Deltoid
2 - Large pectoral
3 - Ulna: olecranon
4 - Humerus: median epicondyle
5 - Condiloidea depression
6 - Retro-deltoid fatty deposit
7 - Ulna
8 - Radium
9 - Ulna margin
10 - Superficial flexor of the finger
11 - Ulnar flexor of the carpus
12 - Ulnar extensor of the carpus
13 - Radial flexor of the carpus
14 - Round pronator
15 - Biceps
16 - Coraco-brachial
17 - Triceps
18 - Brachial

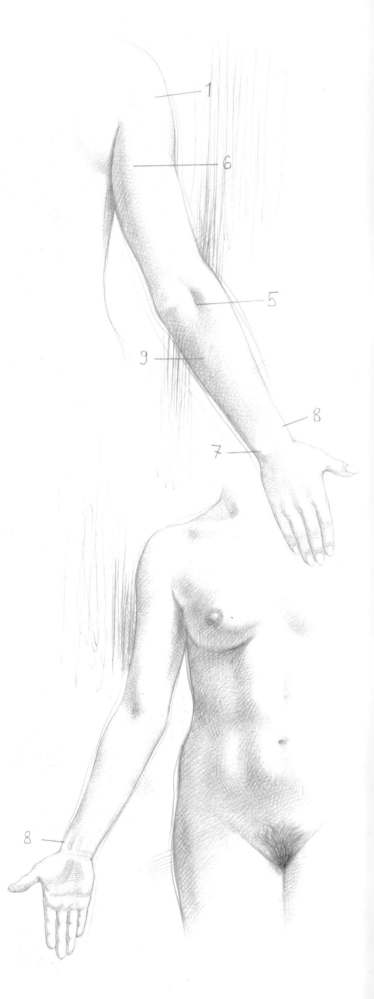

102

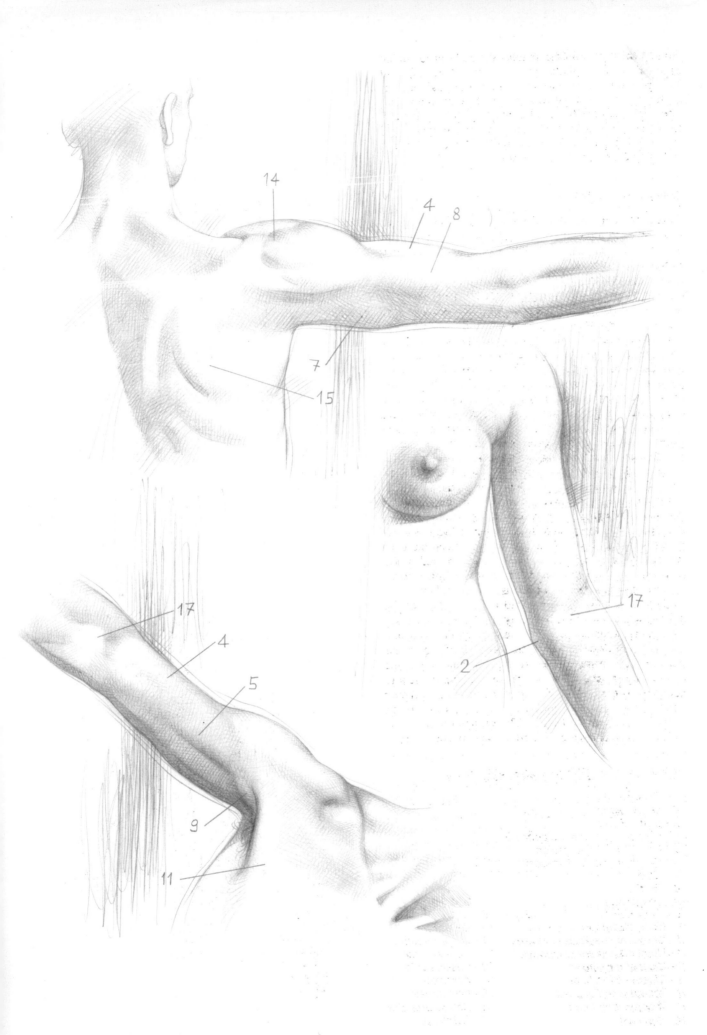

14

4 8

7

15

17

4

5

17

2

9

11

107

Morphology of the Elbow
(sketch 47)

On the upper-limb skeleton, the elbow corresponds to the homonymous joint, realized by the humerus, ulna, and radium. In an anterior-posterior sense, it has a very flattened cylindrical form.

The morphology of the anterior region (elbow fold) in the anatomic position is determined by three muscular protrusions. The inferior portion of the biceps meets the median protrusion by its tendons and the annexation of fibrous sinews from the lower part of the brachial. The rounded lateral protrusion is made up in large part of the muscles of the anterior portion (forearm extensors). They originate from the epicondyle and the lateral margin of the humerus (the radiobrachial and the long radial extensor of the carpus). Muscles of the anterior portion of the forearm (flexors) constitute the medial protrusion. They originate from the epitrochlea of the humerus (the round pronator, the gracilis muscle, the ulnar flexors, and the radial flexors of the carpus).

A triangular-formed depression with vertexes across the base (cubital pit) is found below the median muscular protrusion. Passing the arteries and gross nervous fascicles, it presents a structural analogy with the posterior surface of the knee. Two other muscular protrusions determine the asymmetrical frontal profile of the elbow. The lateral group, posted slightly higher, covers the lateral epicondyle of the humerus and forms an ample, accentuated curvature. The median group originates below the medial epicondyle (epitrochlea). Posted lower, it forms a shorter, less accentuated curvature. Above the muscular protrusion, the epitrochlea is under the skin. Slightly concave skin folds develop on the anterior surface of the elbow across the upper portion. They are situated at the level of the biceps tendons and are accentuated when the forearm is flexed at a quasirecto angle to the arm. Two major veins, the basilica and the cephalic, develop it. Laterally, two small branches, the median cephalic and the median basilica, connect the basilica and medially the cephalic. Their complex disposition resembles an M, but with individual variation.

The posterior region is occupied by the sub-skin bone projections of the olecranon and the ulna. They become very evident during maximum flexion of the forearm. During the anatomic position of the arm, the projection is situated in the region almost centrally. It is covered by abundant gross skin folds that are transversally posted and gathered together, rendering the surface wrinkled overall. This is more accentuated in older individuals, but it distends and disappears during flexion of the forearm. The olecranon is flanked medially by a small hollow that separates from the epitrochlea. Laterally, the hollow separates the olecranon from an ample profound depression defined by the anconeus and the lower margin of the long radial extensor of the carpus. This depression is called condylar because it corresponds to the condyle of the humerus, which joins with the head of the radium.

The external morphology of the elbow, particularly posteriorly, varies in relation to the movements of flexion, when the olecranon and the medial and lateral epicondyles are more evident. On the anterior surface, the robust tendons and cord form of the biceps project at the center. The subtle diagonal projections of the fibrous sinew also annex somewhat medially at this muscle.

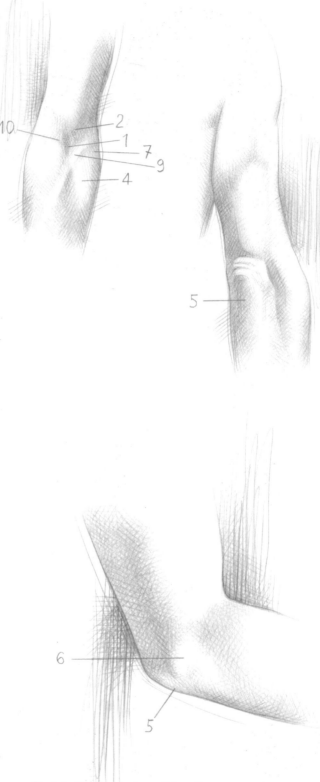

Sketch 47: Formation of the elbow

1 - Cubital pit and fold of the elbow
2 - Tendons of the biceps
3 - Group of extensor muscles
4 - Group of flexor muscles
5 - Ulna: olecranon
6 - Humerus: lateral epicondyle
7 - Humerus: medial condyle
8 - Ulna
9 - Median basilica vein
10 - Median cephalic vein

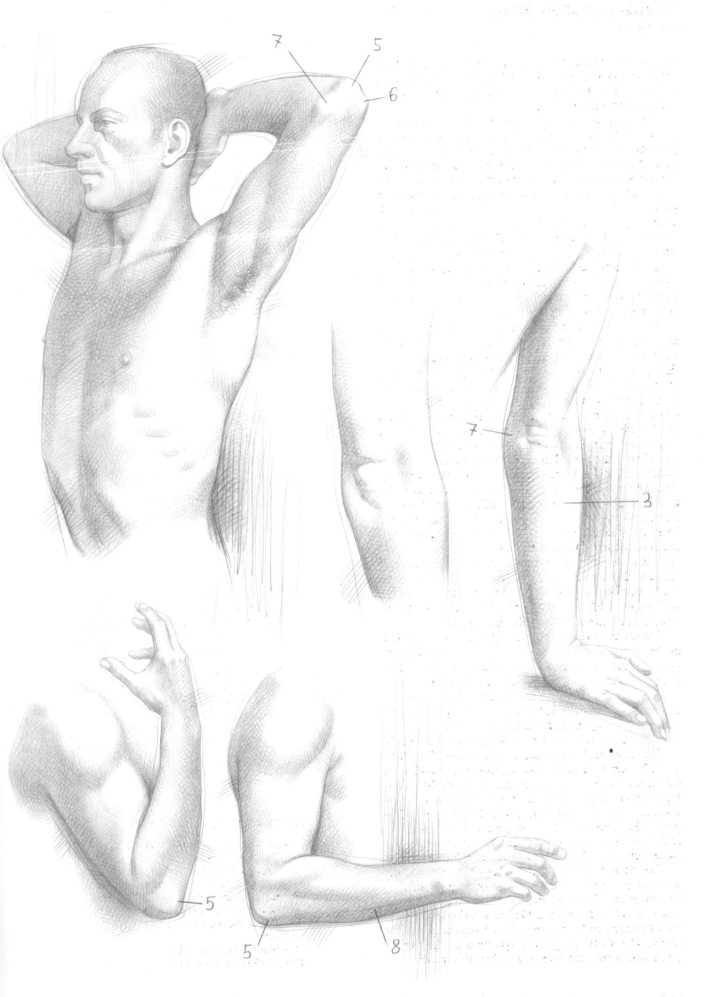

Morphology of the Forearm

(sketches 48–49)

The forearm is the segment of the upper limb compressed between the elbow and the wrist. Its external form varies notably, according to the movements of supination and pronation. Under these movements the radium places itself at the ulna, crossing it, provoking torsion of the muscles and the consequent modification of their projection.

In the anatomic position, the forearm has a flattened cone form in an anterior-posterior sense (while it can be noted that the arm is transversally flattened). It is more enlarged in the upper half, where the mass of most of the muscles of the region are situated. It tapers in the lower half, where it runs along the ulna and the radium, due to only the tendons of single muscles.

The anterior surface of the forearm is flattened. It is formed in the lower portion of two muscular projections separated by a weak longitudinally posted median hollow. Brachioradial muscles and long and short radial extensors of the carpus constitute the consistent and voluminous lateral projection.

Muscles of the anterior loggia constitute the more exiguous medial projection. They originate in the epitrochlea of the humerus. They are flexor muscles, which place themselves in the upper portion of the round pronator. The lower half of the anterior surface is flattened. In proximity of the wrist it shows the subtle longitudinal projections of the flexor tendons.

The fine and hairless skin of the ventral surface leaves the development of the superficial venous reticule visible (at times projected when the limb is pending along the trunk). Its position is subject to individual variation.

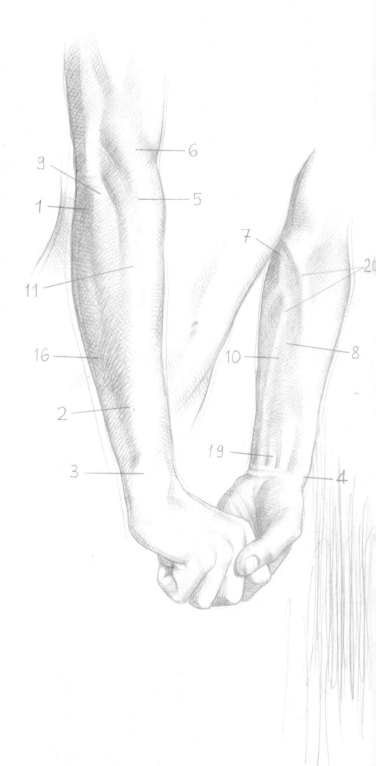

Sketch 48: *Formation of the forearm*

A - Forearm in supination
B - Forearm in pronation
C - Forearm in semi-pronation
D - Forearm in forced pronation

1 - Ulna: olecranon
2 - Ulna
3 - Ulna
4 - Radium
5 - Long radial extensor of the carpus
6 - Brachioradial
7 - Round pronator
8 - Radial flexor of the carpus
9 - Anconeus
10 - Long palmar
11 - Common extensor of the finger
12 - Long abductor of the pollex
13 - Short extensor of the pollex
14 - Long extensor of the pollex
15 - Extensor of the little finger
16 - Ulnar extensor of the carpus
17 - Ulnar flexor of the carpus
18 - Common superficial flexor of the finger
19 - Long tendon of the palmar
10 - Superficial veins

110

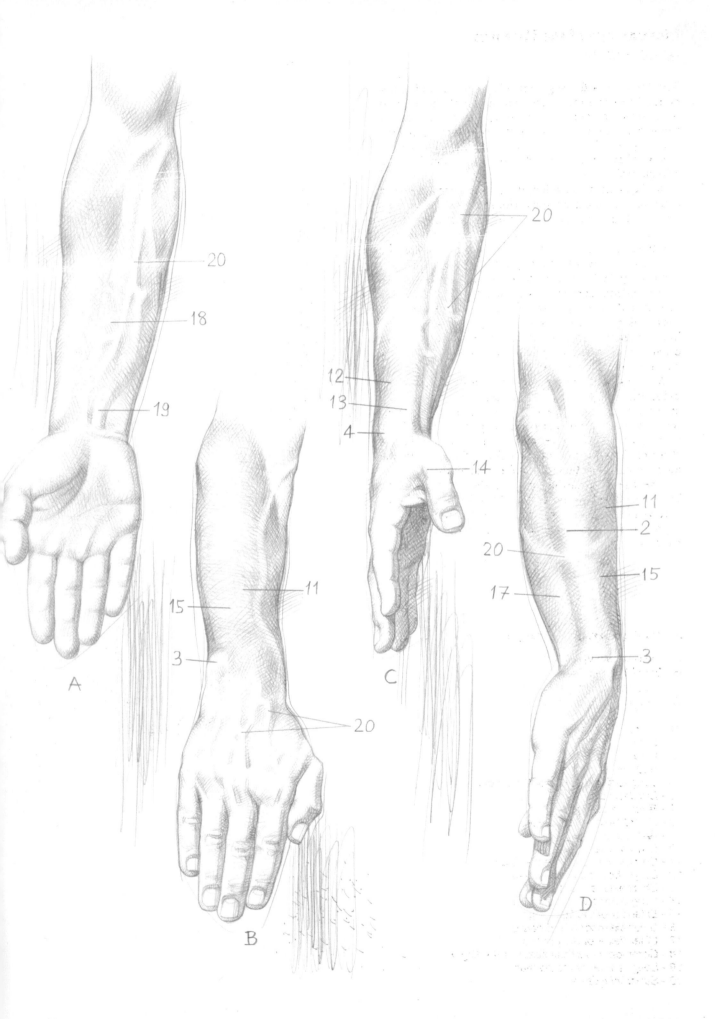

20

18

19

20

12
13
4

14

11

15

3

A

B

C

20

20

11
2

20

15

17

3

D

111

The posterior (or dorsal) surface of the forearm is flattened and only slightly curved. It is separated into two parts by the posterior margin of the ulna, which diagonally crosses under the skin. It determines a slight sulcus between the medial group of muscles (profound flexor of the finger covered by the ulnar flexor of the carpus) and the lateral group (extensor muscles of the posterior vault). The ulnar extensor of the carpus and the common extensor of the fingers are particularly visible during the strong extension of the fingers. The medial margin of the forearm has a uniformly rounded surface that delineates a slightly curved profile. It connects the anterior surface with that of the posterior without showing the distinct muscular projections. A tract of the basilica vein distances it.

The surface of the lateral margin is also rounded, but it is less regular because some muscles determine three long external convexities along its profile. The projection of the long and the short radial extensors of the carpus are noted in the upper portion, while the long abductor muscles and short extensor of the pollex are noted in the lower part. This tract runs obliquely in the cephalic vein.

The skin on the back of the forearm and the lateral margin is covered with long, fine hairs (more so in men) that extend on the medial margin. The anterior surface does not have any.

The feminine forearm has the same morphological characteristics as the masculine. However, the paired muscles are less accentuated, the surface is rounder, and the form is regularly cone-shaped. In the anatomical position, the longitudinal axis of the forearm, with that of the arm, determines an open obtuse angle. This angle is more accentuated in women (physiological elbow valgus). In the woman the extension of the forearm on the arm rejoins a more ample extension than that of the male (hyperextension), depending on the normal relaxation of the elbow joint ligaments.

Sketch 49: Aspects of the forearm in the male and female model

1 - Radium
2 - Cubital depression (pit)
3 - Ulna
4 - Tendons of the triceps
5 - Brachioradial
6 - Short radial extensor of the carpus
7 - Long radial extensor of the carpus
8 - Humerus: lateral epicondyle
9 - Ulna: olecrano
10 - Radium
11 - Common extensor of the fingers
12 - Ulnar flexor of the carpus
13 - Ulna: posterior margin
14 - Superficial flexor of the fingers
15 - Ulnar extensor of the carpus
16 - Long palmar
17 - Radial flexor of the carpus
18 - Round pronator
19 - Anconeus
20 - Long extensor of the pollex (tendons)
21 - Short extensor of the pollex
22 - Brachial
23 - Long palmar tendon
24 - Ulnar flexor of the carpus tendon
25 - Tendon of the radial flexor of the carpus
26 - Tendon of the ulnar flexor of the carpus

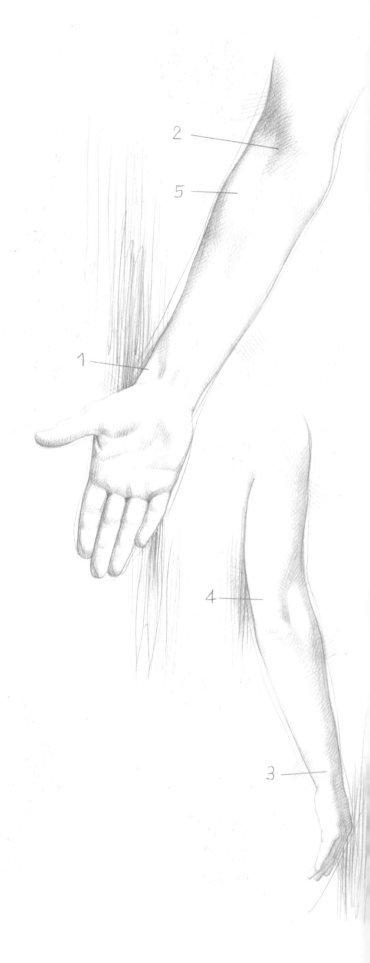

112

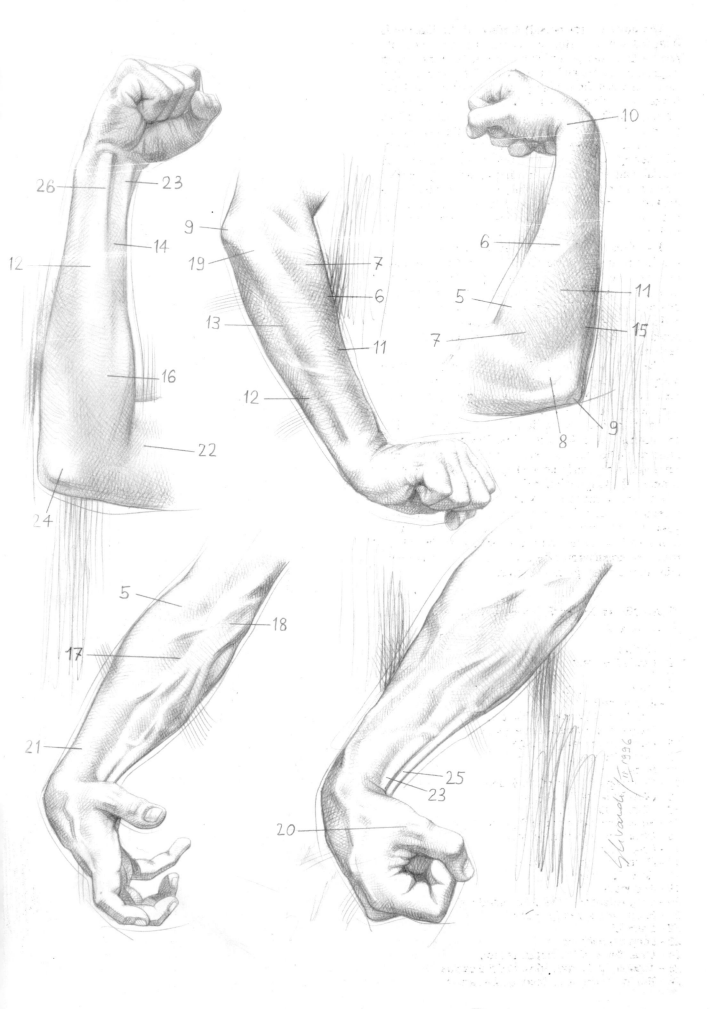

113

Morphology of the Wrist

(sketches 50–57)

The wrist, between the forearm and the hand, is made up of the lower extremity of the ulna and the radium, the first series of carpus bones, and the covering tissue. From the radium-carpus joint, it continues into the fore-arm with the same flattened cylindrical form. The dorsal surface is flat and medially projects the ulna. The exten-sor tendons of the fingers run on the surface, but are not visible due to adherent covering at the lower extremity of the radium. During maximum hand flexion, the wrist's dorsal surface becomes curved, causing the pro-jection of the radium, the scaphoid, and the semilunare.

The medial margin is rounded, but presents at times a slight depression between the tendons of the ulnar flexor of the carpus and the ulnar extensor of the carpus. The flanked tendons of the long abductor, the short extensor of the pollex, and the long extensor tendons of the pollex obliquely cross the lateral margin. The tendons of the long abductor and the short extensor of the pollex cross the lateral margin in the anterior position, while the long extensor tendons of the pollex cross in a more dorsal position. In the "anatomic snuff box" indentation formed, the radium is seen under the skin.

The anterior surface is developed longitudinally by the tendons and flexion action on the hand. The direc-tion of the tendons does not exactly follow the forearm axis, but is slightly oblique. The tendons visibly pair during the weak flexion of the hand. The long palmar posts on the median line of the wrist. It is subtler, being the only one running under the skin, and not covered by ligaments across the carpus. Across the lateral border the tendons of the radial flexor of the carpus are found. The tendons of the superficial flexor of the fingers and the ulnar flexors of the carpus pass across the medial border.

Sub-skin veins run along the wrist's anterior surface, along with skin folds of flexion. They are transversally disposed, almost horizontal but slightly concave across the upper portion. Two folds, near each other at the joint, are closely confined. A third, subtler crease is situated about one centimeter higher. The creases, like tendons, are distinctly delineated when the hand is in slight flex-ion. If the hand is in strong flexion, the small projection of the scaphoid is revealed in the compressed area between the visible terminal tract of the radial flexor of

Sketch 50: Formation of the Wrist

 1 - Ulna
 2 - Tendon of the ulnar flexor of the carpus
 3 - Hypothenar eminence
 4 - Thenar eminence
 5 - Abductor of the fifth finger
 6 - Skin crease of flexion
 7 - Pisiform
 8 - Radium
 9 - Tendon of the abductor of the pollex
10 - Scaphoid
11 - Tendon of the long palmar
12 - Tendon of the radial flexor of the carpus
13 - Tendons of the extensor muscles, covered by the
 third finger ligaments
14 - "Anatomic snuff box"
15 - Long extensor of the pollex (tendon)
16 - Short extensor of the pollex (tendon)
17 - Superficial vein

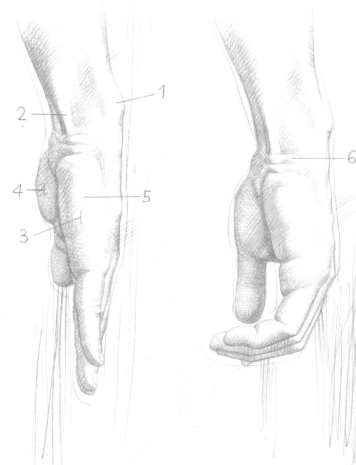

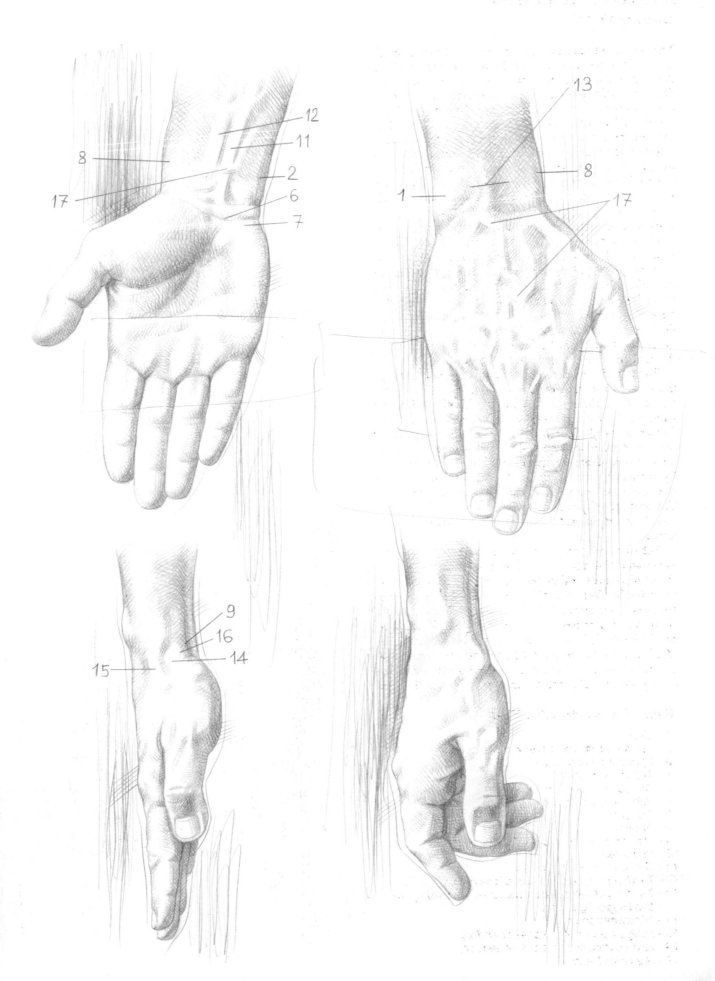

12

11

8

17

2

6

7

13

1

8

17

9

16

14

15

Morphology of the Hand

(sketches 50–56)

The hand is the terminal tract of the upper limb, succeeding the wrist. Its external morphology, above all relative to the dorsal tract, is largely influenced by the skeletal structure. It is distinguished in two sectors: the hand itself and the fingers.

The anterior surface of the hand, the palm, is slightly concave at the center while it is projected along the margin, caused by muscular formation and adipose.

The oblique lateral projection is situated at the base of the pollex. It has an ovoid form and is more voluminous. The muscles of the thenar eminence (short flexor, short abductor, abductor and opponent of the pollex) constitute the medial projection.

The medial projection is an elongated form, brought near the lateral in the proximity of the wrist. It extends onto the border of the hand, corresponding to the middle finger. It is made up of the muscles of the hypothenar eminence (abductor, short flexor, and opponent of the little finger). The projection of the head of the metacarpi, covered and flanked by fatty ovoid cushions, determines the transversal projection.

At the center of the hand the hollow of the palm surrounds these projections. The hollow is a permanent depression that accentuates flexing the fingers. It is determined by the adherence of the skin at the palmar aponeurosis, which completely covers the tendons of the flexor muscles of the fingers.

The skin of the palm is hairless and without visible superficial veins. It is developed by some characteristic creases, subject to individual variation. However, the flexion of the fingers and the abduction of the pollex constantly cause them. There are typically four palm creases or wrinkles, schematically positioned like the letter W: the pollex crease, that outlines the thenar eminence; the crease of the fingers, situated between the hollow and the transversal projection; the longitudinal crease; and the oblique crease, situated diagonally on the hollow of the hand. Other numerous and various

Sketch 51: *Formation of the hand*

1 - Long extensor of the pollex
2 - Long abductor of the pollex and short extensor of the pollex
3 - "Anatomical snuff box"
4 - First metacarpus
5 - Tendon of the common extensor muscles of the fingers
6 - Tendon of the extensor muscles of the index finger
7 - Dorsal ligament of the carpus (retinaculum of the extensors)
8 - Ulna
9 - Radium
10 - Palmar crease
11 - Crease of the pollex
12 - Transversal crease and projection
13 - Head of the metacarpus bone
14 - Phalange crease
15 - First inter-bone muscle
16 - Muscle of the thenar eminence
17 - Muscle of the hypothenar eminence
18 - Tendon of the flexor muscles, covered by the palmar aponeurosis

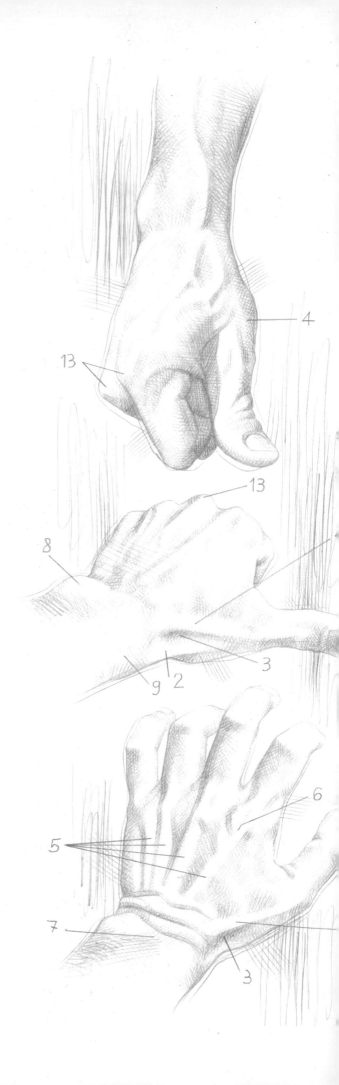

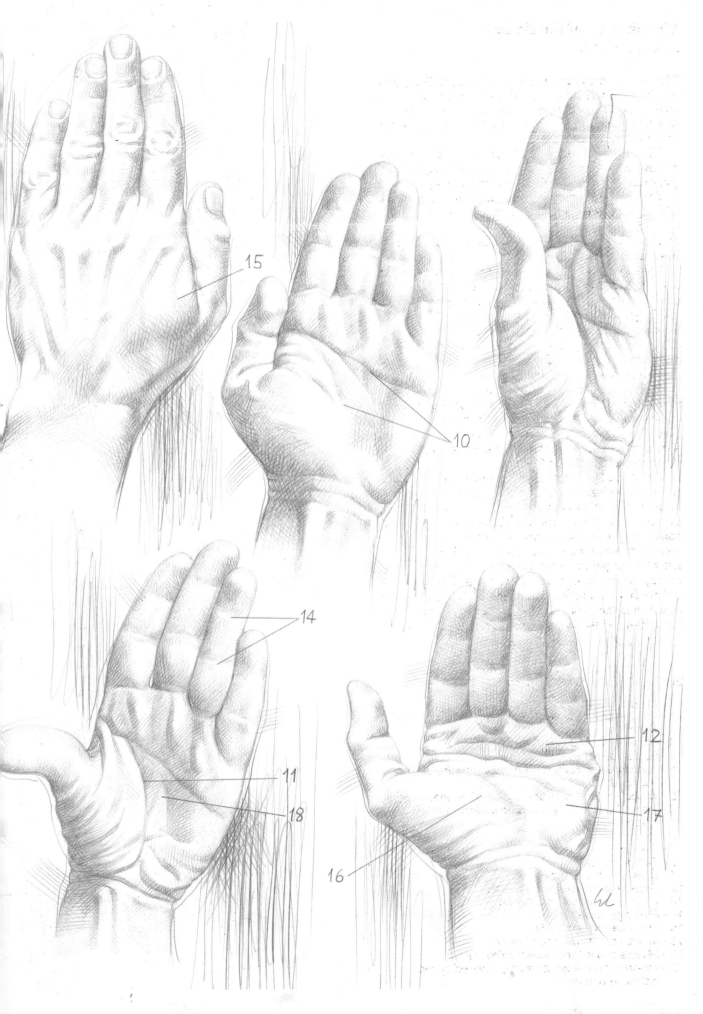

15

10

14

11

18

12

17

16

sulci form occasionally, following the movement of the fingers.

The medial margin of the hand is rounded due to the hypothenar eminence muscle. More specifically, in the proximal tract at the wrist, it is tapered towards the root of the little finger.

The lateral margin is occupied in the upper portion by the base of the pollex, while the lower free portion corresponds to the metacarpus-phalange joint of the index finger. Between the two portions of the margin are the gross skin creases, where the abductor muscles of the pollex are in part contained.

The dorsal surface of the hand is more curved and modeled on the bone structure, which is visible but not noticed overall except for the head of the metacarpus. Some tendons of the extensors of the finger run on the head of the metacarpus and are especially projected during maximum extension. There are two flanking tendons at the index finger. The common extensor of the fingers is posted laterally and the extensor of the index finger is posted medially. The skin of the dorsal side of the hand easily runs on the underlying planes and is more moveable than that on the palm. The back of the hand almost always has no fatty tissue. It is strewn with hair (especially in men), and visible reticular veins (of variable courses) run through it.

The five fingers have an approximately cylindrical form. They originate in the transversal distal margin of the hand.

The first finger (the pollex) has only two free segments. Each of the other fingers is made up of three free segments, jointed between and corresponding to the phalanges.

The dorsal surface of the fingers follows the bone formation. It is rounded and slightly curved. Abundant transversal skin creases interrupt the dorsal surface in correspondence to the joints. The joints are present at the first and second phalange, with some random hairs (especially in men).

Sketch 52: Some morphological aspects of the male hand

1 - Radium
2 - Ulna
3 - Hypothenar eminence
4 - Thenar eminence
5 - Scaphoid
6 - Pisiform
7 - Tendons of the extensor muscles
8 - Superficial veins of the back of the hand
9 - Tendon of the long extensor of the pollex
10 - Dorsal skin creases (projected and in abundance) between the first and second phalange
11 - Dorsal skin crease (flattened) between the second and third phalange
12 - Skin crease of flexion between the second and third phalange
13 - Creases of flexion (doubled) between the first and second phalange
14 - Inter-finger skin creases
15 - First dorsal inter-bone muscle and abductor muscle of the pollex
16 - Tendon of the ulnar flexor muscle of the carpus
17 - Tendons of the flexor muscles (covered by the palmar aponeurosis)

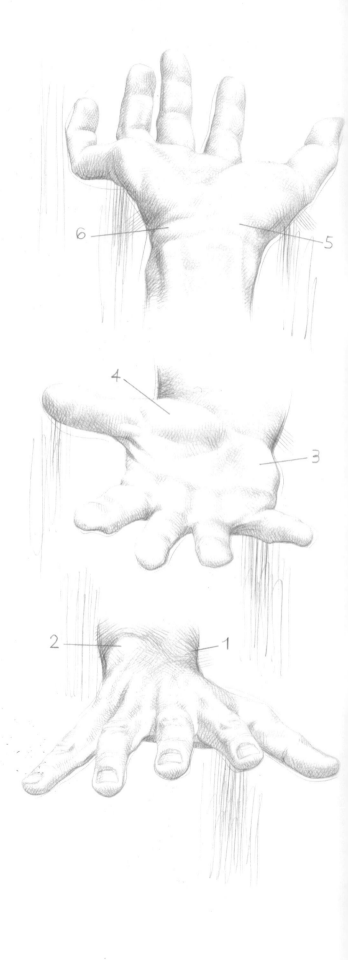

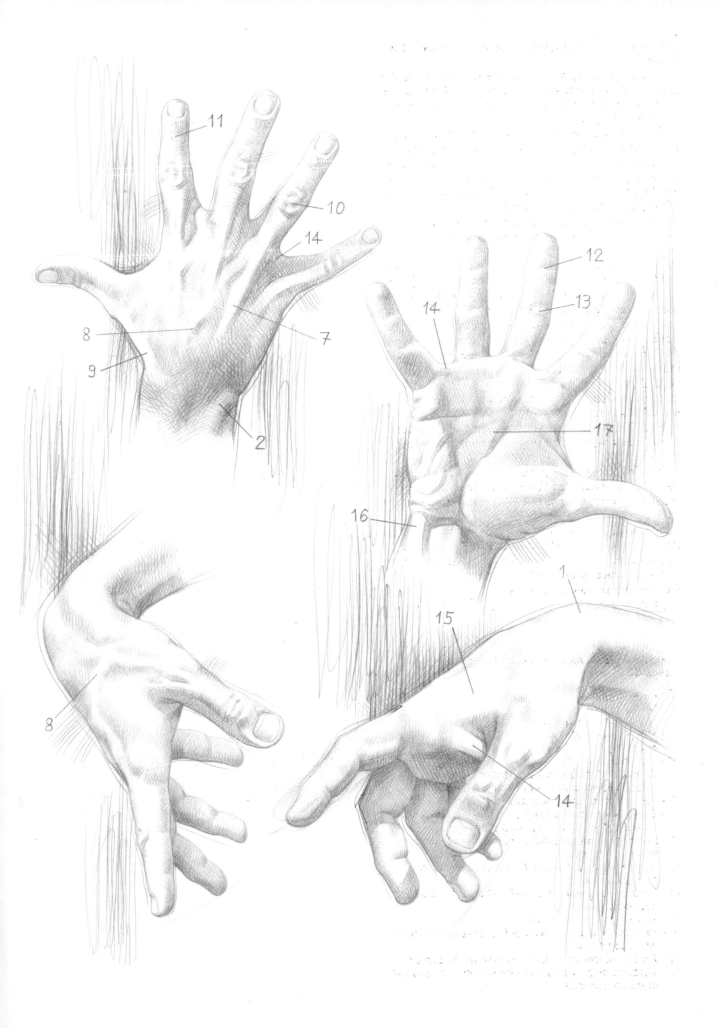

On the back of the third phalange, the presence of the nail is characteristic. The nail is a laminate skin annexation of quadrangular or elliptical form. It is slightly curved transversally and occupies half the length of the phalange. A three-sided skin projection that is easily observable in life surrounds the nail. The thumbnail is always larger in dimension in respect to the others. The nails are proportionate in size to the finger to which they belong.

With the exception of the pollex (thumb), which has its own characteristics and is formed by only two phalanges, each finger is a different length. This is caused by the diverse levels of origin of each finger due to the head of the metacarpus, which follows a curved line at the base.

The third finger (middle finger) is usually the longest, followed by the fourth (ring finger), the second (index finger), and the fifth (little finger). Comprehensively, these four fingers pair longer on the dorsal surface than on that of the palm. On the palm, the transversal distal rejoins half of the first phalange, formed by the creases of the inter-finger union.

The volar surface of the fingers is divided into three curved sectors. They are made up of fatty cushions separated by flexion. The two distals correspond exactly to the relative joints. The upper forms near the half point of the first phalange. The creases are doubled or formed by two fine parallel lines, while the crease between the second and third phalanges is usually single.

The projection of the last phalange, or ball of the finger, has an ovoid form. Its skin is creased by an individually characteristic epidermal crest (fingerprint).

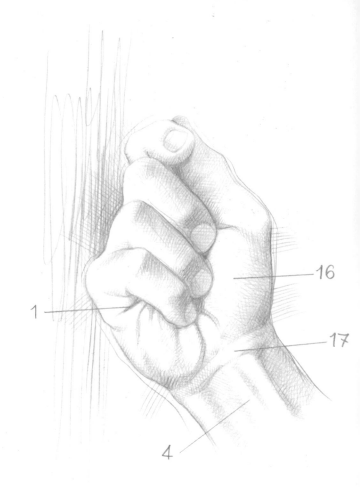

Sketch 53: Morphological aspects of the tightly fisted male hand

1 - Medial extremity of the transversal palmar crease
2 - Crease of the pollex
3 - Tendon of the ulnar flexor of the carpus
4 - Tendon of the long palmar muscle
5 - Ulna
6 - Tendons of the superficial flexor muscles of the fingers
7 - Abductor of the fifth finger
8 - Tendon of the radial flexor of the carpus
9 - Pisiform
10 - The dorsal skin creases of the finger stretch during flexion and the sulci formed by the inter-finger creases obliquely terminate directly toward the ateral border of the back of the hand
11 - Tendons of the extensor muscles of the finger
12 - The curvature of the back of the hand becomes accentuated and the index finger slightly protrudes in respect to the other fingers
13 - Nail (laminate ungual)
14 - Lunula
15 - Vallo ungual
16 - Thenar eminence
17 - Flexion crease of the wrist

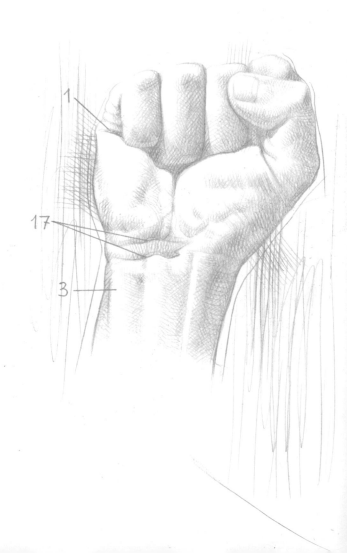

120

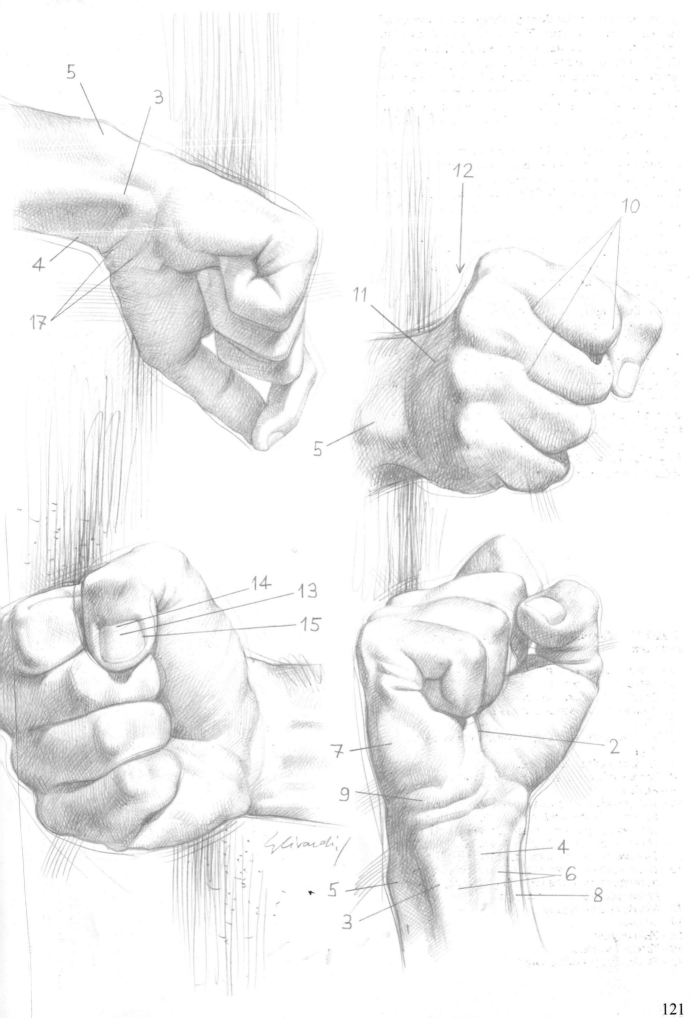

121

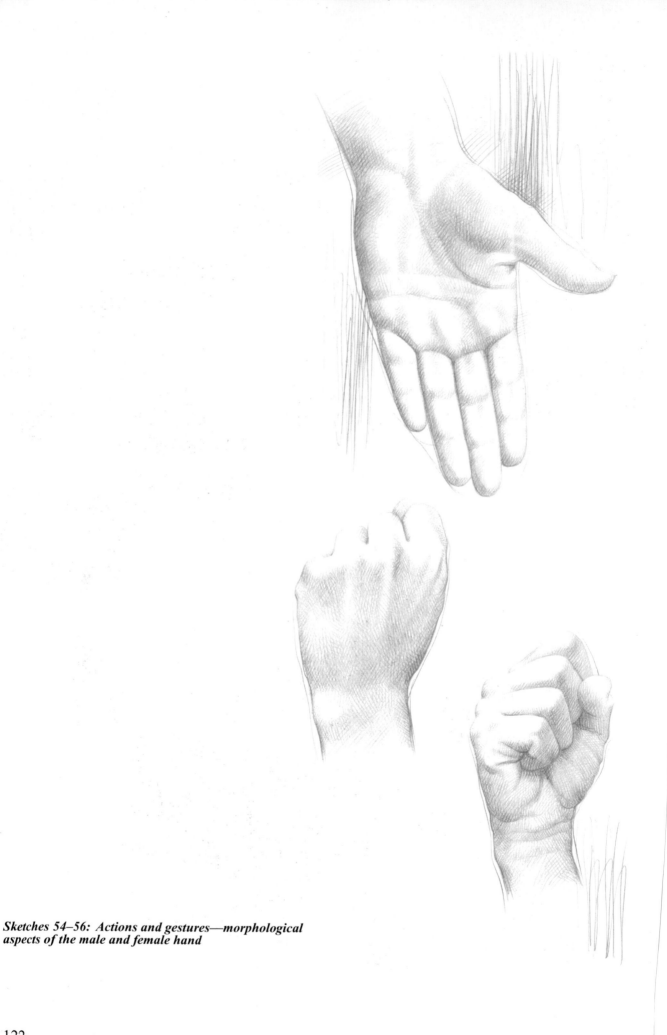

*Sketches 54–56: Actions and gestures—morphological
aspects of the male and female hand*

122

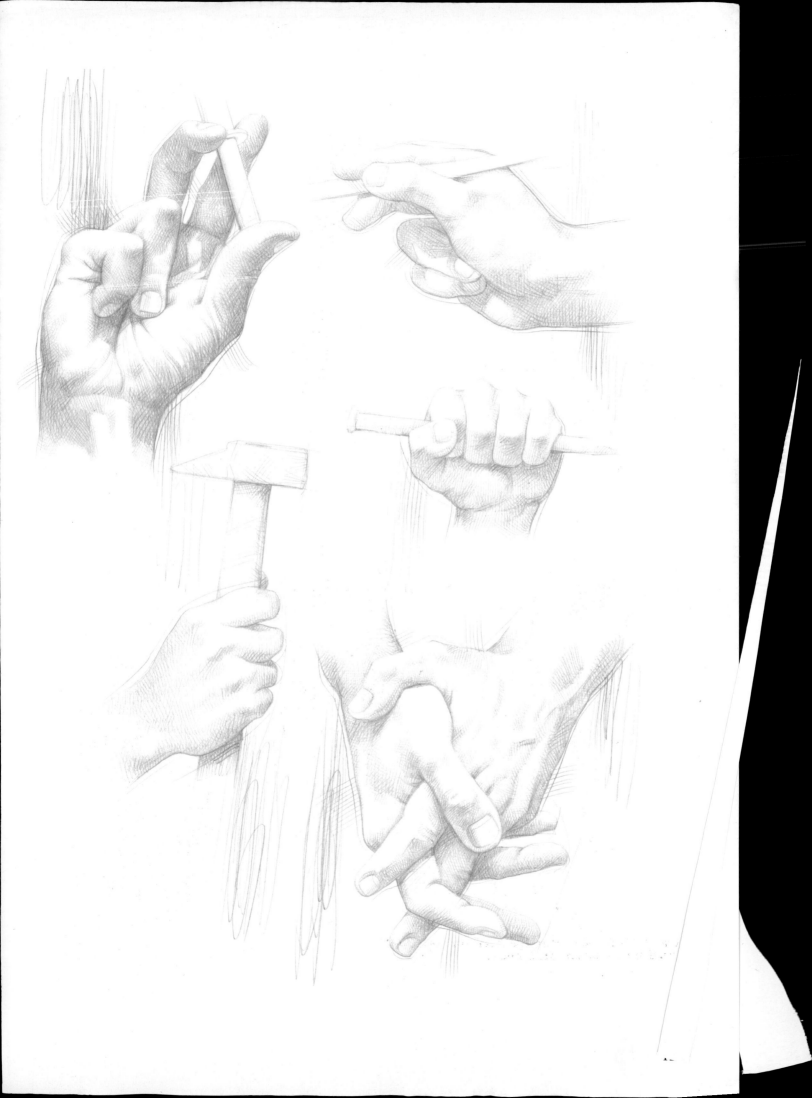

The Lower Limbs

(sketches 57–69)

Sketch 58: Principal regions of the lower limb

A - Iliac
B - Trochanter
C - Anterior femur
D - Lateral Femur
E - Anterior of the knee
F - Kneecap
G - Lateral of the knee
H - Lateral of the leg
I - Anterior of the leg
K - Back of the foot
L - Digital
M - Sub-inguinal
N - Medial femur
O - Medial of the knee

P - Medial of the leg
Q - Anklebone of the leg
R - Sacrum
S - Gluteus
T - Posterior of the knee
U - Posterior of the leg
V - Heel
Z - Posterior femur
W - Back of the knee
J - Lateral ankle bone
Y - Plantar
X - Lateral back of ankle
 bone
XX - Genitals

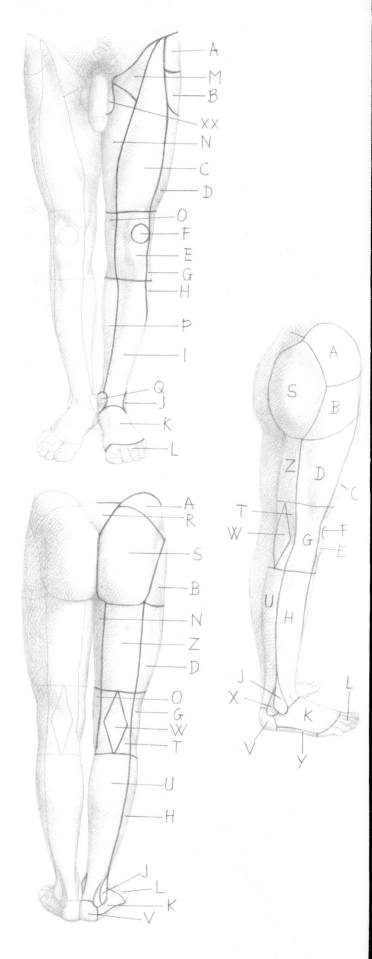

External Morphology

(sketches 57–60)

The lower limbs, equal and symmetrical, are attached at the lower part of the trunk. Each limb is made up of a free portion (thigh, leg, and foot) jointed with the pelvis at the hip and the gluteus region (see page 44).

The general constructive plane is similar to that of the upper limb. However, certain gross muscles are present, mainly the gluteus, which leads towards the first free segment, the thigh. The gluteus contributes to the curved posterior formation of the buttocks, due to the notably developed muscular mass that intervenes in the maintenance of the erect position (orthostatic position). The lower limbs have a static function in the erect position and a locomotive one during mobilization.

The thigh has a conic form, the larger base bending sharply in the upper part. It is slightly flattened on the lateral surface, but raised a bit in the intermediate portion. It holds directly to the trunk, forming an inguinal crease. The muscles are disposed around the only bone, the femur. They are divided into three functional groups: anterior, medial, and posterior. When a subject is in the anatomic position, the thigh's vertical axis is straight.

The lower leg conjoins at the thigh by the knee joint. It has a tapered cone form. In the upper portion, on the lateral and posterior surfaces, it is curved. However, the leg appears narrow towards the foot. The muscles are disposed around two parallel bones, the tibia and the fibula. They can be separated into an anterior-lateral

Sketch 57: Formation of the male lower limb

1 - Large trochanter
2 - Kneecap
3 - Head of the fibula
4 - Anterior tubercle of the tibia
5 - Lateral ankle bone (fibula)
6 - Medial ankle bone (tibula)
7 - Anterior tibia muscle
8 - Lateral twin
9 - Femur biceps: long head
10 - Quadriceps: vast lateral
11 - Quadriceps: vast medial
12 - Quadriceps: recto-femur

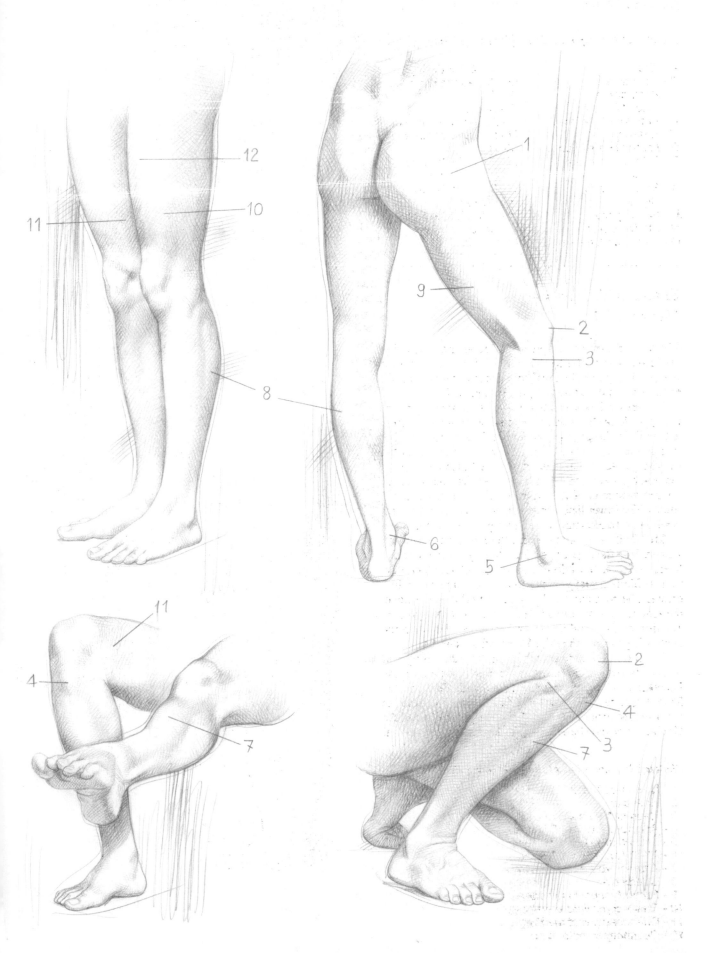

129

and posterior group. The foot is the terminal part of the lower limb. Contrary to the hand, the foot does not prolong the longitudinal axis of the limb. The foot attaches in a right-angle at the heel.

The form of the foot is arched and curved on the dorsal surface. It is concave on the medial margin of the plane, a sector that corresponds to the bones of the tarsus and metatarsus.

The phalanges of the toes constitute the distal tract of the foot, which is usually flattened and enlarged.

Notes on Osteology

The skeleton of the lower limbs repeats the regulating plane of the upper limbs. It is formed by an attachment at the skeletal axis (the pelvis, see page 44) and the bones that compose the free part. They are: the femur, or bone that corresponds to the upper leg and is annexed at the kneecap; the tibia and fibula, which corresponds to the lower leg; and the tarsus, metatarsus, and phalanges, which correspond to the foot.

The femur is the most robust and voluminous long bone of the human skeleton. The diaphysis, which has a moderate curvature in an anterior-posterior direction, presents three facets. These facets are the anterior curved lines, the more leveled and posteriorly convergent laterals in a longitudinal crest (rough line). The proximal epiphysis is characterized by the presence of a spheroid formation (head of the femur, which joins with the pelvis by inserting itself in the acetabulum cavity) connected at the diaphysis, for the path of the femur neck at the base. Here two projections of unequal volume (the large and small trochanters) are revealed.

The distal epiphysis is very large. It has two lateral projections (medial condyle and epicondyle, lateral condyle and epicondyle), which are separated by a profound indentation.

The kneecap is a short bone. It is formed by an irregular disc, which is slightly flattened in the lower portion and of various densities. It is situated between the femur and the tibia and contained in the tendon of the quadricep muscle.

The tibia is medially situated in the lower leg. It is a long column-shaped bone with a large upper epiphysis and a smaller lower epiphysis. The diaphysis appears to be formed by three facets that are united by a clear margin. The anterior-medial surface is subcutaneous

Sketch 58: Some morphological aspects of the male lower limb

1 - Sartorius
2 - Recto-femur
3 - Wide fascia
4 - Vast lateral
5 - Vast medial
6 - Kneecap and kneecap tendon
7 - Head of the fibula
8 - Lateral twin
9 - Medial twin
10 - Soleus
11 - Anterior tibia
12 - Long peroneal
13 - Femur biceps
14 - Semitendonous
15 - Semimembranous
16 - Gracilis muscle
17 - Heel tendon (Achilles tendon)

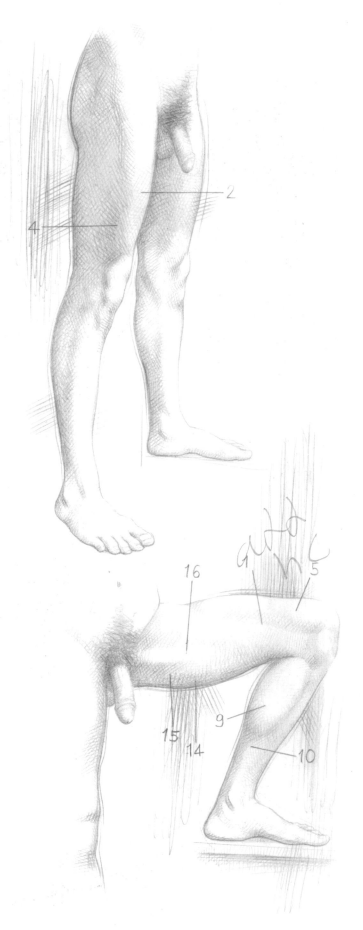

130

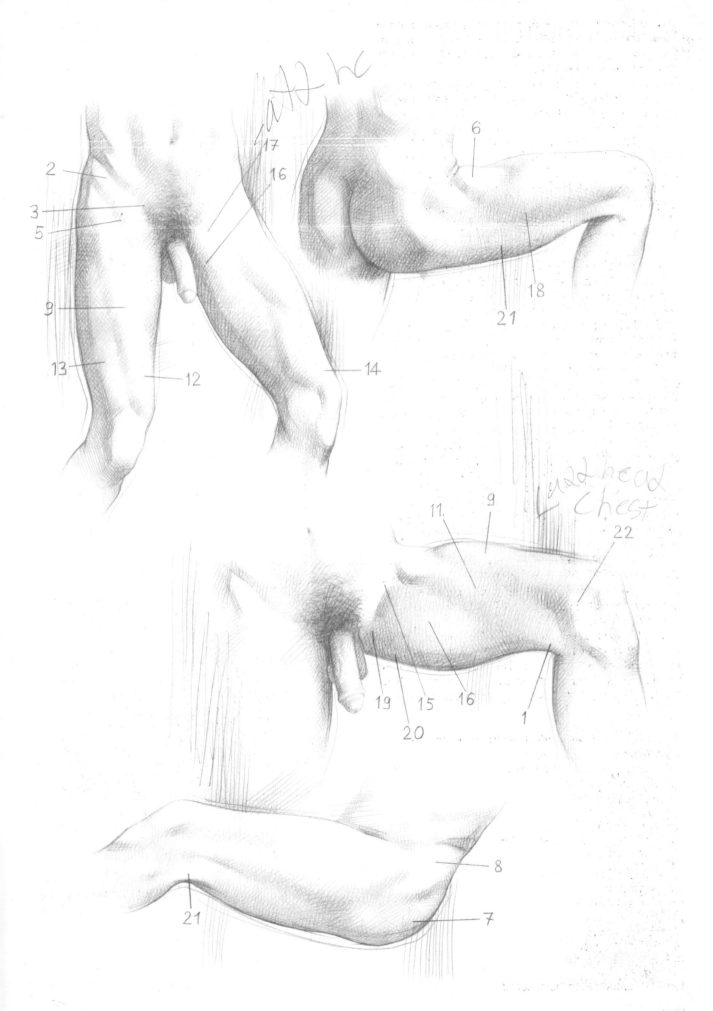

137

structure. It is situated on the median portion of the anterior surface of the thigh and follows the anterior curvature of the femur, delineating the convex profile of the thigh and shading on the lateral surface.

The vast medial occupies the lower medial portion of the anterior surface. The upper potion of its ovoid projection confines the recto-femur and the sartorius. The lower portion extends to the level of the kneecap. The vast lateral flattens in its lower tract and terminates several centimeters above the knee.

The sartorius is a long, ribbon-like muscle. Its contraction determines a slight depression, which diagonally crosses the thigh. Descending from the upper anterior iliac spine, it is brought to the level of the lower third of the thigh and outlines the posterior portion of the vast medial.

The projection of the group of adductor muscles constitutes the upper portion of the anterior-medial surface of the thigh. They are projected across the median line until coming in contact with the contralateral group. On the surface the adductor muscles are not individually distinguished, but they form a compact mass that gradually continues on the posterior surface of the thigh. This defines the upper portion of the gluteus crease and extends from the medial surface at the lateral sulcus. It has a round form on the sides and a slightly leveled form on the median axis. It is constituted prevalently by two paunches of the femur biceps. They are reduced in volume and terminate at the posterior surface margins of the knee. Two slightly divergent projections define the back of the knee area.

The terminal tract of the biceps, the medial projection of the gracilis muscle tendon, and the semimembranous and semitendonous tendons make up the lateral projection.

The subcutaneous fatty tissue renders the thigh uniformly rounded, especially in the woman. In women, the characteristic deposits are localized laterally in the upper tract, just below the large trochanter. Medially they are localized in the lower portion. Often, in men, the thigh is covered by a dense region of hair.

Sketch 62 : Formation of the female thigh

 1 - Sub-trochanter fatty deposit
 2 - Fatty deposit above the kneecap
 3 - Upper anterior iliac spine
 4 - Inguinal crease
 5 - Pubes
 6 - Femur depression
 7 - Back of the knee hollow
 8 - Tensor of the broad fascia
 9 - Large trochanter
10 - Gluteus maximus
11 - Recto-femur
12 - Sartorius
13 - Vast medial
14 - Vast lateral
15 - Tendon of the quadricep (kneecap)
16 - Pectineal
17 - Large adductor
18 - Gracilis
19 - Femur biceps
20 - Medial femur condyle
21 - Lateral femur condyle

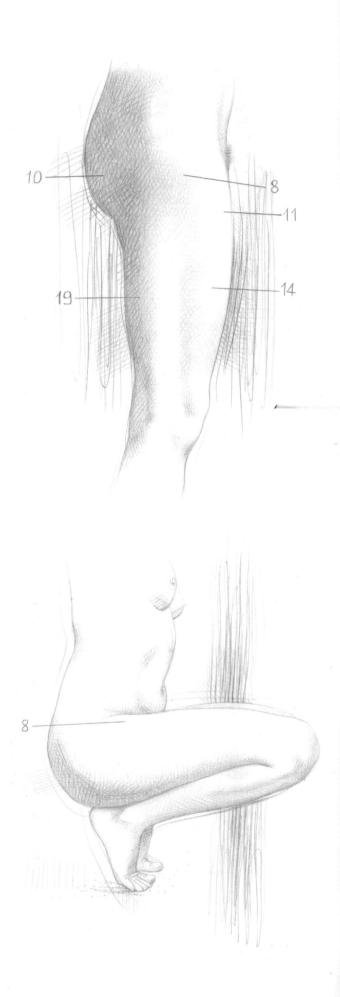

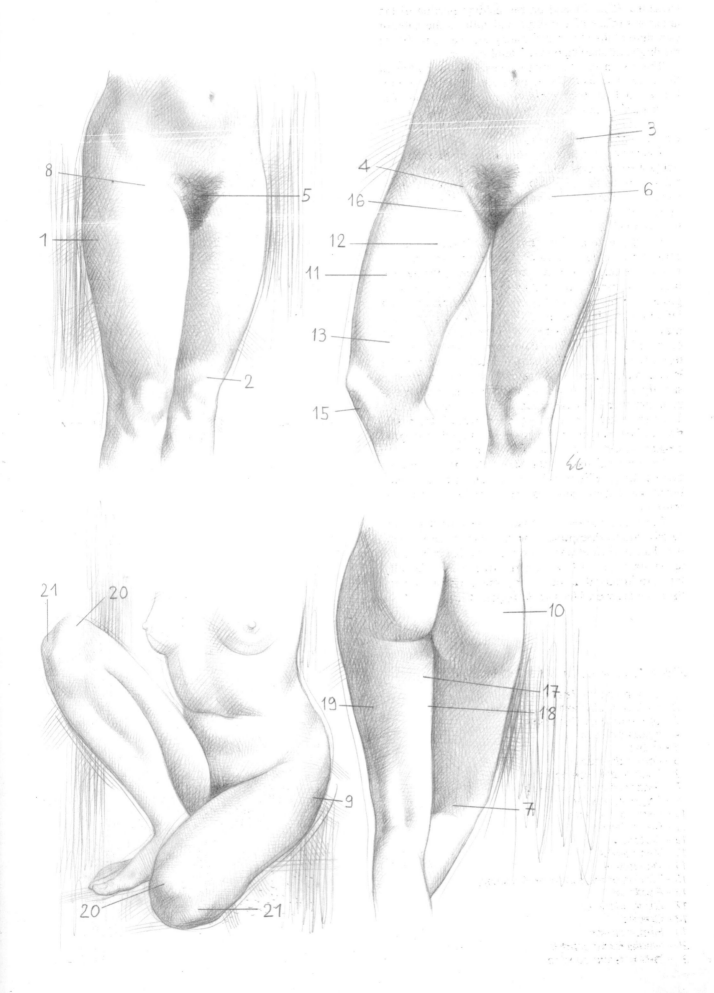

139

Morphology of the Knee

(sketches 63–64)

The knee is the tract of the lower limb that conjoins the thigh and the lower leg without precise natural limits. It corresponds to the homonymous joint between the femur and the tibia. Its approximately cubical form is determined by the underlying bone structure (the femur condyles, the heads of the tibia and the pelvis, and the kneecap) on which stratify the pliable tissue of the tendons and muscles. The muscular portions are aponeurosis formations and subcutaneous fatty tissue. The external morphology of the knee undergoes noticeable modifications, depending on the movements of flexion. It presents very diverse anterior (kneecap region) and posterior (back-of-the-knee region) aspects.

In the anatomic position, the anterior surface of the knee presents the central projection of the kneecap. The kneecap is defined on the sides by the two dimples, which continue to flank the lower portion of the gross kneecap tendon. This is the tendon of insertion of the quadricep on the tuberosity of the tibia. It is very visible when the muscle contracts a moderate flexion of the leg. In a state of repose it is flanked by two slight projections due to a small fatty mass that reascends to the kneecap. An oblique or transversal abundant skin crease can furrow it. A leveled area extends the upper portion of the kneecap and corresponds to the quadricep tendon. It is laterally defined by the vast lateral and the ileum-tibia tract of the broad fascia, while medially defined by the vast medial. The diverse volumes and levels at which the two paunches of the quadricep arrive determine the asymmetrical profile of the knee. The less convex lateral margin is made up of the tapered lower portion of the vast lateral and its tendon. The amply convex medial margin is made up of the vast medial, which with its fleshy mass extends to almost the level of the kneecap.

The external surface corresponds to the vast medial. A slight oblique depression crosses it in a position of repose. The depression is provoked by the subcutaneous presence of fibrous sinew that proceeds from the aponeurosis fascia that covers the thigh.

Sketch 63: *Formation of the knee in the male and female*

 1 - Kneecap
 2 - Medial femur condyle
 3 - Lateral femur condyle
 4 - Head of the fibula
 5 - Anterior tuberosity of the tibia
 6 - Peri-kneecap fatty tissue
 7 - Fatty tissue above the kneecap
 8 - Kneecap tendon (by the quadricep muscle)
 9 - Recto-femur
10 - Vast medial
11 - Vast lateral
12 - Tendon of the femur biceps
13 - Expansion of the gracilis tendons, semimembranous, semitendonous, sartorius
14 - Back-of-the-knee fatty deposit
15 - Back-of-the-knee crease
16 - Medial tibia condyle
17 - Broad fascia
18 - Semimembranous and semitendonous tendons
19 - Lateral head
20 - Medial head

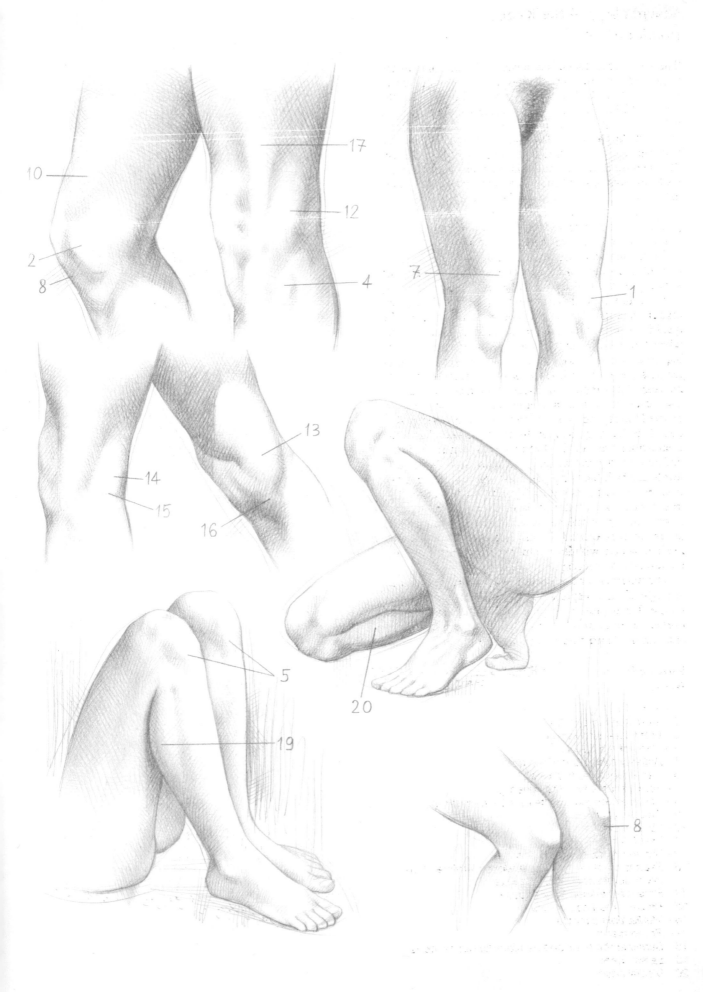

141

The flexion of the lower leg produces noticeable modifications in the external morphology of the anterior surface of the knee. This is due to the placement of the kneecap between the femur condyles and their gradual projection.

During the erect position, the posterior region of the knee is less convex and presents a weak longitudinal projection. This corresponds to the back-of-the-knee lozenge, a rhomboid-shaped area. The area is defined in the upper portion by the bellies of the biceps and the semimembranous, while on the sides of the respective tendons and in the proximal portion it is defined by the plantar. Neural-vascular facets run through the circumscribed region. The spaces are filled by fatty tissue, which determines the external projection of the area. Two slightly longitudinal solci flank the area. The lateral is clearer, following the tendon of the biceps and rejoining at the lateral sulcus of the thigh. The medial is more shaded and continues with the sartorius depression, describing a concave anterior line.

A skin crease of flexion corresponds at the articular connection. It obliquely crosses the back of the knee projection in the lower portion and across the medial margin. During the flexion of the leg, the back-of-the-knee region changes to a profound hollow. The area is defined by the projection of the thigh muscle tendons, which are elongated by the femur during the movement. Laterally, the tendons of the biceps elongate the thigh muscle tendons, and, medially, the gracilis tendons, and semimembranous, and semitendonous tendons also.

The upper portion of the lateral surface of the knee is outlined by the lower portions of the vast lateral and the biceps and is modeled on the bone structure of the knee. The ribbon-like projection of the ileum-tibia tract of the broad fascia runs along the projections of the femur lateral condyle and the head of the pelvis. In the posterior portion the lower tract of the lateral sulcus of the thigh separates the tendon of the biceps.

The medial surface of the knee is rather rounded and convex. It is formed by the lower portion of the vast medial, the slight depression of the sartorius, the dimples that medially skirt the kneecap, and the group of tendons (gracilis, semimembranous, semitendonous). The lower portion continues to shade on the tibia plane.

Sketch 64: Formation of the male and female knee

1 - Kneecap
2 - Medial femur condyle
3 - Lateral femur condyle
4 - Head of the fibula
5 - Peri-kneecap fatty tissue
6 - Fatty tissue above the kneecap
7 - Kneecap tendon
8 - Recto-femur
9 - Anterior tubercle of the tibia
10 - Vast medial
11 - Vast lateral
12 - Tendon of the femur biceps
13 - Back-of-the-knee fatty deposit
14 - Back-of-the-knee crease
16 - Medial tibia condyle
17 - Semimembranous and semitendonous tendons
18 - "Goose leg"
19 - Lateral head
20 - Medial head

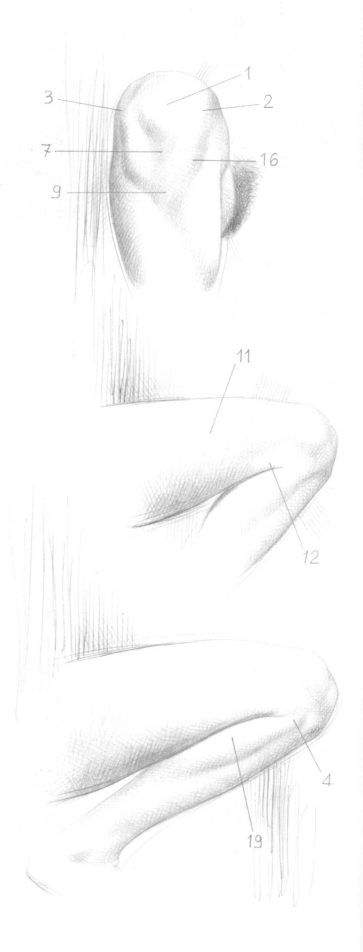

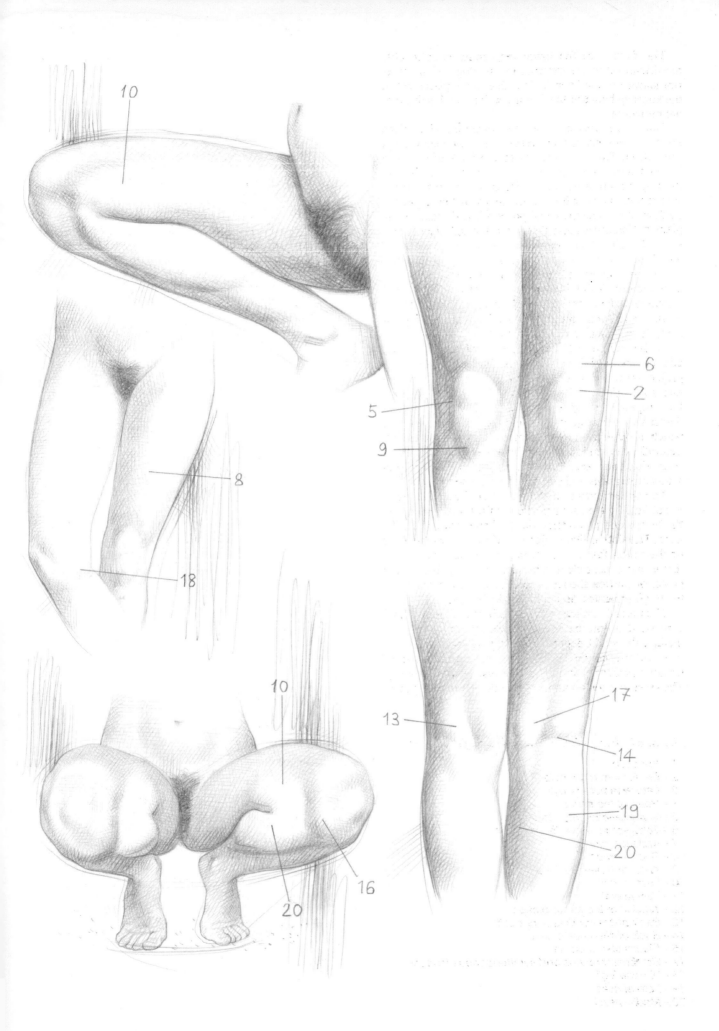

143

Morphology of the Lower Leg

(sketches 65–66)

The lower leg is compressed between the knee and the ankle. It has a conal or somewhat pyramidal form. The upper portion is enlarged, where the paunch is situated and narrow at the bottom, where the tendons are located. The skeletal structure is made up of the tibia and the fibula. It is covered by muscles on three sides only. The medial surface of the lower leg is subcutaneous and its form determines a longitudinal depression, which renders the anterior-medial surface somewhat flattened.

The rounded convex anterior-lateral surface begins in a lateral direction at the anterior margin of the tibia. Its complex projection is part of the muscle group of the anterior loggia. In the front, the bellies of the anterior tibia border a small part of the margin of the anterior tibia in the upper two thirds of the lower leg. The tendons of the anterior tibia, however, run medially on the lower third. The tendons of the long extensor muscles of the toes and the peroneal muscles outline the malleolus of the fibula. Particularly during contractions, they determine the variable internal projection or depression. The line that skirts the lateral border of the soleus conjoins the head at the malleolus of the fibula. The line indicates the posterior limit of the lateral surface, which passes across the posterior region. This is made up of the calf triceps. The calf triceps are two heads that are positioned under the soleus (forming the calf). They continue in the common tendon (Achilles or calcaneal).

The convex posterior surface of the lower leg begins with the slight flattening of the lower portion of the popliteal diamond. It is outlined by the medial margins of the two "twins," and follows the strong projection of the calf. The medial twin is more voluminous and descends lower than the lateral twin. In a state of repose, their lower extremities are ideally linked by one

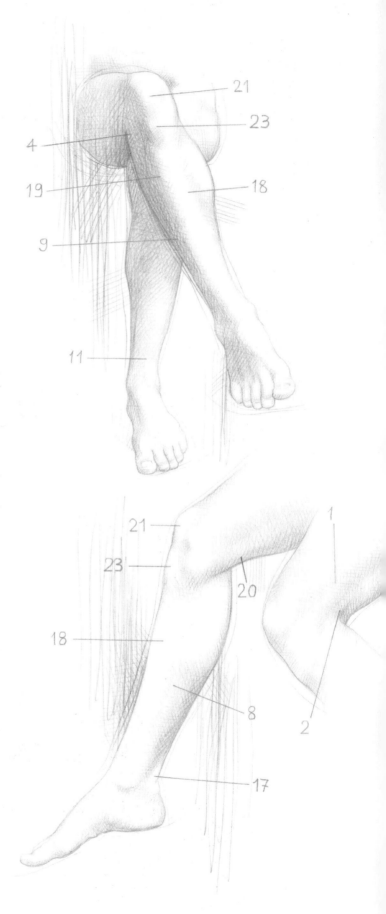

Sketch 65: *Formation of the male leg*

1 - Broad fascia (ileum-tibia tract)
2 - Femur biceps tendon
3 - Back of the knee (occupied with fatty tissue)
4 - Lateral tibia condyle
5 - Long peroneal
6 - Medial heads
7 - Lateral head
8 - Soleus
9 - Long extensor of the toes
10 - Short peroneal
11 - Extensor of the big toe
12 - Head of the fibula
13 - Lateral malleolus
14 - Medial malleolus
15 - Long peroneal tendon
16 - Short peroneal tendon
17 - Calcaneal tendon
18 - Tibia
19 - Anterior tibia
20 - Semitendonous tendon
21 - Kneecap
22 - Surface vein (small saphena)
23 - Anterior tibia tubercle

144

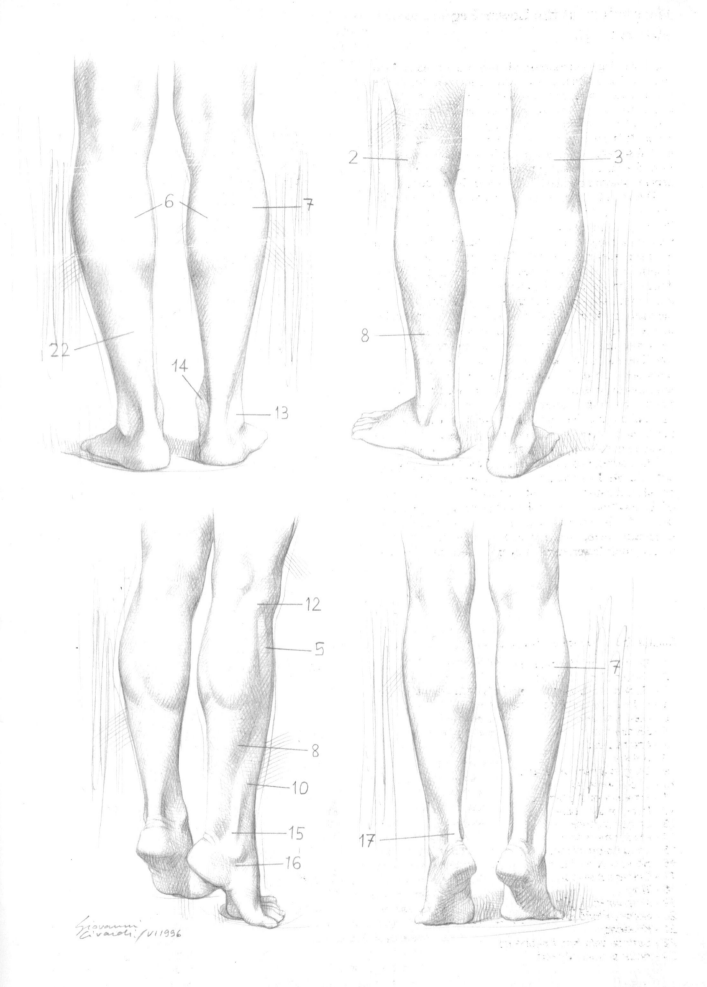

direct oblique line. It delineates a diverse profile of the sides of the lower leg. The medial appears convex in the upper half, while it becomes more recto-linear and somewhat concave in the lower portion. Many dark-haired populations present the inverse relationship of the two twins: they are tapered and the lateral is slightly more elongated than the medial.

During muscular contraction, the margins of the soleus are bordered by the pair at the sides of the lower leg. The lower margins of insertion on the tendons of the two twins forms an arched concave line along the upper portion.

At the bottom of the projections of the two heads extends a triangular area. The area is narrow in the lower portion and less convex than the calcaneal tendon. The muscular insertions of the soleus flank the upper portion of the area. These insertions can terminate from some distance of the malleolus, varying individually. This evidences the retromalleolar dimples and the ribbon-like projection of the tendon. It can also descend further down, reducing the amplitude of the dimples and rendering the tendon less projected.

The medial twin and the medial margin of the soleus constitute the medial surface of the lower leg. Medially a convex line confines with the tibia and the anterior-medial surface.

The skin of the lower leg is covered with hair, especially in men. Two surface veins run along the surface. The large saphena runs on the medial surface. The small saphena runs across the posterior surface into the soleus between the two twins. Collateral borders that pair at times in the lower half of the lower leg link them.

Sketch 66: *Aspects of the male and female lower leg*

1 - Broad fascia
2 - Femur biceps tendon
3 - Head of the fibula
4 - Lateral tibia condyle
5 - Long peroneal
6 - Medial head
7 - Lateral head
8 - Soleus
9 - Long extensor of the toes
10 - Short peroneal
11 - Short extensor of the toes
12 - Lateral malleolus
13 - Medial malleolus
14 - Long peroneal tendon
15 - Short peroneal tendon
16 - Achilles tendon
17 - Tibia
18 - Anterior tibia
19 - Semitendonous tendon
20 - Kneecap
21 - Surface vein
22 - Anterior tibia tuberosity

146

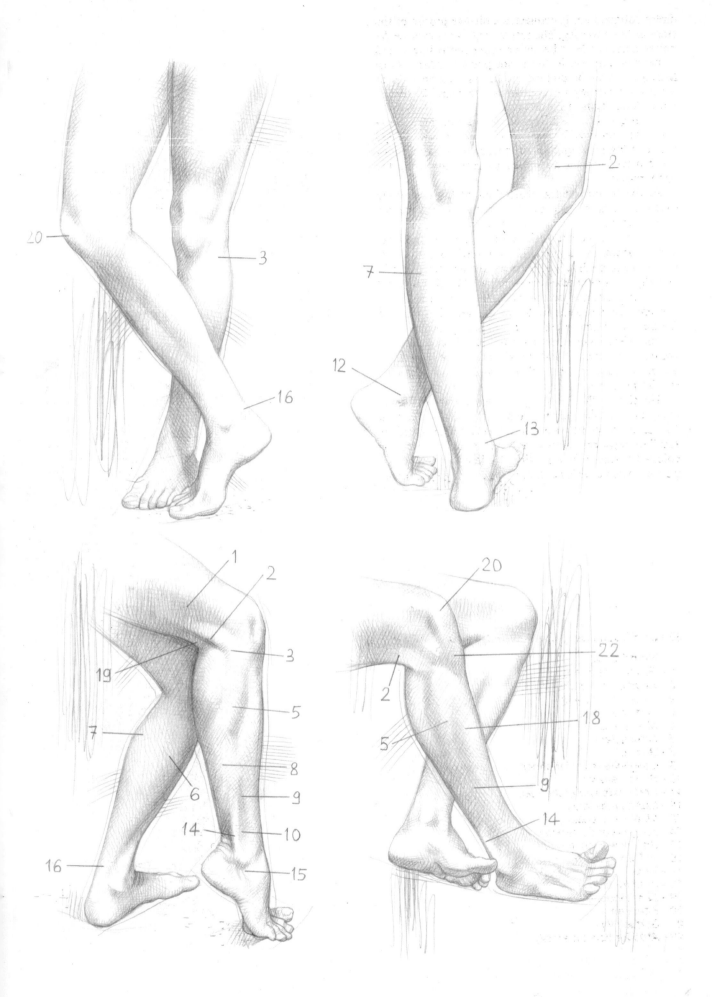

147

Morphology of the Ankle
(sketches 67–69)

The ankle, or neck of the foot, is the part of the lower limb that unites the lower leg to the foot. It has an irregular flattened cylindrical form on the sides, corresponding to the tibio-tarsal joint. The bone structure (lower extremity of the tibia, fibula, and anklebone) and the tendons on it essentially determine the external morphology. One sector is anterior and curvi-linear, characterized by the projection of extensor muscle of the foot tendons. The medial and lateral sectors are made up of the malleoli and the relative indentations. A posterior sector consists of the calcaneal tendon.

The ankle's anterior surface has a convex transversally rounded surface. The extensor muscle tendons pass under the skin, but are partly visible as a ribbon-like projection (especially the anterior tibia) only during muscular contractions, because they are covered, and are fastened to the bone plane, by ligaments.

The posterior region is made up of the Achilles tendon. On the heel, the tendon appears as a strong elliptical projection slightly flattened in the anterior-posterior direction and slightly enlarged in proximity to the point of insertion. Its profile forms a slight posterior cavity.

The skin surface of the posterior region is indented by transversal wrinkles, some permanent and others occasionally appear during movements of plantar flexion. The projection of the lateral malleolus (or peroneal) dominates the lateral surface. The posterior portion of the lateral malleolus is skirted by the long and short peroneal tendons and in the anterior portion by the third peroneal. Analogically, the medial surface presents the projection of the medial malleolus (tibiale).

The retromalleolar dimples are situated in the posterior sector of both surfaces. They are more or less accentuated according to individual formation and continue in the upper portion in two grooves of separation between the malleolus and the calcaneal tendon.

The two malleoli have different characteristics. The lateral malleolus, projected and pointed, is situated at the center of the region and is brought somewhat lower. The medial malleolus, less projected and more rounded, is positioned slightly higher.

Sketch 67: *Formation of the ankle*

1 - *Lateral malleolus*
2 - *Medial malleolus*
3 - *Calcaneal tendon*
4 - *Lateal retromalleolar dimple*
5 - *Medial retromalleolar dimple*
6 - *Short flexor of the toes*
7 - *Posterior tibia tendon*
8 - *Long flexor of the toes*
9 - *Short peroneal tendon*
10 - *Long peroneal tendon*
11 - *Anterior tibia tendon*
12 - *Long extensor of the big toe tendon*
13 - *Long extensor of the toes*
14 - *Third peroneal tendon (anterior)*
15 - *Adductor of the big toe*
16 - *First cuneiform*
17 - *Scaphoid*
18 - *Cuboid*
19 - *Surface vein (dorsal arch)*
20 - *Depression above malleolar*

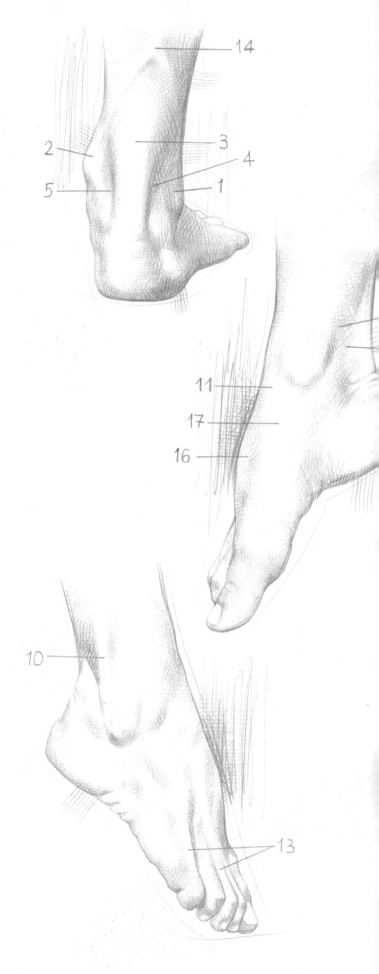

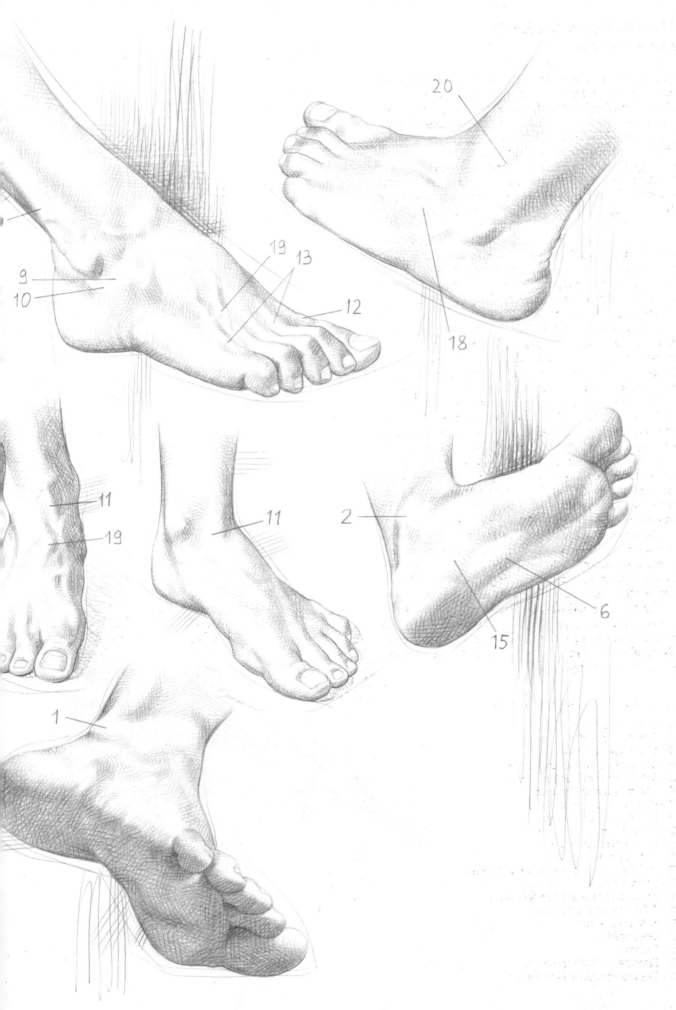

Morphology of the Foot

(sketches 67–69)

The foot is the free extremity at the lower limb that is conjoined at the lower leg, forming a right angle. It is distinguished into two parts: the foot itself (or dome of the foot) and the toes. The external morphology of the foot reproduces the skeletal structure and presents a dorsal, a medial, and a plantar surface.

The dorsal surface is convex and curvilinear. It has the maximum height medially in correspondence to the anklebone and decreases in an anterior and lateral direction. The extensor muscle tendons run along the dorsal surface and diverge by the anterior surface of the ankle across the toes. In the medial portion the anterior tibiale tendon is found, while the anterior peroneal tendon is found in a lateral direction. The fine skin of the dorsal surface leaves the projection of the venous reticulum surface visible. The surface forms the characteristic arch of the large saphena.

The medial surface is triangular in form. It begins at the heel and has maximum extension in correspondence to the tibiale malleolus, tapering in an anterior direction. The lower margin is slightly concave because it follows the outline of the plantar arch. It constitutes the inclined passage border across the plane of the foot.

The plantar surface only in part reproduces the bone structure. It is modified by the presence of an abundant fatty panniculus of the plantar aponeurosis and the thick skin.

The external form is flattened in the posterior area, correspondent at the heel in the anterior area, in proximity of the toes and in the lateral margin. It is concave on the border of conjunction with the medial surface.

At the level of the metatarsi heads, the transversal margin presents a fatty cushion. A deep crease defines it in front of the plantar surface of the toes, separated by single inter-toe spaces. This makes the toes appear shorter on the plantar side in respect to the dorsal surface.

Sketch 68: Formation of the foot

1 - Heel
2 - Lateral malleolus
3 - Medial malleolus
4 - Calcaneal tendon
5 - Anklebone
6 - Navicular
7 - Cuneiform
8 - Cuboid
9 - Fatty cushions of the foot plane
10 - Plantar arch
11 - Tuberosity of the fifth metatarsal
12 - Long peroneal tendon
13 - Short peroneal tendon
14 - Anterior peroneal tendon
15 - Long extensor tendon of the toes
16 - Long extensor tendon of the big toe
17 - Plantar aponeurosis
18 - Cruciate ligament
19 - Adductor of the fifth toe
20 - Adductor of the big toe
21 - Anterior tibia tendon
22 - Dorsal surface vein of the foot

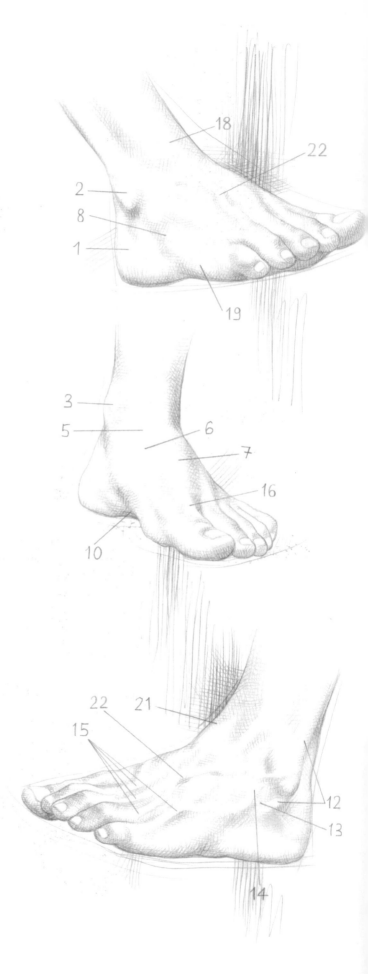

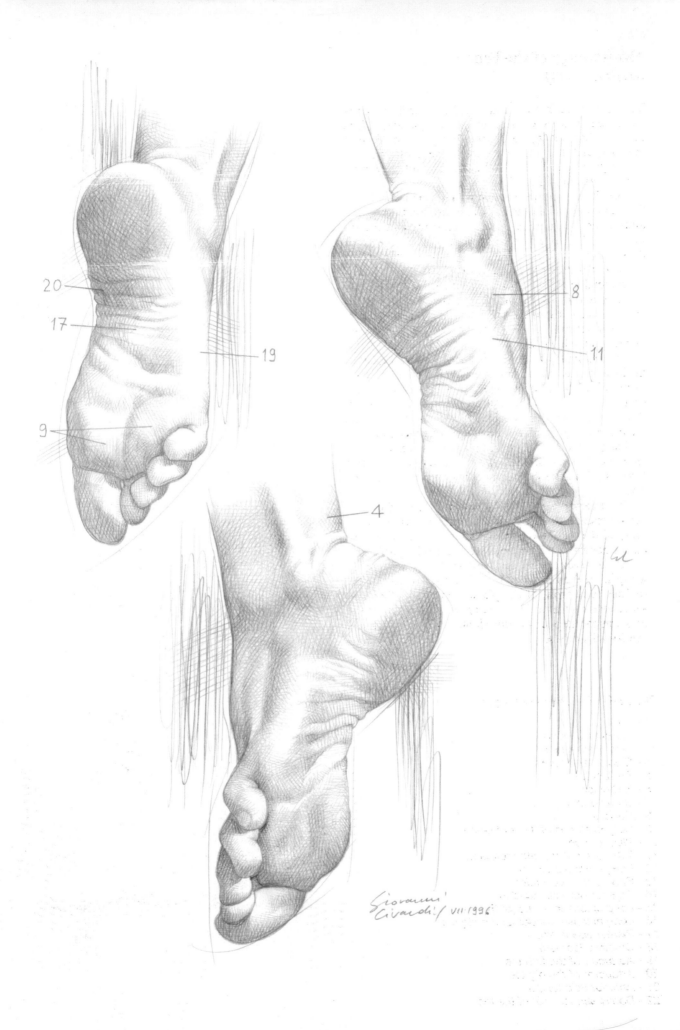

20

17

9

19

8

11

4

Giovanni
Civardi VII·1996

The toes do not have specific names, except for the big toe. This is the largest toe, separated from the other toes by a deep sulcus. An extensive nail furnishes it and its axis is slightly deviated laterally.

The length of the toes progressively decreases starting with the big toe to the fifth toe. At times the second toe is the longest, but the anterior margin of the foot is usually arched regularly.

The ovoid-shaped balls of the fingers are the plantar extremities of the toes. It is due to the presence of fatty cushions that they join at contact (when the toes are not extended) by the transversal anterior margin of the foot. The ball of the big toe is flattened, enlarged, and distinct from the foot because of a clear cutis crease running through it.

The dorsal area of the toes shows the joint enlargement of the phalanges, some transversal skin creases (mostly on the big toe), and the small nail laminates.

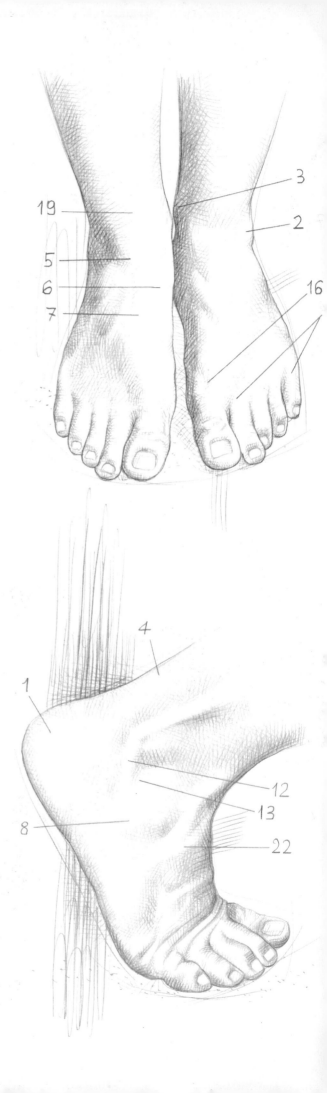

Sketch 69: Some morphological aspects of the foot

1 - Heel
2 - Lateral malleolus
3 - Medial malleolus
4 - Calcaneal tendon
5 - Anklebone
6 - Navicular
7 - Cuneiform
8 - Cuboid
9 - Fatty cushions of the foot plane
10 - Plantar arch
11 - Tuberosity of the fifth metatarsal
12 - Long peroneal tendon
13 - Short peroneal tendon
14 - Anterior peroneal tendon
15 - Long extensor tendon of the toes
16 - Long extensor tendon of the big toe
17 - Long extensor of the toes
18 - Adductor of the fifth toe
19 - Cruciate ligament
20 - Short extensor of the toes
21 - Anterior tibia tendon
22 - Dorsal surface vein of the foot
23 - Short flexor of the toes (covered by the plantar aponeurosis)

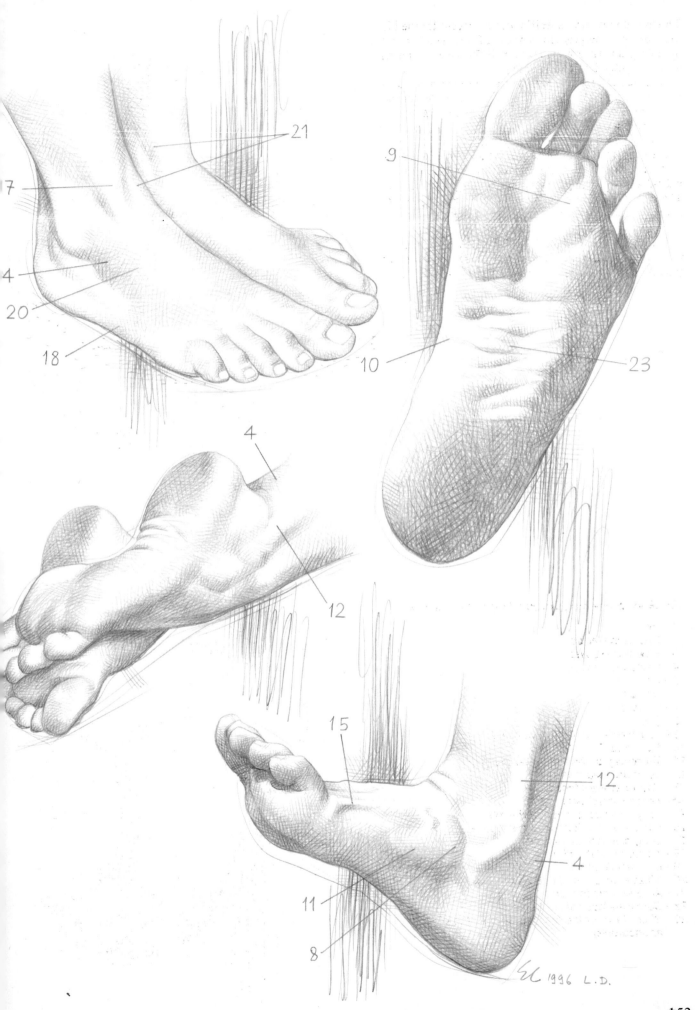

21

7

9

4

20

18

10

23

4

12

15

12

11

4

8

EC 1996 L.D.

153

Appendices

Elements of the Face

Morphology of the Eye

The vision apparatus is composed of two organs situated in a symmetrical position in the orbital cavity. They constitute the orbital region for the external part. The eyebrows, a portion of the ocular bulb, and the eyelids occupy the orbital region.

The eye (or ocular bulb) is quasispherical in form and has a median diameter in adults of about 2.5 cm. The feminine eye differs slightly from the male eye. Due to anatomic aspects, the male eye is slightly smaller.

The anterior part of the bulb, defined by the eyelids, is externally visible. It is characterized by the presence of a small spherical, transparent calotte (the cornea). The cornea is projected and applied on the remaining opaque whitish part (the sclera). This projection is easily noted when observing the eye from the side. It is also perceivable across the depth of the lowered eyelid.

The iris is immediately under the cornea. It is a disc-shaped membrane of less than 1 centimeter in diameter and variable color. At the center of the iris rests the circular and concentric opening of the pupil. It appears black and shows itself, across a crystalline portion, on the bulb cavity. It dilates or restricts in relation to luminous intensity, emotional states, and the distance of the observed object.

The color of the iris varies depending on the quantity of pigment, from blue to gray to brown, with numerous intermediate tonal gradations. The color of the iris is generally correlated to hair color. For example, dark-haired individuals often have dark eyes, whereas blond individuals often have light eyes.

Normally, an increase in the external circumference is noted, on which convergent radiated streaks prolong across the pupil.

The orbital bone cavity is very ample in respect to the volume of the ocular globe. It is protected by abundant fatty material, adapted for the valid thermic and mechanic protection of the eye. Small muscles (four upright and two oblique), that produce delicate and precise displacements in each direction of the stare, move the bulb. In normal conditions, the two ocular bulbs are placed in position, directing the stare in a mid-direction. In particular, the axes of the bulbs are parallel while viewing distant objects, while they slightly converge while viewing very close objects.

The eyelids are two mobile skin folds, the upper more extensive then the lower. They terminate with a free margin, where the external border is supplied with rigid arched hairs, or eyelashes. The two eyelids can be joined, forming a complete covering for the eye. While viewing, however, they are apart and delineate the opening of the eyelid rim, which indicates the anterior part of the eye. This covering has a somewhat oval outline and varies according to individual and racial characteristics. It also varies depending on the displacement of the ocular bulb due to direction of the stare.

In normal conditions of the directly forward stare, the eyelids are situated on the spherical form of the eye and follow the surface curve. In the medial angle the presence of the slightly projected and rosy formation, the caruncle, is noted. The formation opens into the tear duct and is considered an important point of reference because it does not undergo displacement. It maintains the position and proportion of the eye even in prospectively difficult conditions.

Under normal conditions, the adult sclera is whitish in color. It can, however, become a yellowish color in older individuals or bluish in very small infants. The conjunctiva membrane covers the sclera due to tear liquid. In the eyelid opening, it occupies the two triangular areas on the sides of the iris. They are subject to different expositions according to the movement of the eye.

The eyelids have a depth of about 3 centimeters. The lower is less extensive and less mobile, while the upper is more amplified. During the opening of the eye, it retracts in various measures due to the effect of the elevator muscle of the upper eyelid. It determines a deep fold (upper orbit-eyelid sulcus) that forms between the skin of the eyelid and derives from the eyebrows.

The eyebrows are two skin projections that are transversally equal, symmetrical, and mobile. They are in correspondence to the orbital arch of the forehead bone. The eyebrows separate the forehead from the eyelids and are covered by hair that delineates a transversal arch on each side. The hairs are generally similar in color to the hair on the head, or sometimes darker. There are many fixed hairs in the medial part of the eyebrows, near the root of the nose. They are laterally inclined and situated below the corresponding supra-orbital bone tract. In the central portion, the hairs are laterally inclined, almost horizontally. In the lateral area, the hairs are subtle and sparse, situated slightly above the bone margin.

The form of the eyebrows is subject to individual variation in relation to sex (feminine eyebrows are more regularly and distinctly arched) and ethnicity. For example, in Asian populations the eyebrows are finer, while in Mediterranean populations they can be very thick and at times extend into the area above the nose (the glabella).

Morphology of the Nose

The external nose is a pyramid-shaped projection situated at the center of the face and displaced along the median line in a compressed area between the upper portion of the forehead, the sides of the cheeks, and the upper lip. From its surface some parts of its principal characteristics are morphologically considered of common knowledge. They are the root, the back, and the lobe, sustained by a bone-cartilage skeleton. The root, the upper portion of the back, and the lateral surfaces corresponding at the bone define the piriform opening of the facial block. They are nasal bones and the nasal and palatine processes of the maxillary, while the remaining nasal portions are mobile because they have only one cartilage support.

The skin of the nose (overall thin and fluent in the upper portion, while thicker and adherent in the remaining areas) rests upon a fatty layer of reduced depth on the back. The skin contains numerous sebaceous glands,

154

particularly on the lobe, which can render somewhat clearly on the surface. A distinct network of capillaries runs along the skin, contributing to determine, with their contraction or dilation, a pallor or reddening. This depends on the emotional state, ambiance, or situation and can also be affected by age. In older individuals the retinaculum can be more accentuated and permanently visible. Along the outline of the lower opening or nostrils, the skin passes the vestibule, implanted by a certain quantity of projected hairs, the vibrissa.

The root or apex of the nose is a fine area posted between the over-orbital arches in the lower portion at the median surface of the forehead. It is at times separated by a mild transversal (nasal-forehead sulcus). In men, the projection of the eyebrow arch normally determines reentrance, a saddling between the forehead and the root of the nose. In women, its bone structure is more minute, usually absent or very slightly indicated.

The root begins and continues on the back of the nose, which is the rounded anterior margin posted on the median plane and formed by the meeting of the two lateral surfaces.

The dorsal is various in form and size in relation to individual and ethnic characteristics. It can be a fine margin more or less, or somewhat short and enlarged.

There are distinct fundamental types of nose: aquiline (convex), twisted (concave), and snub-nose (flattened). A slight projection on the nasal base indicates the point of passage between the bone skeleton and the cartilage skeleton.

The lateral surfaces are leveled and narrow near the root, but become enlarged and convex in the lower portion. This is where they form the nasal pinnae. These dilate and restrict in various measures for the effect of some skin muscles (mostly the depressor muscle of the septum and the nasal muscle, distinct at times in two portions: the compressor muscle of the nostrils and the dilator muscle of the nostril). The actions of these specific muscles are clearly indicated by their names. They collaborate to produce certain facial expressions. For example, during aggressive or averse gestures, the nostrils tend to dilate. In emotional states of desire or surprise, they tend to restrict, making the nose appear elongated and pointed.

Other than expressive interpersonal significance, the dilation and restriction of the nostrils also has physiological purpose. For example, they allow the inhalation of major volumes of air in order to feed muscular actions. They also limit the afflux, in the condition of very cold air.

A curvilinear sulcus outlines the confines. It starts shading near the point of the nose and continues behind and in the lower portion to outline of the nostrils. The extensions across the cheeks and the upper lip form the nasal-labial sulcus. The depth and length of the nasal-labial sulcus depend on the individual skin characteristics of age and habitual expressive gestures.

The point of the nose (lobe) is situated on the vertex of the pyramid formed by the meeting of the lateral surfaces of the base and the back. It is a rounded fleshy projection. The distinct and clear planes, especially in male individuals, can present it. Its formation is determined by underlying cartilage. In many cases, the lobe appears separated into two ovoid symmetrical halves by a slight median vertical sulcus.

The base of the nose has a triangular surface posted on the plane, which can have a more or less accentuated inclination. It can also be, more frequently, quasihorizontal in relation to the morphological types of nose on which it is indicated. Two sides of the triangular surface correspond and converge across the point. They define the nostrils (two openings of the upper respiratory path). They are separated on the median line of the subseptum (or columella) correspondent to the lower portion of the nasal septum cartilage and by the nasal spine of the two maxillary bones.

The nostrils have an oval-shaped outline. They are often enlarged in the posterior sector and narrower in the anterior portion. Each nostril is directly disposed along the major axis in an anterior-posterior direction. They are deviated laterally and converge across the lobe. The formation of the entire nose and particularly the nostrils permits an approximate anthropological and ethnic distinction of some fundamental types of nose, which correlate to the diverse morphology of the facial block. Some noses are narrow and subtle (light-skinned populations). Platyrrhine noses are large and flattened (populations with dark skin). The mesorrhyne have morphologically intermediate characteristics of the preceding two (in populations with mid-shaded skin tones).

Morphology of the Lips

The lips form the outline of the mouth and cover the anterior portion of the dental arch. They consist of an upper and a lower, somewhat thick fold. They come in contact with the free margins, delineating the transversal fissure, and laterally converge, uniting at the labial angle (commissure).

The closed labial fissure has a median width of about 5cm in adults. There are, however, ample modifications depending on labial movements and variations due to individual characteristics, summarizing the common definitions of a large, medium, or small mouth.

The upper lip continues into the cheeks, while the lower passes into the chin. Together they constitute the anterior inner portion of the vestibule. In the upper portion, they define the sides of the base of the nose and by the nasal-labial sulci. In the lower portion, they define the chin-labial sulcus.

Three layers constitute the inner portion of the lips: an external cutaneous, an intermediate muscular, and an internal mucous membrane. The external skin covering and the internal mucus membrane continue for the passage of a transition zone (the rosy border or prolabium). The zone tapers the specific skin and appears rose-colored in correspondence to the surface of the commonly visible lips.

The rose color of the lips can be intensified or become pale by permanent or transitory conditions, for example external temperature, degree of blood irrigation. and emotional or pathological states.

There are systematic skin muscles in the intermediate layer that influences the mouth region. When contracting, they determine the physiognomic gestures. The spherical mouth muscle is disposed internally. It is flattened and circular in form. Its contractions produce the nearing lips and their closing, curling on the surface. The profound tendon muscle compresses the lips against the teeth. The superficial tendon makes the origin project forward with diverse shading of expression.

Numerous other muscles (canine, zygomatic, elevator, triangular, depressor) work, with various degrees of synergy, on the lips. They are often, however, in antagonism with the spherical because the tendon enlarges, raises or depresses them, determining the respective expressions of happiness, aggression or pain, and sadness or disgust.

A fine skin covers the external surface of the lips. In men, a distinct apparatus, the mustache, covers the upper lip. It presents a slight oval depression (the filter) on the median line, which originates by the sub-nasal sulcus and direct vertically until the rosy lips. The lower also presents a median indentation defined laterally by two projections of the clear transversal chin-labial sulcus. In men, the circumscribed area is clearly covered by hair. Due to a characteristic disposition of the beard, at the center there can be a weak convex projection .

The form of the lips varies individually, and is also a distinctive racial characteristic; the base of the exposed rose-colored border being schematically recognized. In black-skinned populations, thick and protruding lips are prevalent. In populations with yellow skin, the lips tend to be fine, and in white-skinned populations, they are medium in size. In older individuals, the lips lose elasticity; diminishing in size,they wrinkle, at times forming evident vertical lines.

The form of each lip has certain specific morphological characteristics. The upper lip is more tapered and presents a projection (tubercle) correspondent to the conjunction of the margins of the filter. On the sides two slight depressions are noted, on which two slightly convex tracts follow until rejoining at the commissure.

The lower lip is thicker and presents a slight vertical depression on the median plane. The tubercle of the upper lip rests at the two projected symmetrical oval sides.

The confine between the skin and the rose-colored border is always well visible. It appears as a clear, hairless and sinuous line on the outline of the upper lip. It s regularly curvilinear on the outline of the lower lip, where at times it thickens in correspondence to the median indentation and proximal tract at the commissure.

The lips undergo numerous and substantial variations of form and volume in relation to expressive or functional movements, becoming contracted, pulled, or curved. The rim of the mouth can be closed or open to various degrees, revealing the partial exposition of the teeth (above all, the somewhat flattened upper incisors and the cone-formed canines) and at times also the gums. They determine the thickness of the vertical curl or loss on the surface.

The nasal-labial sulcus adapts to all of these modifications. It laterally defines the slight ovoid projection that is situated near each commissure. It is made up of the crossing of various muscular fascicles on the spherical of the mouth.

The external surface of the mouth extends laterally onto the cheeks. The maxillary bones and the subcutaneous fatty panniculus mark its form, while the inferior portion continues into the chin. This constitutes a projection that is characteristic to the human species (it is almost absent in other primates). It is posted on the median plane and delineates the inferior portion of the surface, presenting variable individual aspects in relation to the form of the mandible or the local subcutaneous fat deposits. In the male it is somewhat larger and more projected in the middle, clearly defined and cov-

ered with hair (the beard). In women it is more rounded, minute, and hairless.

The chin is separated from the lower lip by the chin-labial sulcus. It frequently presents a depression or indentation at the center due to the direct adherence of a skin portion on the bone plane.

Morphology of the Ear

The external human ear is made up of an auricular covering, that is easily accessible by way of the external hearing meatus (or conduct), a canal that joins to the eardrum. The outer portion of the ear, a skin fold with a cartilage skeleton, is situated symmetrically on the lateral surface of the cranium at the point where the surface of the cranial box and neck touch.

The external acoustic meatus corresponds at the homonymous opening of the temporal bone. It represents an important point to find the anthropometric measure. It is also useful for design purposes because its positioning on the individual allows the head to be placed in the correct manner easily, even if it is seen in uncommon prospective conditions.

The form of the outer coverings is somewhat complex and joined at its functions. The path of the evolution process delineates them. For example, the structure at the concentric fold is adapted to carry sounds without distortion across the hearing apparatus. This is particularly advantageous for humans, who in contrast to other species do not move the ear. Another secondary function joins at the intense vascularization of the skin of the coverings. They perhaps were originated to disperse heat and regulate the body temperature (as in other mammals), but are now important only for aspects of interpersonal communication (as can be noted, the ears become red during particular emotional states).

The formation of the outer ear is similar to that of a shell at the oval outline, or more simply an oval with a flattened enlarged portion. The major axis is quasivertical, slightly inclined in the posterior portion and oblique across the side and the lower area. It is about 6cm in measure. The minor axis is horizontal, laterally situated to form an open acute angle with the cranial inner walls. It is about 3 centimeters in measure. If the head is visible in a lateral projection, the covering is not perfectly perpendicular on the visible axis. It is somewhat oblique across the frontal plane.

The ear can be normally situated in correspondence to the mastoid process of the temporal bone. Its height is compressed between the two parallel horizontal lines that pass by the eyebrows and the base of the nose. The inclination of the major axis is similar to that of the nose and the mandible branch.

The medial surface of the covering is arched across the cranium. It is convex and undulated by projections and depressions correspondent to the external surface. It is attached at the cranial inner walls with only the convex anterior part. The large free border is distanced in various measures by the inner walls. The external surface of the outer ear is creased by numerous folds, which determine the characteristic circumvolutions. The central portion of the outer ear covering is placed somewhat across the anterior of the covering. A large indentation, the concha, occupies the bottom of the area, initiating the acoustic meatus. The peripheral portion, or free margin of the ear, is constituted by the helix. The

helix is an ample curvilinear fold that originates at the bottom of the concha, slightly above the hearing conduct (it divides into an upper oval sector and a lower profound extensive sector). The helix delineates the external outline of the ear covering, tapering in the lower portion of the ear, the lobe.

A slight pointed projection, "Darwin's tubercle," can frequently be found on the anterior margin of the upper helix tract curve.

The lobe is a small fleshy mass without any cartilage. It is flattened and ovoid in shape on the free margin because it adheres to the cranium (near the mandible branch) with the upper portion of the anterior border. It is not rare to see an attached lobe, however. It unites with its anterior margin at the mandible skin area.

Concentrically at the helix, to define the posterior outline of the concha, is the anti-helix, a marked, semi-circular cartilage projection at the anterior cavity. The projection starts with two convergent projections (the lower is more distinct and the upper more shaded) defining the navicular (or scaphoid) indentation of the antihelix. It continues curvilinearly and terminates with a rounded projection, the antitragus. The subtle area compressed between the helix and antihelix, or sulcus of the helix, is slightly depressed and leveled in its lower tract.

The tragus defines the concha in the anterior portion. The tragus is a rounded and projected triangular tongue. Hairs (tragi) can grow on its inner walls, especially in the older years. It corresponds to the temporal-mandible and continues across the antitragus with a projected margin, defining the inter-tragus notch. The concha also constitutes the posterior-medial inner portion of the outer ear. The outer ear is strongly convex (in relation to the corresponding cavity of the external surface) and unites at the cranial region to determine the anterior inclination (20–30 degrees) of the external surface of the outer ear.

Elastic cartilage constitutes the skeletal structure of the ear. It is absent only in the lobe and the short terminal tract of the lower margin of the helix. It assures a flexibility of the outer ear and limited mobility for the effect of the auricular muscles and intrinsic fibers. There are three auricular (or extrinsic) muscles, the anterior, upper, and posterior. The first two originate by the aponeurosis of the temporal muscle, while the third originates by the mastoid fascia. The muscles of the outer (or intrinsic) ear are the large and small muscle of the helix, the tragus muscle, the antitragus muscle and the transversal muscle. They are thin subcutaneous facets, which are inefficient from a functional point of view.

The skin that covers the outer ear is very fine, and it is amply vascular. This justifies the rosy color, which intensifies under emotional or temperature influx.

The form of the outer ear varies mostly in the attachment of the lobe. Anthropologists of the last century have tried a minute classification, almost comparable to the digital impressions. For the artist, it is sufficient to observe reality, to collect fundamental elements and characteristics of the multiform aspects, and to synthesize them in a way that is useful for one's work.

The individual characteristics of form are in part hereditary and can also assume racial aspects, although they are less significant (for example, in many black populations, the ears of the appertaining individuals are somewhat small, with at times almost no lobe).

The feminine ear (referring to adult subjects) is finer and smaller, with a more marked fold in respect to the masculine. During old age, the ear tends to elongate along the major diameter in both sexes. This is due to the loss of elasticity and stretching of sustaining tissue, which also determines some subtle vertical creases behind the tragus.

Functional Movement Characteristics of the Vertebral Column
(see sketches 13–15,17, 37–39)

At the ends of the artistic figuring of the human body it is indispensable to know some constructive characteristics of the rachis and its relationship with the head and pelvis. In this manner, they are correctly interpreted not only by the movement of the trunk, but also the positions of equilibrium of the entire body. It is also useful to view certain morphological-functional considerations relative to the vertebral column in its entirety, rather than single components.

The skeletal structure that runs on the median posterior portion of the trunk from the head to the pelvis comes together, forming the vertebral column. It is integrated by a robust system of joints and specific muscles, forming the rachis. This is particularly important in the static and dynamics of the body. It must sustain and stabilize the upper arms and the head (with eventual applied force), while also guaranteeing free movement. Like characteristics are associated at a particular anatomic structure. They are constituted by numerous distinct bone elements, which under the functional aspect are tightly joined in a manner that guarantees solidity (static function) and mobility (dynamic function).

The vertebral column is made up of a series of bones, normally 32 or 33, subdivided in five segments: 7 cervical vertebrae (correspondent at the neck), 12 thorax vertebrae that join as many pairs of ribs, 5 lumbar vertebrae, 5 sacrum vertebrae and 3 or 4 small and rudimentary coccyx vertebrae.

While the first three segments are mobile, the final two tracts are made up of bone elements fused together. Although there is no possibility of movement, they are an integral part of the pelvis, joining the two iliac bones. Almost all of the vertebra (with the exceptions of the first cervical vertebra joined with the occipital) have some morphological characteristics that easily permit their assignment at the segment of the appurtenance, but they also have common constructive parts.

A typical vertebra of the mobile portion is formed of diverse parts fused together to form only one bone:
1) the body, cylindrical, with slightly concave upper and lower surfaces (to receive the inter-vertebral disc), progressively larger and more robust than the cervical or lumbar vertebra
2) the arch, rounded, situated in the posterior portion to define the vertebral opening
3) the joint processes, upper and lower (of each side), joined with the corresponding processes of the joint vertebrae
4) the transverse processes, directed laterallyposterior
5) the spinous process, unequal median, dorsally and directed somewhat lower.

The structural complexity of the vertebra is also justified by the principal functions on which the vertebral

column is able to sustain the trunk, permit mobility and protect the spinal medulla (the nerve fascicle that runs in the canal formed by the over-position of the outer vertebrae).

Laterally observing the vertebral column reveals the augmented volume of the cervical or lumbar vertebra. It also shows the delineation of at least three physiological curves in an S shape. They are the cervical lordosis, the dorsal kyphoses, and the lumbar lordosis. In the elderly or in pathological situations, these curves can accentuate and determine the entire curvature of the back.

When seen in an anterior-posterior direction, the column appears rectilinear, except in the somewhat frequent cases during which it curves laterally (scoliosis, not necessarily pathological if of modest intensity) mostly in the thorax tract, determining the following posture adaptations. These characteristics of external morphology are at times perceivable in the models. They need to be kept account of in order to gather their significance of deviation form normalcy and eventually correct them in the drawing.

The vertebrae, which constitute the column, are joined by diverse articulations in relation to the forms of the parts that come into contact:
1) The joints between the vertebral bodies are synarthrosis (symphysis) in which the following vertebral body surfaces are joined by the inter-vertebral disc. This is made up of fibrous tissue of various densities (denser at the periphery and more gelatinous at the center, where it assumes the major width). It has functions of the ponderal load, other than to accentuate the possibility of displacement relative to the single vertebra. With the progression of age, discs undergo degeneration and tapering, provoking a reduction of possibility in movement of the trunk and shortening in stature in older individuals.
2) The articulations between the vertebral joints, diarthrosis (arthrodia), are covered by joint capsules. They permit movements of diverse intensity and direction according to the tracts. They are mostly movements of flexion and extension.
3) Some other types of joint meet at particular sites of the column, for example the ondontoid-occipital (between the first cervical vertebra and the occipital), the rib articulations (between the thorax vertebra and the ribs), and the lumbar-sacrum joint (between the fifth lumbar vertebra and the sacrum).

The joints of the vertebral column are reinforced by numerous ligaments, which secure the robustness and flexibility of the internal structure. The ligaments common to the entire column (others are disposed between following vertebrae or small groups of vertebrae) are the anterior longitudinal ligament along the posterior surface of the vertebral body and the over-spinous ligament that passes the spinous process, mostly by the seventh cervical vertebra at the sacrum (in the cervical tract it takes the name of "nuchal ligament" and is more robust to maintain the head in a position of equilibrium without excessive muscular force).

The muscles which work on the vertebral column are numerous and displaced at the layers in a complex manner. The layers are distinct in muscles of the vertebral (or paravertebral, which runs in proximity to the vertebral) and in muscles of the dorsal and inner portion of the abdomen. They collaborate with the axo-appendicular muscles of the upper and lower limbs to form the static

gestures and various movements of the trunk (flexion, extension, rotation, and lateral inclination).

For the artist a detailed knowledge of the single components of the muscular motor structure of the vertebral column is not indispensable. Many are profoundly situated and therefore morphologically not perceivable. Instead, in the depiction of the nude figure, it is culturally interesting and of useful practice to consider at least the principle muscular groups divided according to functions and actions.

The extensor action of the vertebral column is performed by the sacrum-spinal muscles (which run in the posterior portion at the column, from the sacrum to the nape, forming a muscular system of many layers with short stretched facets between the arch and the spinous processes of the following vertebra). The long muscles of the back (obliquely directed by the sacrum and the lumbar vertebrae at the ribs), the splenius muscles (which rejoin the occipital on the cervical column and extend the head), and the trapeziums (which, together, with the stretched muscles of the scapula to the occipital, extend the head and the neck). The muscles of the abdomen in large part turn the flexion action. Their insertion on the ribs and pelvis perform the approach of the thorax to the pelvis (above all the recto-abdominal muscles). They also perform rotation with lateral flexion (mostly the oblique internal and external muscles). Others work the ileum-psoas muscles. They are situated in the pelvic cavity, stretched between the lumbar and femur vertebrae. The muscles above and below the hyoid, platysma. and sternum-cleido-mastoid assist, in various measures. the flexion and rotation of the head and the neck.

The muscles that flex the spine turn the rotary action. They can join the scalene and short muscle of the nape at the neck or head level (the most mobile sector of the vertebral column).

The rotary movement of the entire spine requires the combined action of a series of muscles posted on both sides, other than the paravertebral rotary muscles.

The lateral flexor action is completed at the lumbar level of the quadratic muscle of the loins (that conjoin the seventh rib, the costiform process of the lumbar vertebra, and the iliac crest), the psoas muscle, and the oblique internal and external muscles. That of the cervical level is completed by the splenius muscles (the first four cervical vertebrae and the upper angle of the scapula), the scalene muscles (between the cervical vertebrae and the first two ribs), and in part the sternum-cleido-mastoid muscle (stretched between the sternum, the clavicle, and the mastoid process of the temporal). The lateral flexion is assisted along the entire spine by the complex paravertebral of the transverse and inter-transverse muscles.

As has already been pointed out, the principal functions of the vertebral column are to sustain the trunk, protect the medulla, and ensure mobility.

The stable, or static, function is fully performed by the elemental structure (the vertebrae). They allow the elasticity essential to redeem the repercussions and the maintenance of the erect station by means of the physiological curvature. The diverse segments of the column opportunely receive and unload the weight of the underlying body part by concentrating it on the gravity axis (in the anatomic position, by way of the occipital bone

and on the median plane across the body of the fourth lumbar vertebra, it passes near the center of the pelvis and joins at the area of the support of the foot).

Median constructive characters also allow the mobility function. The slight displacement between the single vertebrae (limited by the bone formation of the processes and by the joint ligaments) adds up along the entire column and permit ample flexibility.

Following is a list of the movements that the vertebral column can normally accomplish:
1) Flexion - the curving across the base of the plane. It does so by means of the compression of the anterior parts of the inter-vertebral discs, mostly in the cervical and lumbar tracts and in minor measure in the upper thorax.
2) Extension - the displacement behind the saggital plane. It is completed in the in the cervical tract and particularly in the lumbar (lumbar-sacrum joint), but finds by the mechanic limits in the projection of the spinous processes. Whether in flexion or extension the physiological curve attenuates or annuls, joining to outline an accentuated curve, which continues in the maximum flexion. The thorax tract is part of the lumbar, which tend to make it rectilinear in the extension.
3) Rotation (or torsion) - the displacement across the right or left side by a horizontal plane. It is completed mostly in the cervical tract, where it is the maximum. It is also completed in the thorax tract (compatibly with bonds posted by the thorax cage), while it is reduced in the lumbar tract due to robust joint and ligament connections.
4) Lateral flexion - the curving across the side on the frontal plane. It is possible mostly in the cervical and lumbar tracts, but finds by the limits in the ribs and in the muscle-ligament system by which the movement of flexion almost always associates a moderate torsion.
5) Circumduction - the combination in succession of the various movements and somewhat limited, except in the cervical sector.

The vertebral column occupies the median posterior part of the trunk. It is in large part covered by the musculature of the back and the relative robust facets. When the body is in the anatomic position it presents less apparent characteristics. They are, however, more important for an efficient drawing or modeling of the human trunk. The spinous processes are the only elements of the vertebrae that are subcutaneous. They run in a vertical crease, which is deeper in the lumbar tract. It is defined by the projection of the profound superficial dorsal muscles.

Along the crease the processes are scarcely visible, except that of the seventh cervical vertebra and the first thorax. It is easy to localize some other vertebrae in the position discussed (useful mainly for the sculptor), considering certain points of reference. For example, the transversal line, which unites the lower angle of the scapula across the spinous process of the seventh thorax, the line that unites the summit of the iliac crest, crosses the spine of the fourth lumbar vertebra.

The spinous processes become less evident during extension. They deepen in the sulcus, emerging as clear subcutaneous ovoid projections aligned at regular intervals. During accentuated anterior flexion, the muscles on the thorax cage flatten, causing the sulcus to disappear.

The movements of the vertebral column determine

other external morphological variations of the entire trunk (abdominal creases, emergence of the ribs and the rib arch, inclination of the pelvis, scapular and clavicle displacement, etc.). They are easily observable "in life," particularly in athletic male models. The movement becomes slowly and repeatedly turned in certain fixed phases rather than "rejoined."

Notes on the Static and Dynamic of the Human Body

Movement represents the most important function of the skeletal muscles. The action is completed by means of the displacement of bone segments provoked by the contraction (and therefore, usually by the shortening) of the muscular tissue. This locomotive activity also brings esthetic value because it almost always determines the modification of the external form of the body. Locally, for example it is useful to note the projection or the depression caused by tendons or muscles in action, accompanied by skin tensions, creases, or wrinkles, or also the following adaptation of the entire corporal asset at a partial gesture.

The different movements have the principle function to post the body or some segments in the space, or to complete an expressive gesture or a coordinated activity. In every case, however, the movements require an energetic expense at the bulk of the muscular tissue to win over various forces (gravity, inertia, friction, etc.) that oppose postural gestures or body positioning.

The studies of these arguments assume two different yet tightly connected addresses. One appertains to the "static" (look near the center of corporal gravity, analyzed by mechanisms of equilibrium in the erect station or stretched or seated positions). The other appertains to the "dynamic" (an analysis of movement in walking, running, jumping, swimming, etc.). The mechanical structure of the human body is made up of a passive component, the skeletal system. It is also made up of an attaching component, the joints, that are diversely conformed in relation to the various necessary functions, and finally of an active component, the muscles, whose contractions work on the complex system on the slight bone-joint.*

It seems useful now to briefly review some characteristics of the single components.

The Bones

The skeleton, the structure with the functions of sustenance and passive movement, is composed of two portions: the axle portion, made up of the cranium, the vertebral column, the ribs, and the sternum; and the apendicular portion, made up of the bones of the limbs. The bones of the upper limbs are the scapulum, clavicle,

* A lever and a rigid axle (the arm) wheel inside and at a fixed point (fulcrum) when a force is applied that overpowers the resistance. The lever is of type I when the fulcrum is posted between the force and the resistance. It is of type II when the resistance is between the force and the fulcrum and of type III when the force is between the fulcrum and the resistance. In biomechanics the arm of the lever is the bone, the force is the muscle, and the resistance is the objective or passive weight of the corporal segment, the fulcrum and the joint.

humerus, ulna, radium, carpus, metacarpus, and the phalanges. The bones of the lower limbs are the pelvis, femur, tibia, fibula, tarsus, metatarsus, and the phalanges. The pelvis and the vertebral column (see p. 157) assume a fundamental importance for the spatial situation of the human body, whether static or dynamic.

The bones are of various forms, brief, platelike, irregular, and long. They recognize two extremities, the epiphysis that also constitute the head joints, conjoined by an elongated portion, the diaphysis. For the long bones, it is relevant to consider the mechanical axis (at times different from the anatomic), made up of the straight line that joins the centers of the joints posted at the extremities of the bones.

The internal architecture of the bones rejoins the maximum degree of solidity at the maximum slightness. The long bones of the limbs, or functional corporal segments, are more relevant in locomotion. They have a hollow cylinder form, while the trabeculae of the extremities expanse, positioned in a manner to mechanically reinforce the joint surface, are destined to undergo maximum pressure.

The Joints

At the base of the diverse form of the head joints and at the eventual presence of the joint cavity come classifications of fixed joints (or synarthrosis) and mobile joints (or diarthroses). In each case (for example, in the knee and the shoulder) they are reunited in complex joints.
1) The synarthroses are two junctures of continuity. The interposition of connective tissue or cartilage is completed in this joint union. There are three types: a) the syndesmoses, in which head joints are united by connective fibers. In the structure the bone segments are united by means of the margins (for example, the bones of the cranial box). In the gomphosis, the bone segments are embedded in bone cavity (for example, the teeth); b) Joint segments are united by hyaline cartilage (for example, the ribs); c) The symphysis, in which the segments are united by hyaline and fibrous cartilage (for example, the pubes).
2) The diathroses are also junctures for continuity because the adjoining of the head joints, covered by hyaline cartilage, passes with the interposition of a joint cavity and at times with the joining of a fiber-cartilage disc. A capsule and the ligaments wrap the joints. They are distinguishable as three types: a) The arthrodia, where the joint heads have flat surfaces (for example, the carpus); b) The enarthrosis where the joint heads have a tightly curved spherical form, a concave and a convex (for example, the hip); c) Joint heads have a curved ellipsoide form, a concave and a convex (for example, the temporal-mandible); d) The ginglymus where the joint heads have a cylindrical formed segment, a concave and a convex. There are two varieties of ginglymus. They are the angular ginglymus (or trochlea) at the angle, like the elbow joints and the lateral ginglymus at the posts like the proximal radium-ulna joint and the atlanto-odontoid.

The principle function of the joints is to give the bones the possibility of movement and to complete joint mobility. This must be in limited measure, evading instability or loss of the normal relationship between the joint surfaces.

The limitation factors of joint mobility (or stability) are connected at the bone heads, the system of the cap-sules and the relative internal pressure, the system of ligaments, and the traction of the adjacent muscles. The three spatial planes, conventionally adopted in the anatomic description, complete the fundamental movements:
1) The movements in the saggital plane (anterior-posterior) are that of flexion (directly across the anterior plane, with diminution in the joint angle) and of extension (directly across the posterior plane or also of simple flexion return). In the limbs they can rejoin more ample degrees of mobility, such as hyper-flexion and hyperextension.
2) The movements in the frontal plane are that of abduction (laterally directed with the elongation of the median plane) and lateral flexion for the movement of the head and the trunk.
3) The movements in the horizontal plane are that of lateral and medial rotation for the forearm of pronation and supination.

The direct principle movements rejoin the limbs in an oblique plane, the intermediate between the frontal and lateral planes and those of circumduction in an ordered sequence of movements that unfold in diverse planes.

The Muscles

The skeletal musculature (striped or voluntary) constitutes the active component of corporal movement. In life, the muscles always conserve a slight degree of physiological contraction or "muscle tone." The effective movements, however, are normally completed across an ordered sequence. The nervous impulse (voluntary) provokes the contraction of muscular tissue at which it is destined (the belly of the muscle). The passage of the tendons determines the displacement of the raised bone.

The active movements of the body or of body segments (different from the passive, which do not require some force because they are executed by others on the body of the subject) are completed almost always with the intervention of numerous muscles other than these specifically responsible for the movement considered. It is a muscular coordination, in which different muscles collaborate to regulate the space, amplitude, or intensity of a corporal placement by means of contrast or facilitation (synergy) of the movement.

The muscles can then assume diverse finalized functions. They can recognize the muscles of sustenance or stabilizers (because they are near the joint heads and track along the bone axis) and muscles of movement. The movement muscles impress a displacement at the mobile bone. In diverse modes, their fibers are in "red" prevalence (rich in hemoglobin), or those which favor the slow or prolonged contraction. They can also be prevalently "white" (low in hemoglobin), or those which favor a rapid and energetic contraction.

The motor muscle (or agonist) is directly responsible for a movement. The immobilization muscle, stabilization muscles, and muscles of sustenance are those in which static contractions sustain part of the body, balancing actions of motor muscles or the force of gravity. The neutralization muscle is opposed to secondary actions provoked by the agonist. The antagonist muscle is that which provokes the opposite movement of that executed by the agonist muscle.

The muscular contraction can be shortening (concentric or isotonic). The muscular belly provokes the

curtailment and therefore determines the placement of the raised bone on which the muscle is applied. The elongation corresponds to the gradual release of the muscle, with return to the length of the state of repose. The static (or isometric) is for the equilibrium effect of force of two antagonist muscles in action or during the sustenance of a weight. The muscle is completely or in part contracted, but with modifications of length.

The Mechanism of Partial Joint Movement

The static position and complex movements of the human body are better understood if the possible single partial movements situated in the mobile corporal region are considered.

It seems useful, therefore, to review in a very schematic manner, the mechanic characteristics of some joints of the limbs and to list the principle muscles that work or intervene in their various movements. Whether for physiology or for anatomy, the review of important data that covers the vertebral column is developed separately (see page 157: "Functional Movement Characteristics of the Vertebral Column").

The Upper-Limb Joints

The Shoulder

The joint of the shoulder allows the movement of the arm on the trunk. Here, the scapula-humerus joint and the joints of the scapular belt collaborate.

1) The scapula-humerus joint is an enarthrosis formed by the head of the humerus and the glenoid cavity of the scapula. The scarce correspondence between the two surface joints (one is quasispherical and convex, the other concave, but slightly deep) permits an ample possibility of movement, but also requires a robust apparatus of contention. Other essential joint components are the capsule and the mucus membrane pouches (near the deltoid and above the acromion), the ligaments (coraco-humerus, glenoid-humerus, and scapula-humerus), and the reinforced muscular elements of the local muscle tendons (super-spinous, long head of the biceps, sub-spinous, etc.).

The possible movements and the principle muscles that work to complete them are:
- the flexion or anterior pulsion (large dorsal, large round, posterior portion of the deltoid)
- abduction: in the first phase, until 90 degrees (media portion of the deltoid, super-spinous), in the second phase, beyond 90 degrees with the intervention of the other joints of the scapular belt (large dentate, trapezium, rhomboid)
- adduction (large pectoral, large dorsal, large round, sub-spinous, sub-scapular). At the free limb the gravitational force is sufficient.
- the lateral rotation of the humerus (sub-spinous, small round, trapezium, rhomboid)
- the medial rotation of the humerus (clavicle portion of the large pectoral, large dorsal, large round).

The complex movements of horizontal flexion, horizontal extension and circumduction involve in various measures and successive times many of the motor muscles of the shoulder.

2) There are two joints located in the scapular belt: The acromion-clavicle is an arthrodia that passes between the acromion of the scapula and the clavicle and is rein-forced by a capsule and the ligaments (acromion-clavicle and coraco-clavicle). The movements of the scapular belt are strictly linked at those of the arm and brought by the displacement of the scapula by means of some specific movements:
- the elevation or heightening of the scapula, or the elongation of the scapula by the rib surface (ascending portion of the trapezium)
- the adduction or nearing of the medial margin at the vertebral column (small rhomboid, large rhomboid, transversal portion of the trapezium)
- the rotation in the upper portion (ascending and descending portions of the trapezium).

The sternum-clavicle joint is an enarthrosis reinforced by the capsule and the ligaments and allow some movement of limited amplitude.

The Elbow

The elbow joint is of the trochlear type. It is composed of three joint heads (humerus, ulna, and radium), contained in a single joint capsule, reinforced by ligaments (collateral ulna, collateral radium, and annular of the radium). It is made up of three distinct joints (humerus-radium, humerus-ulna, and the proximal radium-ulna) that permit two types of movement. They permit movements of flexion and extension (that involve all three joint bones and those of pronation and supination, which instead involve bones only of the forearm, the ulna, the radium, and their distal joints). The joint movements are:
- extension (brachial triceps, anconeus)
- flexion (brachial biceps, brachial, brachial-radium)
- pronation (square pronator, round pronator)
- supination (supinator, brachial biceps).

The Wrist

The wrist joints are numerous, given the quantity of bones involved. Beyond the radium-ulna joints, which allow the pronation-supination of the forearm (and therefore, of the hand) they recognize the radium-carpus joint and the inter-carpus joints.

1) The most functionally relevant joint is the radium-carpus, between the joint surface of the radium and the carpus bones of the proximal line (scaphoid, semilunar, pyramidal, but not the pisiform). Various ligaments (radium-carpus, collateral ulna, collateral radium, etc.) reinforce the capsule. The possible movements, of different amplitude depending if the hand is in pronation or supination, are:
- flexion, which rejoins at 90 degrees (radial flexor of the carpus, ulna flexor of the carpus, long palmar, long abductor of the pollex)
- extension, which rejoins at 70 degrees (short radial extensor of the carpus, long radial extensor of the carpus, ulna extensor of the carpus)
- radial abduction or inclination (long abductor of the pollex, short extensor of the pollex, radial flexor of the carpus, radial extensors of the carpus, short extensor of the pollex)
- ulna adduction or inclination (ulna extensor of the carpus, ulna flexor of the carpus)
- circumduction, or the complex and ordered succession of various simple movements, followed that of the hand.

2) The inter-carpus joints are completed between the

carpus bones of the proximal line and those of the distal line (trapezium, trapezoid) and permit only small gliding between the bones of the same row. Instead, the middle carpus joints, which are completed between the two lines of carpal bones, allow major amplitude of movement.

The Hand

The joints specific to the hand perform between the bones of the carpus, the metacarpus, and the phalanges, with some difference in mobility between the thumb and the remaining four fingers.

1) The carpus-metacarpus joint of the pollex is in opposition to the carpus-metacarpus joints of the other four fingers. It permits the execution of ample movements, until the circumduction:
- abduction (long abductor of the pollex, short extensor of the pollex, short abductor of the pollex, opponent of the pollex)
- adduction (adductor of the pollex, short flexor of the pollex, long extensor of the pollex)
- flexion (short flexor of the pollex, adductor of the pollex)
- extension (long abductor of the pollex, long and short extensors of the fingers)
- opposition, which is the movement with which the pollex touches the point of each of the other four fingers (opponent of the pollex, short flexor of the pollex).

2) The inter-phalange joints intervene between the phalanges of the single fingers. They are the trochlear joints wrapped by the capsule and reinforced by anterior and lateral ligaments. They permit only movements of flexion and extension, which is the work of the muscle that functions on the first phalanges and the distal phalanges. A limited hypertension is also possible, but in different degrees between the various fingers.

The Lower-Limb Joints

The Hip

The hip joint (or coxofemoral) allows the movement of the lower limbs on the trunk. It is an enarthrosis that operates between the head of the femur and the acetabulum cavity (at the formation of the three bones of the pelvis: the ileum, the ischium, and the pubes). If compared with the scapula-humerus joint it easily reveals that the major robustness, due to the depth of the acetabulum and the complex system of contention, reduces the liberty of movement, but in contrast grants the large stability necessary at the lower limb to sustain the weight of the trunk in the erect station and during locomotion. The factors of stability are therefore dated by the form of the joint surface by the capsule, ligaments (round, ileum-femur, pubes-femur, ishium-femur, across the acetabulum), reinforced muscles and the quasivertical direction of the mechanical axis of the femur.

The movements of the femur at the level of the hip and the principle muscles that determine them are:
- flexion (tensor of the broad fascia, pectineal, ileumpsoas, recto-femur of the quadricep, upper portion of the large adductor, gracilis)
- extension (semitendonous, semimembranous, femur biceps, gluteus maximus)
- abduction (gluteus minimus, gluteus medius, tensor of the broad fascia, upper portion of the gluteus maximus)
- adduction (large adductor, long and short adductors, gracilis, pectineal)
- external rotation or extra-rotation (obturators, piriform, gluteus maximus, gluteus minimus, gluteus medius, ileum-psoas)
- internal rotation or inter-rotation (anterior portion of the gluteus minimus and gluteus medius, gracilis)
- circumduction, which sets the ordered succession of movements in three axes, in analogy with the joints of the shoulder, but with minor amplitude.

The Knee

The knee joint is complex and assimilable at an angular ginglymus with particular formations that allow, other than flexion and extension, a slight rotation if the leg is flexed. The surface of the joint heads has a discordant form because the two condyles of the femur have different dimensions. They are ovoid and strongly convex, while those of the tibia are only somewhat hollow. The stability of the joint is secured by a robust capsule with annexed mucus membrane pouches by the menisci, a complex system of ligaments (kneecap, collateral tibia, collateral peroneal, back-of-the-knee, and cruciate) and the muscular tendons, above all the kneecap tendon, which covers the kneecap and the ileum-tibia tract of the wide fascia.

The possible movement of the leg and the involved principle muscles are:
- flexion (femur biceps, semimembranous, semitendonous, sartorius, gracilis)
- extension (femur quadricep, recto-femur, vast medial, vast lateral, vast intermediate).

As is noted, if the knee is flexed, it becomes an external (femur biceps) and internal (semimembranous, semitendonous, gracilis, sartorius, back-of-the-knee) limited rotation of the tibia.

The Ankle and the Foot

The ankle joint, or tibia-tarsus joint, is a trochlea, formed by the anklebone and the distal extremities of the tibia and fibula. It is wrapped by the capsule and reinforced by robust ligaments (deltoid, talo-fibular, etc.). It permits only movements of flexion (dorsal flexion) and extension (plantar flexion).

The joints of the foot are numerous, but in comparison to those of the hand, they allow somewhat limited movements. They include the anklebone-calcaneal joint, the tarsus-metatarsus joint, the inter-metatarsus joint, the metacarpus-phalange joints, and the inter-phalange joints. All are reinforced by robust ligaments confering the solidity and necessary functional elasticity of the foot.

The possible movements are similar in the diverse sectors of the foot. In particular, the joints of the ankle allow dorsal flexion (anterior tibia, anterior peroneal, long extensor of the toes, long flexor of the big toe) and plantar flexion or extension (soleus, long peroneal, posterior tibia, short peroneal, long flexor of the toes, long flexor of the big toe).

The tarsus joints permit the completion of:
- dorsal flexion (anterior tibia, anterior peroneal, long extensor of the toes, long extensor of the big toe).
- plantar flexion (posterior tibia, long flexor of the toes,

long flexor of the big toe, long peroneal, short peroneal).
- medial rotation or adduction (anterior tibia, posterior tibia, long flexor of the toes, long flexor of the big toe)
- lateral rotation or abduction (long peroneal, short peroneal, long extensor of the toes).
 The joints of the toes permit:
- flexion (long flexor of the toes, long flexor of the big toe, short flexor of the toes, short flexor of the big toe, short flexor of the fifth toe)
- extension (long extensor of the toes, long extensor of the big toe, short extensor of the toes).

Equilibrium and the Static Position

Equilibrium

Equilibrium is the whole of the muscular and cerebral function of adaptation, which maintains the sustenance of the human body during active and passive movements of displacement in space. The body is continuously sub-posted by mechanical force (gravity, transfer, friction, etc.) even when it does not manifest certain movement. In this condition, the agent forces reciprocally annul themselves, and are therefore in equilibrium. This can be "static" when it is identified with the posture of the body, or the function that tends to maintain the body in a "normal" position (particularly the erect position) in respect to the surrounding space, contending the line of gravity inside the area of corporal sustenance. It can also be "dynamic," correlating to the execution of movements, above all those that involve the entire body like walking, running, jumping, climbing, and swimming.

Equilibrium, in a mechanical sense, is strictly linked to the position of the center of gravity of the body. This is definable as a point on which every side of the body is balanced and on which the forces work. In humans in the erect position, this is situated in the pelvis, in correspondence to the vertebral tract that comes from the fifth lumbar and the second sacrum.

The center of gravity, across which the line of gravity passes (or the perpendicular that conjoins at the soleus) does not change position or undergo slight oscillations until it does not mutate the form of the body or the disposition in the space of its part. Instead, the center of gravity in human individuals in the erect position fits at the levels slightly diversely in relation to the morphological type, age, and sex.

The human body maintains equilibrium (with continuous adaptation, if the line of gravity falls at the inside of the support base), which, in the erect position, is qualified by the plantar surface of the two feet and the inter-posted area that can be more or less ample in relation to the distance or vicinity of the feet. In the other static position, for example the axis as reclined, the support base corresponds to the surface of the body parts, which adhere to the support and are more extensive, in order to allow decisively more equilibrium. The mechanical factors of maintenance of the equilibrium are governed by complex cerebral coordination of reflexes coming from the peripheral sensory apparatus at the internal ear by visible, psychological, or physiological stimulus. There are two types. One is the passive (bone resistance, elasticity of ligaments and the capsules, joint structure, position of various corporal segments, etc.). The other type is active (contraction of muscles at the antigravitational action, for example, the extensors of the head, the trunk, lower limbs, or muscles of the abdominal inner portion).

The Erect Position

The erect position, with the body weight supported equally on two feet, is static and specific to humans. Observing the body frontally in this position reveals the median plane, directed in an anterior-posterior direction, and the passing of the line of gravity which divides the body into two symmetric halves.

Observing the body laterally, instead, reveals the frontal plane correspondent at the line of gravity. The line of gravity crosses the various body segments asymmetrically. The vertical passes slightly in front of the external hearing opening and the lateral malleolus.

The diverse body sectors (head, trunk, lower limbs, etc.) each have their own center of gravity and axis. Their over-position reveals a split line at various angled segments in an anterior-posterior direction.

The muscles, but above all the ligaments, work to maintain the sectors in equilibrium, one on the other, by means of continuous adaptations to transmit the weight at the base of the support along the line of gravity.

In the normal erect position, the ligaments and the extensor nape muscles do not allow the head to fall forward. The extensor paravertebral muscles of the column evade the falling forward of the thorax segment, while the abdominal obstructs the posterior falling of the trunk. The ileum-psoas muscles, the tensor of the broad fascia, and the ileum-femur ligament restrict the flexion of the knee, while the twin muscles and the soleus do not permit the anterior flexion of the tibia.

The external morphology of the human body in the erect position is characterized by the contraction of the nape muscles, a slight tension of abdominal muscles, slightly revealed dorsal surface muscles (lumbar tract), tension of the broad fascia, and contractions of the posterior leg muscles and the anterior tibia.

On the other hand, in the forced erect position, the contractions of the femur quadriceps (and the following fixation of the kneecap), of the gluteus maximus, and of the dorsal musculature are also noted.

Variants of the Normal Erect Position

The erect position can also be maintained in gestures other than the "normal" pose.

In these cases, a displacement of the center of gravity is verified (and a consequent modification of the amplitude of the support area) in relation to the deviation of the corporal assets of the gravitational line. The conditions of equilibrium vary in conformity at the assumed gesture and are maintained by means of the continuous joint adaptation and action of the specific involved muscles.

The poses derived from the normal position are various, but can be brought back to some types in which one stands on both feet, or only on one. They are almost always characterized by a condition of equilibrium.

1) The two-footed erect posture with legs apart shows the amplitude support base in a transversal direction. It allows ample excursion of the line of gravity on the

frontal plane, and therefore a major possibility of equilibrium on this plane. The relationship between rachis and pelvis remains almost unaltered, as long as a slight diminution of the lumbar and the femur is found in abduction at the level of the hip. In this position, the muscles of the trunk and of the involved lower limbs are involved in the maintenance of the "normal" erect position.

2) The two-footed erect posture with anterior-posterior limbs presents characteristics analogous to that of the limbs apart. The resulting area of support is augmented, but in an anterior-posterior direction, allowing major body stability in a saggital sense; a factor also useful in movement. The directly posterior limb demonstrates the femur in hypertension in respect to the hip, the knee in extension, and the angle formed by the axis of the foot with the axis of the leg slightly lower, at 90 degrees.

The directly anterior limb, instead, presents the femur moderately flexed on the hip, the knee in slight flexion, and the foot/leg angle slightly greater than 90 degrees.

3) The gesture with metatarsus-phalange sustenance, which is the support at the point of the feet, is fairly frequent. It brings a relevant diminution of stability on the saggital plane and confers a complex equilibrium to the body. The lumbar extension of the femur on the hip and the extension of the knee results are accentuated.

In the maintenance of this position some muscles of the lower limb work more intensely. They include the adductors, the quadricep and the soleus, the posterior tibia and the long peroneal, but not the gluteus.

4) The posture having support only on the heels is very unstable. For that reason, it is seldom voluntarily assumed and only for a short time. With some analogy, it can however be found in some phases of movement. The lordosis lumbar diminishes, the femur is in slight flexion on the hip, and the knees are extensive. Beyond the quadriceps, some muscles of the foot and the leg work intensely (anterior tibia, long peroneal, etc.).

5) The asymmetrical erect position brings an asymmetrical cutting of the vertical corporal axis. Popular during the era of the best Greek sculpture, this posture offers much interest for artistic representation.

In this position, the weight of the body is almost completely on one limb, while the other foresees the maintenance of equilibrium. It is a reposed position because it permits alternative placements of the side, putting force on the robust ligaments of the hip (in particular the ileum-femur) and on the broad fascia.

The supporting limb is hyperextended and somewhat inclined laterally, elongating itself by the line of gravity. The leg is held in position by the contraction of the twins, soleus, and other flexor muscles (biceps, semimembranous, long peroneal, etc.). The muscles of the other flexed limb are, instead, almost totally relaxed.

The skeletal structure of the trunk undergoes movements of lateral inclination because the side of the pelvis correspondent to the flexed limb becomes shortened in respect to the other. A slight movement of rotation makes the "supporting" hip slightly more displaced in front of the other. Consequently, the thorax, to compensate the inclination of the hip and maintain the corporal equilibrium, must flex itself at the level of the lumbar column on the opposite side. The head is also adapted to the new equilibrium, flexing itself laterally on the more elevated shoulder.

Observing the figure frontally or dorsally in the erect position easily reveals the inclination posted opposite of the transversal axis at the level of the shoulders and the pelvis.

The shoulder correspondent to the side of the supporting limb appears shortened and closer to the hip. Consequently, the rib margin of this side joins a brief distance of the iliac crest, while the contrary happens on the opposite side.

The pelvis is inclined in a direction contrary to the shoulders. It is more elevated in correspondence to the supporting limb and more shortened on the side on which the limb is flexed.

To judge the degree of inclination, it is useful to refer to the subcutaneous bone points specific to the two regions: the acromion, and the anterior superior iliac spine. While the external form of the flexed limb is entirely rounded, it does not demonstrate valued muscular projection. That of the supporting limb demonstrates a flattening of the lateral surface of the leg (due to the tension of the stabilizers of the broad fascia), the contraction of the posterior muscles of the leg, and the contractions of the vast medial and lateral. The buttocks assume a different formation because the supporting leg is straighter and more revealed, caused by the contraction of the gluteus medius and also at times the gluteus maximus. It determines the delineation of a clear gluteus sulcus, which appears more shaded on the other side.

On the back, the transversal lumbar sulcus appears more accentuated on the side of the supporting leg. The sacrum-lumbar muscles are slightly contracted by the side of the flexed limb, to contrast the lateral curvature of the vertebral column. At this level the vertebral sulcus appears profound and convex across the part of the flexed limb.

6) The erect monopodalic position can easily foresee the motion of leaving that asymmetrical position, which holds the body weight on only one limb.

Because the surface of the support is reduced, the equilibrium of the body in this position is decidedly unstable. By the point of which the line of gravity passes, the position is passively maintained for a brief time or by means of transient and alternating contraction by the gluteus muscles, the adductors, and the tensor of the broad fascia correspondant at the supporting leg. It is obvious that the raised limb can be orientated in various degrees of flexion and in various directions, for example laterally, forward, or posterior.

7) If carrying a heavy object, the human subject is constricted to assume certain characteristic gestures of adaptation with the limbs and trunk in conformity to the degree of displacement that the center of gravity undergoes. It is also effected by the displacement of the corporal axis in respect to the line of gravity.

The inclination of the body or its segments can arrive in an anterior, posterior, or lateral direction in relationship to the dimensions, the weight transported and the entity of the displacement and the muscular force to maintain the body and weight carried in equilibrium.

Other Static Positions

Beyond the erect position and it's variants, exist numerous other habitual postures. They are, in general, more static and reposed, which the body can easily assume such as the seated and stretched positions.

164

The principal and most frequent positions can be listed to complete the argument. They present some interest from an anatomical-artistic point of view.

1) In the seated position, the lower limbs lose their function of supporting the trunk. The base of the support corresponds to the gluteus region at the posterior surface of the leg. It appears ample, and therefore, the equilibrium of the body is fairly stable, allowing the displacement of the trunk to be more extensive from behind, the side, and mostly from the front. It can comport some displacement of the upper and lower limbs or the head to make the assumption of the new equilibrium easier. The free-seated position, with dorsal support, also allows the vertebral column to diminish the physiological curvature, particularly the lumbar, which can also annul itself when the trunk is flexed forward with support on the elbows. The paravertebral muscles mainly work in the maintenance of equilibrium in the seated position. The nape muscles keep the trunk and the head erect, against a gravitational falling forward.

The external forms are influenced by the seated gestures and usually characterized by the projection of the abdomen, caused by the release of ventral muscles by the accentuation of the straightening of the dorsal surface, the lower flattening, and the posterior/lateral projection of the fatty gluteus tissue.

2) The squatting position reveals the support only on the feet, but the difference in the erect position comports the simultaneous flexion of all of the joints of the lower limbs, and therefore a notable shortening of the center of gravity. Overall, it does not comport a very stable equilibrium, especially if the podalic support reduces at the points. Numerous variations of this posture exist, for example with the two heels raised and the plane completely supported at the ground, with one foot placed forward and laterally in respect to the other, etc., but the base remains small. A major stability returns at the unloading of the body weight, including the upper limbs touching the floor.

Each of these positions presents different skeletal adaptations and diverse complex working muscles, which it would be excessive or superfluous to describe anatomically because they are easily observed with attention to the external morphology of the model.

3) In the kneeling position, the anterior surface of the knee, the leg, and the dorsal surface of the extended feet forms the base of support. A variation of this position reveals the support on only the knees and the toes. Another variation reveals the support on only one limb in one of the two positions noted, while the other is flexed to form a right, slightly acute or obtuse angle between the upper and lower portions of the leg. The body (the head, trunk, legs, and upper limbs) can be kept erect on the knees vertically or with a certain degree of inclination. It can also be supported on the heels and the posterior surface of the lower legs.

4) The stretched or reclining positions bring favorable conditions to the stable equilibrium because the base of support is very extensive. Three fundamental positions can be identified, which merit some morphological consideration. In their numerous varieties, they have been and are frequently chosen for artistic purposes.

a) The stretched supine position is also called anatomic because it corresponds to the cadaver on the sectored table. The body supports on the base with the occipital region, the surface of the upper dorsal tract, the sacrum region, the posterior surface of the legs, and the heels. The feet result in slight plantar flexion, and the vertebral column, in order to maintain its physiological curvature (only slightly diminished in the cervical and thorax tracts) demonstrates an accentuation of the lumbar lordosis.

The corporal center of gravity is very low, in correspondence to the second sacral vertebra. It falls at the center of the area of support, rendering the position more stable. The external form undergoes certain modifications due to the effect of the force of gravity and the compression on the surface of the support. Other positions can be derived from this one, for example with one or both lower limbs flexed at the plantar support of the feet, or with abduction or extension of one or both of the arms bent under the nape, etc.

b) The prone position is assumed more rarely because it is somewhat uncomfortable for respiration, which requires lateral rotation of the head to become easier. The body is supported by the chin (or the cheeks), almost the entire anterior surface of the trunk, and the legs, and back of the feet.

c) The stretched lateral position offers scarce stability in the transversal sense because the body supports with its lateral surface of somewhat limited extension. The center of gravity is elevated and comports an inclination across the fallen anterior or dorsal of the trunk, in order to find an intermediate more stable and relaxed position. The partial flexion of the lower limbs and the displacement of the upper effectively contrast the trunk. The pelvis can undergo a slight anterior or posterior rotation. The vertebral column is able to maintain and reduce the physiological curvature, but always demonstrates, on the frontal plane, a convexity across the lower portion of the lumbar tract and one in the upper portion of the thorax tract.

In this position, the gravitational form also has influence on the fatty tissue and the relaxed muscular mass, determining characteristic variations in the external form of some regions (abdominal, gluteus, pectoral, etc.).

The Dynamic Gestures

As in the erect position, in locomotion (the displacement of the surroundings by means of muscular force) the positions and placements of the center of gravity and of the line of gravity of the entire body have great importance.

Human locomotion is bipedal (performed on two feet), plantigrade (with support on the ground of the plane of the feet), and orthograde (spread out in the erect position).

The coordinated and rhythmic movements of the lower limbs and the other corporal segments determine the placement of the body center and the base of the sustenance. The locomotive actions naturally specific to humans are walking or running. They depend on two ordinary factors. One of these factors is intrinsic to the individual (sex, age, state of health, constitutional type, etc.), the other is connected to the surroundings (inclination or irregularity of the terrain, etc.). Every individual walks or runs with a distinctive style, which is variably influenced by cited factors, but it has been possible to identify the typical fundamental mechanisms of the two locomotive actions.

Walking

Walking (also marching or running) is the particular type of terrestrial locomotion characteristic to humans to move the body from place to place. While walking, the body never leaves the ground. The lower limbs are placed alternately one in front of the other, transporting the head, the upper limbs, and the trunk. Walking accomplishes a succession of passages. After two steps complete a cycle, the lower limbs are found in the initial position again.

In the complete cycle of walking, some typical phases have been identified to be normal to a human in healthy condition. In reference to only one lower limb, there is a phase of support and a phase of oscillation. In reference to both the lower limbs (and the entire body), there are two phases of support and two of unilateral support.

In a simplified manner, the sequence of movement can be reassumed, considering the following fundamental aspects:
- the walking mechanism on a level terrain begins in the erect position with bilateral support
- the flexion of one lower limb that enters in the oscillation phase with flexion at the hip (ileum-psoas), at the knee (femoral biceps, sartorius, etc.), and at the ankle (flexor muscle of the foot, above all the triceps of the calf). It provokes the monolateral support of the body weight on the supporting side. This opposes the straining force to flexing by means of the contraction of the broad fascia, the recto-femur, and the gluteus medius and minimus.
- the oscillating joint extends the leg to rejoin the ground, contacting the quadriceps of the ileum-psoas
- the supporting limb extends the foot, placing it forward, allowing the oscillating foot to rejoin the ground
- it allows the phase after the support, in which the forward limb is supportive, while the other initiates flexion to become oscillating.

The phases of walking to be noted are as follows:
1) The phase of support, or moment in which both feet are supported on the ground
2) The phase of unilateral support, or the successive moment when a limb is situated in the posterior portion and brought forward, placing the body weight on the other foot, which is supported on the ground first by the heel and then by the point of the foot.
3) The phase after support, in which both feet adhere at the ground, the heel is brought forward, and the point is placed behind.
4) The phase of unilateral support, in reference to the foot that has been brought forward

While walking, the trunk performs a slight torque and continues anterior-posterior and lateral oscillations in a manner that, positioned with gravity centered, the line of gravity continually falls inside the variable area of support.

The upper limbs oscillate normally and spontaneously, with movements in opposition to those of the lower limbs. The arm of one side is placed forward, while the leg of the same side is placed behind. Their movement determines the alternate torsion of the trunk, mostly evident at shoulder level.

The manner in which walking is completed is somewhat different according to the characteristics of the terrain on which one is moving (inclination, smoothness, etc.), as well as other particular conditions.

During various phases of walking some modifications of the corporal extern are noted. Some of these are easily identifiable with direct observation of the model, for example:
- The gluteus region of the supporting limb appears contracted, while that of the other leg is more flattened.
- The projections of the quadriceps of the supporting leg appear clear and well delineated, caused by the contraction, but only in the first part of the support phase, because soon after the muscles relax and the projections attenuate.
- In the oscillating limb, during the first part of the phase, the flexor muscles of the upper leg appear contracted and projected (sartorius, tensor of the broad fascia, etc.), as do the flexor muscles of the lower leg (femoral biceps, semimembranous, semitendonous, etc.).
- In the trunk, beyond the muscles of the nape, the spinal muscles of the lumbar tract that are posted on the corresponding side of the oscillating limb becomes contracted.

Running

Running, like walking, is a manner of frequently adopted locomotion because it allows rapid displacement. Running, however, does not have a supportive phase of the lower limbs because air suspension of the entire body quickly follows the period of unilateral support. It becomes projected by the action of the supportive foot on the ground, by means of the strong contractions of the triceps, which raise the heels.

Direct observation is not sufficient for the study of running, due to the rapidness of the movement. Therefore, some basics, useful for the artistic figure, can be listed:
- The trunk undergoes some modest torsion, but its inclination (forward at the beginning of the support phase and behind during the relaxation) is more accentuated in respect to that of normal movement and also in relationship to the velocity at which one is running.
- The feet touch the ground at this point, but quickly the heel is raised off the floor and gradually the rest of the foot, finishing with the toes, which are the last to leave the terrain.
- During the phases of running, the lower limbs are not extended, but in a more or less accentuated state of flexion.
- The upper limbs move in a manner analogous to that of walking, but accomplish a more ample excursion and conserve a certain degree of flexion.
- Equilibrium during running is somewhat unstable because, in almost all of the phases, the center of gravity falls outside of the base of support (which is constituted particularly on the point of the foot), and the entire body undergoes, aside from the force of gravity, the force of inertia as well.
- The muscular group, which enters in the unfolding function of the running phases, are the flexors of the leg, the quadriceps, the triceps, the gluteus muscles, and the dorsal flexor of the foot.

More precisely:
1) In the phase of unilateral support, when the foot touches the ground, the quadriceps and all of the muscles of the leg are strongly contracted to aid the yielding

of the knee joints and the tibio-tarsal. When the foot begins to separate from the ground, the twin muscles and the soleus contract decisively to display the propulsive function. Successively, the flexor muscles of the lower leg enter into action on the upper leg (femoral biceps, semitendonous, semimembranous).

2) In the suspension phase, during oscillation of the limb the flexor muscles of the upper leg enter the function (sartorius, recto-femoral, tensor of the broad fascia). The gluteus muscles, which have a modest role during walking, work intensively and in a different manner while running. They work mostly during the suspension phase, during which is noted a strong contraction and distinct projection of the gluteus maximus correspondent to the raised limb behind, while that of the other limb appears relaxed and flattened.

Jumping

Jumping is a manner of displacement in space rarely used by humans in comparison to locomotion. It consists of a rapid and potent extension of the lower limbs, flexed in various degrees, to the effect that the body is raised forward and upward.

Jumping is accomplished with diverse executive modality, but it is neither useful nor opportune to point out the characteristic morphological variations because they are corporal gestures rarely represented in art and can be valued completely only by means of photographic examination. It is sufficient then to consider

that, in every type of jump, there are three phases:

1) the preparation phase, during which the body and the lower limbs are flexed. They incline or procure the impetus.

2) the suspension phase (ascending or descending), during which the body is separated from the ground and raised also by the movement of the upper limbs.

3) the terminal phase, during which the feet touch ground and the lower limbs are flexed to appease the counterstroke.

The artistic representation of locomotive movements is close to the scientific analysis that the observation of nature has a fundamentally correct and very expressive sequence of gestures and an essential dynamic sense.

For example:

1) Walking is almost always represented in the phase after support, in the gesture that shows the feet partially elevated off the ground. The trunk is inclined forward to weigh down on the supporting limb, which is slightly flexed at the knee.

2) Running is almost always pictured in the phase of unilateral support, with the supporting limb slightly flexed and the other raised behind. The trunk and the head are strongly inclined forward. It responds less to the "scientific" scheme (in which the trunk is somewhat erect, until causing the line of gravity to fall into the area of support), but it is much more expressive in the dynamic, muscular tension, and instability of the equilibrium sense.